NB1140.R6 32

THE APPRECIATION OF THE ARTS 2

General Editor: Harold Osborne

Sculpture

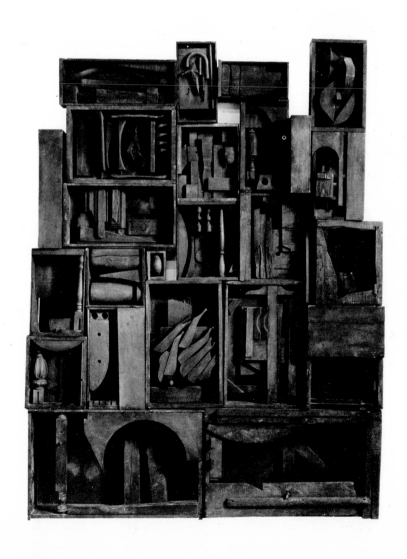

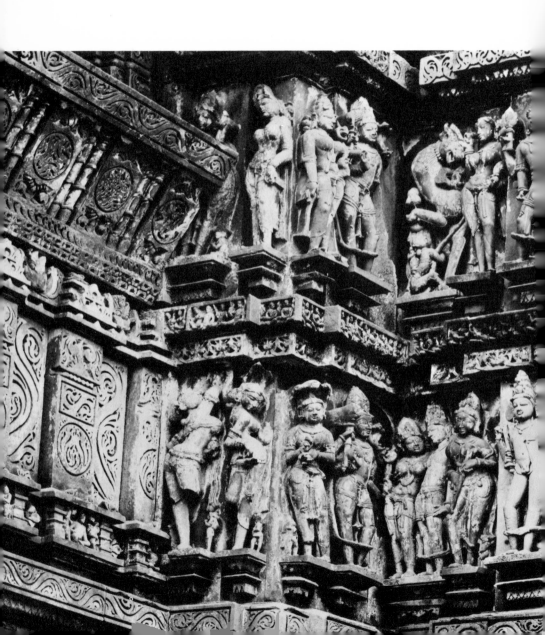

SCULPTURE/*L. R. Rogers*

London · *Oxford University Press* · New York · Toronto · 1969

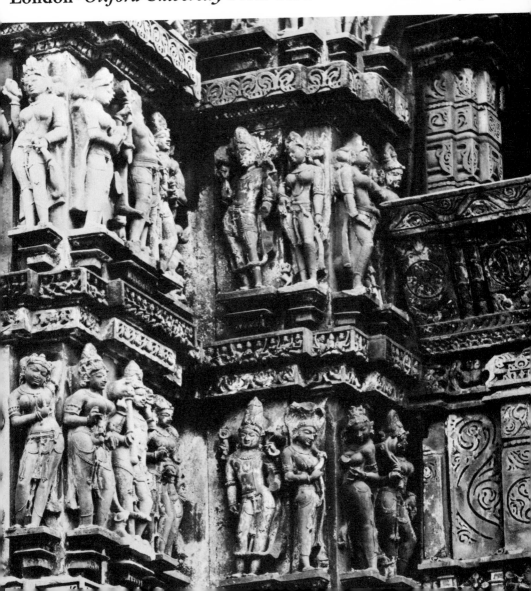

Oxford University Press, Ely House, London W.1

GLASGOW NEW YORK TORONTO MELBOURNE WELLINGTON
CAPE TOWN SALISBURY IBADAN NAIROBI LUSAKA ADDIS
ABABA BOMBAY CALCUTTA MADRAS KARACHI LAHORE
DACCA KUALA LUMPUR SINGAPORE HONG KONG TOKYO

Made and printed by offset in Great Britain
by William Clowes and Sons, Limited,
London and Beccles

To my wife

Contents

Illustrations

All drawings and diagrams are the work of the author and are not listed here

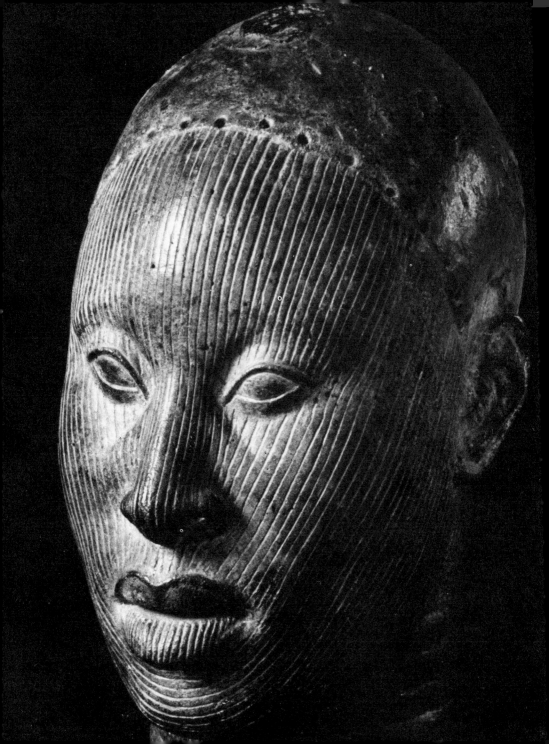

Introduction[1]

. 1
nale Figurine, Moravian,
aeolithic; clay, 11·4 cm.

. 2
on Licking Its Back, antler
ving from La Madeleine,
rdogne, Palaeolithic;
e cm.

nze Head, African (Ife),
century; 12 in. *Ife
eum* (photo: *Herbert List*)

One of the most important side-effects of the development of
twentieth-century art has been a broadening of our interest in
and appreciation of the art of cultural traditions other than our
own. Few people today believe as did those of a generation or
so ago that the art of painting began with Giotto or that the
only kind of sculpture worthy of serious attention is that which
originated in classical times and was continued and developed
in Renaissance and post-Renaissance Europe. We are now
aware that excellent sculpture has been produced in almost
every society, primitive and advanced, that has ever existed,
and we prize as works of art many sculptured objects which a
few decades ago would have been valued merely as curios or
for their interest to archaeologists and anthropologists. The
approach of this book to the appreciation of sculpture will,
therefore, be a broad one that seeks to avoid any kind of paro-
chialism, either geographical or historical.

That a refined sensibility to sculptural form can exist in even
the most primitive societies is clearly evident from the clay
models and carvings in stone, ivory, and bone which were
produced by Palaeolithic man. They include representations in
the round and in relief of female human figures—the prehistoric
'Venuses'—and of many different animals. Although not as *Figs. 1, 3,*
48
immediately impressive as the more widely known cave draw- *Fig. 2*
ings and paintings at such places as Altamira and Lascaux, they
are no less remarkable and reveal an equally astonishing sen-
sitivity, particularly to the expressive forms of animals.

The great civilizations of Egypt, Mesopotamia, India, China,
South-East Asia, Central and South America, the Mediter-
ranean, and medieval Europe, together with the tribal cultures
of Africa, Oceania, Central Asia, and North America, have all
produced magnificent sculpture in a vast profusion and di-
versity of styles. All kinds of buildings, from massive stone
temples and palaces to small tribal wooden huts, have been
decorated inside and out with sculpture, and every kind of
implement and utensil, from a fly-whisk to a sarcophagus, has
either been embellished with sculpture or has itself been

[1] Numbers in the right-hand margin of the text refer to illustrations.

conceived in sculptural form. And in addition to being associated with architecture and functional objects sculpture has also existed independently in the form of religious icons, tombstones, cult objects, magic charms, monuments, garden and civic statuary, portraits, and domestic ornaments.

A large part of the sculpture of the past has been irrecoverably lost. Countless wood-carvings—the main kind of sculpture produced in Africa and Oceania—have perished through the effects of climate and through attack by insects and fungus. Vast quantities of metal sculpture have either corroded completely away or have been melted down for plunder or so that their metal could be used again. Over the centuries stone carvings have eventually been broken up by frost or eroded to stumps by the wind and rain. A great many works, too, have been destroyed by religious, moral, and political fanatics, who appear everywhere to have made the mutilation of sculpture one of their main preoccupations. Yet in spite of these and other hazards a great wealth of excellent sculpture has survived and is available today in museums, art galleries, temples, churches, and public places all over the world. And in addition to what remains of the work of the distant past and of cultures remote from our own there is a vast and increasing abundance of sculpture from modern times. This includes work in all the styles of post-medieval Europe and the immense range of sculpture being produced by present-day sculptors all over the world.

In a sense it is misleading to speak of the art of the past as if in contrast with the art of the present. The phrase 'the art of the past' suggests that we are dealing with something which is over and done with, which has become merely a matter for the historian, like the events and people of the past. But pieces of sculpture which were produced hundreds or thousands of years ago exist here and now and are present to our senses in the same way as those that were produced yesterday. Apart from effects of wear and tear their age or newness does not affect their quality as works of art. There is no such thing as aesthetic obsolescence. Renaissance art did not invalidate medieval art in the way that the Copernican system invalidated the Ptolemaic system. What was a beautiful and expressive masterpiece two or three thousand years ago still has the power to move and delight us even when we know nothing about its origins or about the significance it once had in a system of customs and beliefs that has disappeared beyond recovery.

Fig. 3
VENUS OF LAUSSEL, limestone relief from the Dordogne, Palaeolithic; 44 cm.

There is another sense in which the age, place of origin, and cultural background of sculpture are of little consequence. There are no language barriers to be overcome, as there are in ancient and foreign literatures, before we can make contact with sculpture. There are not even the kinds of barriers that make Chinese and Indian music difficult for ears attuned to Western harmonies and rhythms. The language of sculpture is a universal language and it can speak directly to us even though we know nothing whatever about a particular work apart from what we can see of it in front of our eyes. The accents of this language, so to speak, may vary in different times and places but fundamentally it is always and everywhere the same language.

But if everything that is to be seen in works of sculpture is there in full view in front of our eyes, why is not all sculpture immediately and universally appreciated? The brief answer to this question is that the aesthetic qualities of sculpture *are* directly accessible to us but that we can perceive them only if we have acquired the power to do so. Nothing is hidden in sculpture; the only limitations there are to what we can see in it lie within ourselves. If we fail to appreciate great works of sculpture, it is usually because we have not acquired the perceptual skills, attitudes, and sensibilities that would enable us to do so.

There are some qualities of sculpture which may be appreciated without much effort. They are almost universally recognizable and immediate in their appeal. Consider, for example, the overwhelming pathos of the Perpignan Crucifix, the dignity and power of Michelangelo's *Moses*, the tenderness of 62 the gesture of the man's hand in Rodin's *The Kiss*, the warm 4 radiance of Maillol's and Renoir's sculptures of women, the 6, 19, 60 erotic appeal of an Indian apsaras, and the youthful charm of 7 the choirboys from Luca della Robbia's *Cantoria*. All these are 5 qualities to which most people can readily respond because, although they are raised above their normal intensity, they are all qualities to which we habitually respond in everyday life. The deeper our ordinary feelings are, and the sharper our emotional responses in life, the more keenly do we appreciate such qualities of sculpture. Certainly we need no special kinds of perceptual skills, attitudes, and sensibilities in order to apprehend and enjoy them. There is only one way to develop our responses to this aspect of the art of sculpture and that is by becoming more generally sensitive human beings.

It is by recognizing and responding to these straightforward

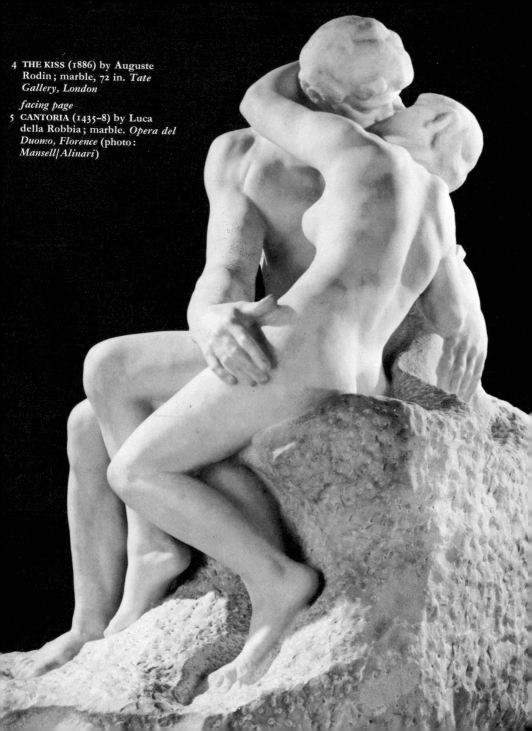

4 THE KISS (1886) by Auguste
 Rodin; marble, 72 in. *Tate
 Gallery, London*

facing page
5 CANTORIA (1435–8) by Luca
 della Robbia; marble. *Opera del
 Duomo, Florence* (photo:
 Mansell/Alinari)

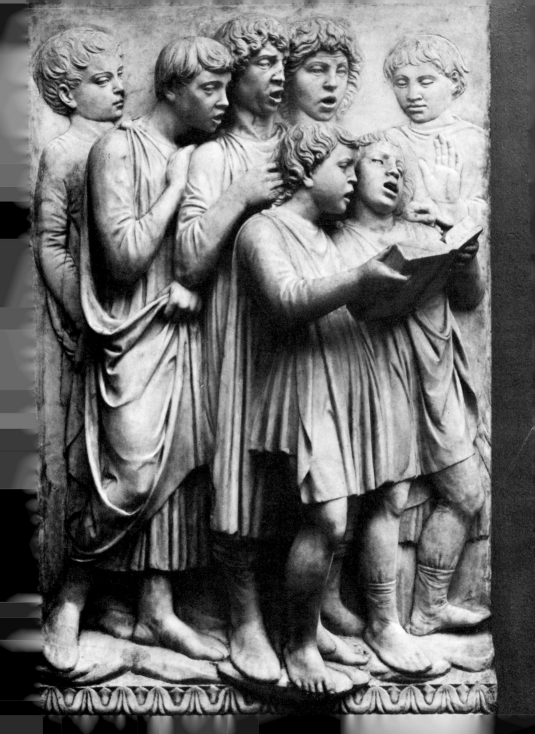

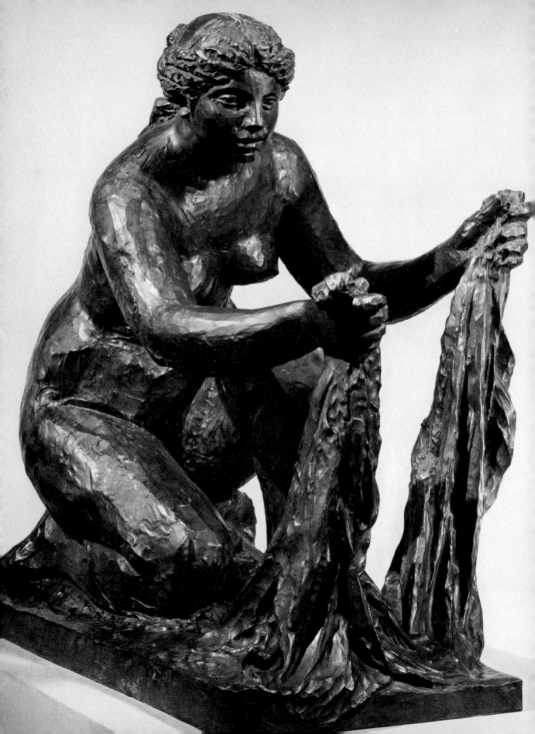

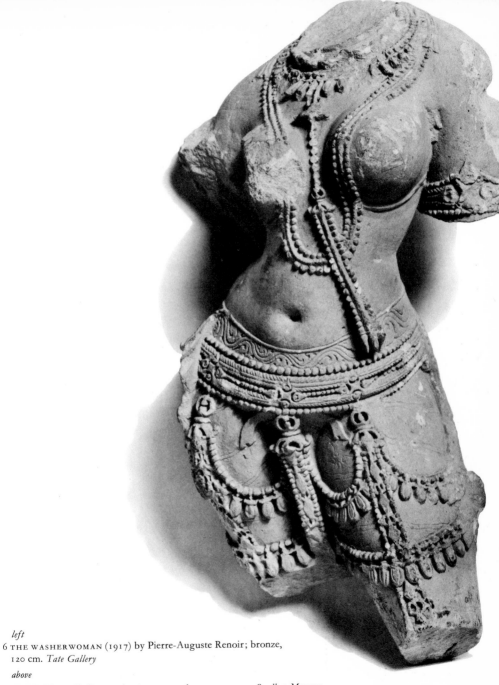

'human' qualities that most people first make contact with the art of sculpture and become interested in it. But important though these qualities are where they do exist, they are only as it were the first and most easily reached layer of meaning or significance in sculpture, the merest fringe and superficiality of what it has to offer. To limit ourselves to appreciating only this aspect of the art of sculpture would be to cut ourselves off entirely from the deeper levels of expressiveness and beauty of form that exist in all great masterpieces. It would also mean cutting ourselves off from all the sculpture in which these rather obvious expressive qualities are either not present at all or are present only to an insignificant extent.

There are two main ways in which we may develop our interest in sculpture beyond the level of these immediately appealing expressive qualities. One is by acquiring the various kinds of knowledge and information about it that are made available through the work of historians, archaeologists, anthropologists, iconographers, biographers, and technical experts. This includes the answers to such questions as: Where, when, and by whom was it made? For what purpose was it made? What, if anything, does it represent? What myths or religious beliefs does it express? Is it symbolic, and if so of what? Does it throw any light on the events of the artist's life or on the times in which he lived? How was it made? Is it an original work or has it been derived or copied from another? What influences have contributed to its style? . . . and so on. Any lover of sculpture is likely to want to know the answers to some questions of this kind about the works he admires and will either undertake research himself in order to find them out or will look them up in the appropriate authorities.

The other main direction that our interest may take is towards a fuller apprehension of the expressive forms of sculpture itself; that is, towards a deeper awareness of it as something presented to perception. Our capacity for this kind of sensory apprehension depends not on the acquisition of factual knowledge but on the development of special kinds of sensibility, perceptual skills, and attitudes. It is with this approach to sculpture that we shall be chiefly concerned in the chapters that follow. This is not because the other approach has nothing to contribute to our appreciation. On the contrary, provided we do not lose sight of the sculpture as an object presented to the senses, the contributions of the archaeologist, historian, and

so on can add significantly to our total experience of sculptur
But the apprehension of the perceptual qualities of sculpture lie
at the centre, as the core, so to speak, of appreciation. And the
other aspects contribute to our appreciation of the sculpture as a
work of art only in so far as they are related to this central core.

There are, as we have already mentioned, certain works of
sculpture about whose social background we know next to
nothing but which we nevertheless can and do appreciate as
works of art. This does not imply that our appreciation of them
might not be enhanced if we did know something more about
them. Some kinds of information about a work of sculpture
may enlarge our visual awareness of it by directing our attention
to features we may not otherwise have noticed. They may also
add other dimensions of significance which enrich our re-
sponses to the formal and expressive qualities of the work. Con-
sider, for example, the magnificent bronze images of South
India. We may enjoy these for their formal–expressive qualities 8, 84
alone without enquiring further into their social and historical
background and religious significance. But how much richer
our appreciation of their perfectly proportioned and unified
sculptural volumes becomes and how much our responses to
their expressive qualities are heightened when we learn some-
thing of the cosmic forces that are symbolized by the deity they
portray! Or when somebody interprets for us the significance of
their poses and the conventional language of their gestures and
when we have seen these gestures and poses become alive in
the great tradition of Indian dance to which the sculptures are
related; or when we can bring to the sculptures a knowledge of
Hinduism and of the gods and legendary figures that are repre-
sented in them. In other words, how much more we are able to
appreciate them when we are able to set them against their own
cultural background as we are able to set our own Western
sculpture against its background of Christianity, classical
mythology, and European history! Such knowledge should not
divert us from an appreciation of the expressive form of the
sculpture or detract from its central importance. On the con-
trary, it should surround what is directly presented to our senses
with light, atmosphere, and meaning, and enrich our total
response to it.

But fascinating and necessary though it may be, the search
for information about sculpture can become a trap, especially
for people whose training and habits of mind are intellectual or

literary rather than perceptual. In the attempt to 'understand' works of art they may tend to overrate the learning of facts about them and to apply to them approaches which may be appropriate in their own fields but which will not get them very far in the appreciation of sculpture. Not knowing what to look at in the individual works themselves, they may turn with relief to theoretical discussion or to research and the pursuit of information for its own sake—activities which are more congenial to their intellectual skills and training in abstract thinking. Their interest may then shift from the centre to the periphery, from the works themselves to the study of the history of art, the philosophy of art, the psychology of art, or even to the study of art criticism as an academic interest in itself. We do not of course in any way discount the value of these disciplines in themselves, provided that they do not become a refuge from the demands that the visual arts make on our powers of perception. It is not at all easy for people with highly developed intellectual and verbal skills to come to terms with the fact that in visual matters they may be less well-equipped than children; yet this is often the case.

Apart from the fact that the perceptual aspects of sculpture are of central importance in appreciation there are two other reasons for devoting most of the pages of this book to them. First, the historical, iconographical, technical, and other factual and informational aspects of the appreciation of sculpture have been dealt with extensively in a great many books—although it must be noted in passing that the number of books written about sculpture is far fewer than those devoted to painting—while the visual techniques of appreciation have hardly received any attention at all. Second, whatever our views may be about the relevance of various kinds of factual information to the appreciation of sculpture, it is certain that such information is easier to acquire than the perceptual skills, sensitivity, and attitudes that are necessary for the appreciation of its expressive forms. Of course, a scholar researching into the history or iconography of a work of sculpture may be faced with enormous difficulties; but all that is required of the person making use of the scholar's discoveries is a certain amount of reading. And in our highly verbalized culture reading comes easier to most people than intense and intelligent looking.

One of the worst sources of confusion in discussions about the appreciation of the visual arts is the common practice of

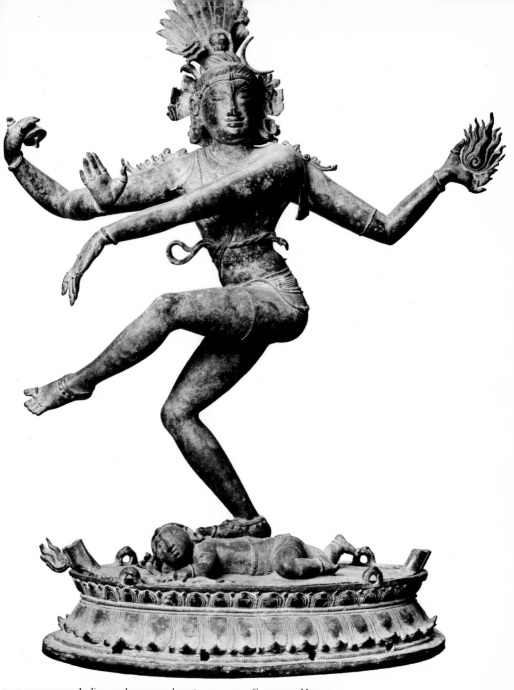

SIVA NATARAJA, Indian, 11th century; bronze, 114·5 cm. *Government Museum,*
Madras (photo: *Royal Academy*)

making too sharp a distinction between conceptual understanding and the more direct and seemingly immediate process of perceiving. Perception is often taken to be a kind of immediate, unthinking soaking-up of the world (including works of art) by the senses—a direct awareness during which we switch off our busy conceptualizing intellects and put ourselves into a state of pure receptivity. There is of course a certain amount of truth in this. If we can think of nothing more to do with a work of art than stand in front of it asking ourselves questions about its date, the mathematical relations between its parts, and its significance for psychoanalysis, we are not likely to get very far in appreciating it as a work of art. But if we are using our intelligence in the wrong way, the remedy is not to give up using it altogether by adopting a purely receptive attitude, whatever that may be; what is needed is to apply intelligence in more rewarding ways. We may stare for ever at a work of art, or at anything else for that matter, without getting anything out of it. For what is required is not merely a rest from asking ourselves irrelevant questions but also a heightening of sensory awareness and emotional responsiveness, a certain attitude of mind, or mental set, and an intense perceptual activity. The rewarding perception and appreciation of sculpture, as of the other arts, is a strenuous and demanding task, not a form of amusement in relaxation. Sculptures are created purposively and intelligently and they must be looked at purposively and intelligently.

In appreciating sculpture we have to be able to distinguish visually and to apprehend spatial relationships and qualities of form of extreme subtlety and complexity. Before we can do this to any worthwhile extent, concentration and effort are required. We have to learn how to look; that is, we have to develop special perceptual skills and cultivate the appropriate attitudes and sensibilities, and we have to know the kinds of things to look for. Without this kind of training nobody is directly aware of what constitutes the art of sculpture. That we should have to learn to see something that is standing before us in broad daylight is puzzling to many people. Yet the recognition that this is so is the first step towards the appreciation of the visual arts on any but the most obvious level.

THE SENSE OF FORM IN THREE DIMENSIONS There are many qualities in sculpture that may be appreciated without using any perceptual skills beyond those required for

the appreciation of such two-dimensional arts as painting and drawing. We may, for example, enjoy the colour or texture of its stone or wood, the patina and sheen of its bronze, the subtle gradations of tone on its surface, the linear qualities of its contours, the flat shapes of its silhouettes, the decorative linear patterns that enliven its surface, or the way in which it has been painted. These are important visual qualities that we cannot afford to ignore, but they are not the special qualities of sculpture as an art form. For unlike paintings and drawings, which only suggest or evoke the third dimension on a two-dimensional surface, sculptures actually exist in three dimensions and have three-dimensional form. And this actual existence in three dimensions, even when the third dimension is condensed or reduced as it is in relief sculpture, is essential to sculpture as an art. For sculpture is one of the arts—architecture and pottery are others—which cater especially for our capacity to perceive and respond to form in three dimensions, that is for what is usually called our 'sense of form'. In this respect sculpture differs radically and fundamentally from the two-dimensional arts.

The ability to apprehend form in three dimensions is not a rare gift depending upon the possession of a special kind of organic equipment or quality of mind. It is something that every normal person has in some degree. In the majority of people, however, it is not developed much beyond the low level necessary for day-to-day living. For most of life's ordinary purposes it is not necessary to look intensively or for any length of time at the three-dimensional form of anything. All we need to do is to notice those characteristics of an object's form that serve our practical purposes by enabling us to recognize the object and handle it intelligently. A glance or, at best, a cursory examination is all that is usually required for doing this. For the appreciation of sculpture, however, it is necessary to develop the sense of form far beyond this elementary, pragmatic level.

In order to develop our sensibility to sculptural form we must acquire the habit of looking at sculpture for the sake of looking, of regarding it as something intended primarily to be perceived. This, of course, will come more easily as we learn more of what to look for and gain experience and skill in perceiving it. It is pointless telling anyone to concentrate on looking at a piece of sculpture for what it is in itself unless he knows what he is expected to attend to in it and has the ability to see this. Our goal should be the power to perceive completely all

the complex and subtle expressive forms of great works of sculpture, to be aware of all their aspects, features, and qualities and also their relations within the total organization of the sculpture.

TOUCH AND VISION The ability to perceive and respond to three-dimensional solid form does not come entirely from vision; the sense of touch also plays an important part. We grasp things and handle them as well as look at them, and these two modes of perception become inextricably blended in our sense of form. A congenitally blind person's experience of three-dimensional form is mediated to him entirely by touch. He must rely on bodily contact, on exploring things with his hands. The person who can both see and touch things co-ordinates the knowledge he acquires through both senses so that when he sees something he can tell what its shape would feel like and when he grasps or handles something he can tell what its shape would look like.

There are few things that appeal so directly and effectively to both touch and vision as pottery. Watch a potter assess a bowl. The first thing he does is pick it up. He feels its weight, runs his thumb over the rim, holds it by its foot and looks at its internal and external curvature, feels its thickness and the way in which it thins out towards the rim, examines its decoration and colour and feels the 'dryness' of the unglazed clay body or the smoothness of the glaze. He uses his sense of touch as much as his sense of sight and sometimes appears to be recapitulating in his imagination the peculiarly intimate process of throwing on a potter's wheel that moulds the plastic clay into a pot. There are some kinds of sculpture that appeal in a similarly strong way to the tactual component of our sense of form. They invite us to explore them with our hands, to stroke and palpate them, and if possible to pick them up.

The tactual qualities that may be appreciated in sculpture are of three main kinds. First there are what are often called *tactile surface qualities*, that is such qualities as smoothness, roughness, slipperiness, and so on—the quality of sand-papered wood contrasted with that of terracotta. These may have little to do with three-dimensional form as such, but they have a great deal to do with our impulse to pick up a piece of sculpture or run our hands over it. The second quality that we appreciate by handling three-dimensional forms is their *weight*. A small carving in stone or a small solid metal sculpture feels very different in this

respect from one in wood or fibreglass. The third and most important quality is that associated with the *volume* of the forms. This quality is not easy to describe briefly and if the reader finds what I say here somewhat obscure, I must ask him to be patient because the next chapter will include a fuller account of this supremely important sculptural quality. Briefly, then, it is the extension of a solid in all three dimensions, its 'all-roundness'. It is the quality which we learn to appreciate by grasping an object and surrounding it with our hands. Experiencing the volume of sculpture is quite different from feeling its surface qualities by stroking it or feeling its weight by picking it up. A sculptural volume is self-contained and can exist by itself. A single volume is, in fact, the basic unit of three-dimensional form that can be perceived or conceived in the round. As a sensory property of three-dimensional forms, volume has nothing to do with the physical property that is measured in cubic inches and centimetres. A large version of a small sculpture does not have more volume; moreover, some tiny sculptures may convey to us a much greater feeling of volume than a huge monument. It is not their size that counts but the way in which they have been conceived and executed in the round. This is most clearly shown in some small African wood-carvings. 33, 58

Volume should also be distinguished from mass. Mass is indeterminate, a mere quantity of matter. A volume is a structured or shaped quantity of matter—mass which has a determinate shape. The mass of a piece of sculpture may be made up of a number of volumes joined together to form a complex structure.

Of course only small sculpture that lacks a fixed base can actually be picked up and turned over in the hands. But we need not actually pick up or even handle sculpture in order to appreciate its tactual qualities, although naturally they are much more vivid if we do. Our previous experience and the interplay between the different senses enable us to 'feel' the weight and to become aware of the volume of the sculpture simply by looking at it. It is the sensations of weight and volume which we derive from the sculpture that count in our appreciation of it, not its actual weight and volume considered in an objective, measurable sense.

Moore's description of what it means for a sculptor to 'think of and use form in its full spatial completeness' is often quoted, but since it is the most vivid first-hand account we have of an

awareness at a highly developed level of the tactual qualities of three-dimensional form, I will quote it once more. The sculptor, he says,

gets the solid shape, as it were, inside his head—he thinks of it, whatever its size, as if he were holding it completely enclosed in the hollow of his hand. He mentally visualises a complex form *from all round itself*; he knows while he looks at one side what the other side is like; he identifies himself with its centre of gravity, its mass, its weight; he realises its volume as the space that the shape displaces in the air.[1]

CONTOURS, SILHOUETTES, AND VIEWS

There is one common misapprehension of what is meant by appreciating the three-dimensional form of sculpture that arises from a failure to take into account its specifically tactual qualities and an over-emphasis on certain of its visual aspects. Since this often confuses people and prevents them from understanding what is really involved it is important to show why it is wrong.

We are often told to walk round a piece of sculpture in order to see it from many viewpoints, or we hear it said that it is better from one viewpoint than another. Of course sculpture does present a number of views and there is sense in speaking of viewpoints in connection with it. But people who are trying to understand what is meant by seeing sculpture as form in three dimensions and appreciating its three-dimensional structure or volume often suppose that the sculptor by some mysterious process combines innumerable silhouettes or contours in order to make his three-dimensional forms, and that what they as spectators should do is to walk round the work and take a number of visual snapshots of it from various points of view. But in general sculptors do not think predominantly in terms of silhouettes or contours, although for some types of work they may turn their attention to them and take great care to ensure that they are satisfactory. And although it is often necessary to turn complex three-dimensional forms round in the hands or to walk round them in order to apprehend them as fully three-dimensional, the knowledge acquired is not like a comprehensive set of photographic stills. No amount of experience of flat projected views will ever add up to an experience of the volume or three-dimensional structure of the sculpture. Gabo is quite definite about this: 'to think about sculpture as a

[1] 'Notes on Sculpture', first published in *The Listener*, 1937.

succession of two-dimensional images would mean to think about something else, but not sculpture'.[1]

What causes people to fall into the error of paying too much attention to silhouettes and contours at the expense of disregarding three-dimensional structure and volume is the complexity and subtlety of sculpture. Most people can appreciate the three-dimensional nature of a cube easily enough without thinking of silhouettes, contours, and views, but when confronted with more complex forms they tend to see them two-dimensionally because they lack the skill to apprehend their three-dimensional properties.

Manuals on the techniques of sculpture mention contours and views very frequently and sculptors such as Rodin and Cellini have said a great deal about them and the role they play in their work. Perhaps this is why these two-dimensional aspects are treated with such undue respect by some writers on sculpture. But it is important to remember that contours and silhouettes are used by most sculptors mainly as a means of arriving at or checking the desired three-dimensional forms. Only in certain kinds of sculpture made for special purposes do the three-dimensional forms exist for the sake of the contours and silhouettes that they give rise to. For contours and silhouettes are not self-subsistent entities but something that the forms have, rather as they have light and shade on their surfaces. As such they should be appreciated as part of what the sculpture as a whole presents to the senses, but not at the expense of its more important three-dimensional properties. A potter, to take a simple example, may consider the profile of his mass of clay as it revolves on the wheel and use it as a guide to the forms he is creating; but if you were to suggest that he was thinking primarily of the profiles or silhouettes of his pots, he would most likely deny it vehemently. He would say that it is the volumes and their qualities and relations that are uppermost in his mind and that it is these he would like people to appreciate. And he might go on to say that it is usually a sign of an undeveloped sense of form in a potter, as it is in a sculptor or in anyone appreciating the two arts, if he pays excessive attention to such two-dimensional aspects as contours and silhouettes while neglecting volume and three-dimensional structure.

[1] 'Russia and Constructivism', an interview with Naum Gabo by Abram Lassaw and Ilya Bolotowsky, 1956. From Read and Martin, *Gabo* (London, 1957), p. 156.

EXPRESSIVE QUALITIES In our perception of three-dimensional form we do not simply apprehend its geometric properties, its shape as such; we become aware also of its expressive character. These two aspects are in fact inseparable; we perceive not just forms but *expressive* forms. A moment's reflection on the kind of language we use for describing three-dimensional form will make it obvious that we are usually more aware of its expressive character than we are of its geometric structure. The neutral terms that we use—'four-sided', 'plane', 'cuboid', 'pyramidal'—are few compared with the terms that refer to expressive qualities— 'full', 'rounded', 'still', 'dynamic', 'rugged', 'aggressive', 9, 'tense', 'sagging', 'drooping', 'soft', 'fluid', 'heavy', and so 12 on. In the perceptual experience of three-dimensional forms these expressive qualities are regarded as properties of the forms themselves, as objective as any of their neutral, measurable, geometric properties.

The forms of sculpture are expressive in this sense and if we are to appreciate a sculpture as a work of art we must be able to perceive the expressive character of its component forms both in themselves and in the context of the expressiveness of the

from left to right

9 Detail of CONFIGURATION (PHIRA), 1955, by Barbara Hepworth; wood, 32 in.

10 Detail of VIRGIN AND CHILD, English, late 11th century; 24 in. (plaster cast)

11 Detail of MARY SALOME AND ZEBEDEE (c. 1506) by Tilman Riemenschneider

12 Detail of THE WATCHERS (1960) by Lynn Chadwick; welded iron frame infilled with compound, 92 in.

13 PARVATI, Indian, 14th-15th century; bronze, 26½ in.

14 Detail of FATHER AND SON (1963) by Ralph Brown; resin bronze, over life-size

sculpture as a whole. For this it is necessary to develop a wider and more refined sensitivity to the expressive qualities of three-dimensional form than is required for ordinary practical purposes. This is also part of what is included in a highly developed sense of form.

Anyone who develops an interest in sculptural form will also inevitably develop an interest in natural form and acquire an increasing amount of knowledge of different kinds of form in both realms. The variety of natural form is staggering. As we become acquainted with the forms of human bodies, animals, plants, fishes, landscape, rocks, pebbles, bones, shells, crystals, [18, 25, 42] and so on, we begin to develop associations and to see similarities everywhere. Many of these associations are embodied in our language and are the raw material of metaphor. We speak of the 'brow' of a hill and of the 'trunks' and 'limbs' of trees and bodies. Indian sculptors were expected to bear in mind forms drawn from the animal and vegetable kingdoms when they were shaping the parts of the human figure. The shoulder and arm have the character of the head and trunk of an elephant, the forearm that of a young plantain tree, the shins are like fishes

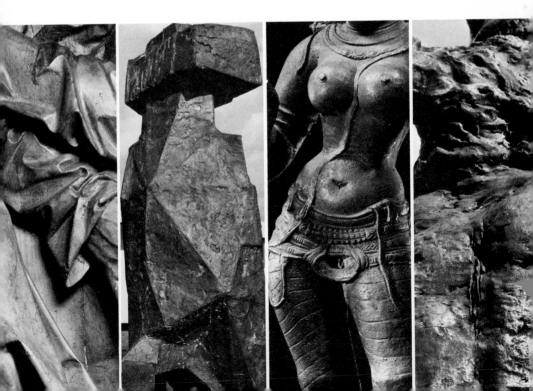

full of roe, the hands like lotuses and the fingers like peapods or beans. And Rodin said that when he was drawing a woman's body it amazed him to find that it also provided him with 'pictures of insects, birds, and fishes'.

There is a level in the development of our knowledge and appreciation of three-dimensional form where we become aware not merely of a superficial resemblance of overall shape in things but of a much more profound and far-reaching identity of principle in the structure and expressive character of their forms. We begin to perceive similarities of structure and expressiveness everywhere and to build up a system of concepts which derive from these recurrent properties. This perceptual knowledge and experience is not readily put into words and our language is poorly equipped for dealing with it. The medium or 'language' by means of which men's knowledge and experience of the structural and expressive qualities of three-dimensional form may be developed and made articulate is sculpture. If a sculptor is aware of these qualities, his work may become expressive and structural in a universal and profoundly satisfying way. Instead of being a mere imitation of natural forms at the superficial level of appearances or a simple and obvious or incoherent abstract invention it can acquire an expressive subtlety and organic cohesion similar to those of natural form. And being made especially to cater for human powers of perception it can, moreover, be lucid, intelligible, and expressive to a degree and in a way that natural forms cannot be.

THE USE OF PHOTOGRAPHY Photographs can indubitably record a great deal of visual information about sculpture and few people now would wish to return to a situation in which either they were entirely dependent on their visual memory for recalling works of art or drawings and engravings were the only means available for illustrating books about art. But photography has its dangers too, and these become acute when photographs are used as a primary means for making contact with works of art rather than as an aid and supplement to memory of direct visual experience. Sculpture creates special problems for photography in addition to those which it shares with the other arts. Because sculpture is essentially an art of three-dimensional form, its most important qualities cannot be reproduced in photographs. Yet photographic images of three-dimensional objects have become such

a familiar and acceptable part of our visual experience that we tend to forget what insubstantial ghosts of the real things they are. A camera reduces a work of sculpture, which should be appreciated mainly for its qualities as a configuration of expressive three-dimensional forms, to a configuration of coloured or toned areas on a two-dimensional surface. The effect of photography on drawings and paintings is not so radical, because it translates them from one two-dimensional medium into another. But its effect on sculpture is to transform the work completely by translating its actual volumes and actual three-dimensional spatial relations into the notional or 'illusory' pictorial space which is the special province of the two-dimensional arts.

It is therefore unfortunate that most people today are likely to spend more time looking at photographs of sculpture in books and magazines than they spend looking at the works themselves. By doing so they are in danger of becoming responsive only to those qualities in sculpture that reproduce well in photographs and of neglecting the others, which from the point of view of appreciation are more important.

It would be churlish as well as inconsistent to complain about photographs in a book that makes use of a great many of them, but something must be said about their use and misuse in appreciation. Nevertheless it cannot be emphasized too strongly that in order to appreciate sculpture as an art it is necessary to be in frequent direct contact with actual works and that looking at photographs can never become a substitute for looking at the works themselves.

As a supplement to first-hand experience photographs are extremely useful and for some purposes indispensable. By using his lighting equipment, scaffolding, and telescopic lenses the photographer can make us acquainted with details of works which would otherwise be completely inaccessible or only visible from a great distance or in a poor light. There are, for example, many carvings on medieval cathedrals and Indian temples which the visitor does not see because they are out of view or hidden in a dark corner or niche. Even works which are readily accessible may be skilfully lit so as to bring out aspects that are not noticeable under the conditions in which they are usually seen.

But the most important and far-reaching consequence of the use of photography has been to acquaint us with an enormous

number of works of sculpture and to make works in every known style available in some form at least, on our bookshelves. If it were not for the camera, few Europeans or Americans would have any idea of the sculpture that is in India, Cambodia, Egypt, and Mexico, and the study of art as it is pursued today by historians, iconographers, anthropologists, and archaeologists would be unthinkable. Unfortunately, both with art historians and with their readers, a wide acquaintance with photographs of sculpture tends inevitably to become a substitute for a profound and first-hand visual experience of actual works. This is another temptation for the person whose habits of mind are primarily intellectual and who places a high value on being well informed. The ability to recognize, name, and date a great many works of art has little to do with appreciating them. If the choice had to be made, it would be far better to have a deep first-hand experience of a few masterpieces than a knowledge mediated by photography of all the sculpture in the world.

Photographing sculpture calls for a special kind of attitude in the photographer. In one respect his relation to the sculpture is like that of an instrumentalist to the musical composition he is interpreting. His main responsibility is to put his skill at the service of a work of art and to resist the temptation to use the occasion as an excuse for self-expression or showing off. Nevertheless, although photography provides us with a much more objective record of the visual appearance of an object than is possible in a drawing, the personality of the photographer contributes a great deal. During the actual exposure the camera is automatic but before this takes place the photographer has made a great many decisions and has given a great deal of thought to the setting up of his picture. He has to decide, quite literally, from what point of view and in what light we shall see a work of sculpture, and he is obliged by the limitations of photography to choose which aspects and which characteristics of the work he will bring out most strongly in his picture. Sometimes this choice is difficult because some of the qualities that are of the greatest importance in the sculpture may be impossible to show together in one photograph.

If a work of sculpture is designed to be seen from one point of view or is a relief, then the question of where to place the camera is easily settled. But if (like the work of Giovanni da 17, 63, Bologna or Henry Moore) it is designed to be seen all round, the 40, 102

photographer has to decide for himself which view to take and perhaps no one view is likely to be wholly satisfactory. Even if he presents us with a series of views taken from different positions all round the work, we are still faced with the task of deriving from these a realization of the sculpture as a fully three-dimensional structure in space. Merely seeing a work of sculpture from a number of different points of view does not, as we have noted in a previous section, entail grasping its essential nature as a configuration of three-dimensional forms. It is extremely difficult to apprehend the form of a complex or subtle sculptural composition from a series of photographs. To do so requires a highly developed sense of form and a considerable experience of looking at actual works. The fact that the camera provides us with pictorial views encourages the kind of over-estimation of their value in the appreciation of sculpture which we have already discussed.

The most important decisions a photographer has to make concern lighting, and it is in this aspect of his work that a sensitive photographer who is himself aware of the qualities of sculpture can contribute most to our appreciation of it. One of the things that attracts so many photographers to sculpture is the way in which the surfaces of its three-dimensional forms modulate the light that falls on them. Gsell tells of an occasion when Rodin went round a piece of sculpture with a candle and by holding it in different positions revealed subtleties of surface modelling that could not be fully appreciated in ordinary light. The spectator is not often in a position to vary the light on a work of sculpture, which is a pity because it is a fascinating and rewarding thing to do. Usually he has to accept the lighting that is provided by museums and art galleries and, for reasons not always under the keeper's control, this is often far from ideal. The photographer, however, has the privilege of experimenting and arranging his own lighting. By doing so he can bring out different aspects of the sculptor's work. The camera may not lie, but the kind of truth it is allowed to tell is very much in the control of the photographer. He can pick out textural qualities, delicate surface detail or subtle surface modelling, stress the fullness of volume, strengthen the contrast between highlighted prominences and dark recesses, clearly silhouette the work against its background or merge it into its surroundings. He can, moreover, 'interpret' the sculpture in a variety of ways that have much in common with

different styles of painting, giving it, for example, the limpid clarity of definition of an early Flemish painting, the blurred haziness of an Impressionist painting, or the mysterious gloom of a Rembrandt.

Many sculptures are designed for a special kind of lighting; for example, the strong outdoor light of sunny countries like India or Greece or the darkness of the interior of a Romanesque church. A sensitive photographer bears this in mind and arranges his lights accordingly. But on many occasions the photographer has to decide for himself what kind of lighting is most sympathetic to the sculpture. In this connection the comments of William Fagg on the photographs of African sculpture [3, 58,] taken by Herbert List are of great interest. He remarks that List has adopted the 'almost unheard-of technique' of photographing in natural daylight and has thereby achieved 'the closest sympathy with the original artists—who were similarly limited by the light of the sun'. He goes on to say:

A related characteristic of his work lies in the avoidance of strongly contrasting backgrounds. It is above all for its forms that African art is remarkable, and I am constantly surprised by the tendency of photographers (including some whom I greatly admire) to overemphasise its outlines (which of course are rarely in a single plane) in such a way as to distract attention from the formal qualities (however well these may have been photographed). By using dark backgrounds for dark objects, List softens the silhouette to a properly secondary status and so partly overcomes the limitations of the two-dimensional surface.[1]

These comments draw attention to a situation involving a choice that is typical of many that face the photographer of sculpture. In this instance the choice is between placing the emphasis on the silhouette or on the plastic qualities of the interior forms of the work. A free-standing sculpture is a self-contained, completely separate object leading its own life, so to speak, in space. We can walk round it, see the space all round it, and distinguish it from its background. In order to do justice to this aspect of the sculpture a photographer will usually throw some emphasis on the completeness and continuity of the silhouette because, on a flat monochrome surface, a clear [8, 15] outline is necessary as a means of separating the object from its background. If the sculpture is dark (or light) and part of its silhouette is lost against a dark (or light) background, we do

[1] *Nigerian Images* (London, 1963), Preface.

not get much of an impression of this all-roundness and spatial completeness. On the other hand, if the photographer wants to show the plastic qualities of the interior forms to the best advantage, he will usually avoid a strong silhouette because the 96 contrast between the edges of the sculpture and the background tends to detract from the modelling of the forms within the contour and also obscures their relationships in depth by connecting all their outer edges in one continuous outline.

Whichever choice the photographer makes—and he must choose—what he offers is an 'interpretation' based on the selection of some qualities at the expense of others. Herein lies the danger of using photographs as objects of appreciation instead of using them as records—and always partial records only—of seen objects.

A further point that must be made about the use of photographs in appreciation concerns their effect on scale. Two pictures exactly the same size in the pages of a book may represent, respectively, an extremely diminished Egyptian colossus and a magnified ivory chess-piece. The effect of the scale of the actual sculpture on the spectator, which is of great importance, is lost. The elimination of scale is one of the most serious drawbacks to the use of the illustrated book as a substitute for direct contact with works of art.

This levelling effect of book-sized photographs does, however, produce one interesting result. A large sculpture is almost always impressive, even if it is artistically negligible, but small-scale works are easily overlooked and are often under-estimated 36, 55, 56, by the uninitiated merely on account of their diminutive size. 93 71, 88, 92, This applies not only to sculpture but also to small-scale paintings. When we see them in photographs comparable in size with larger works, we are often persuaded to take them more seriously and to look at them more thoroughly. A small terracotta may be 'monumental' in its proportions and may *look* monumental in a photograph. But the *actual* size is always important and we lose rather than gain if photography leaves us with a false impression of size.

There are some excellent photographers of sculpture who interpret it with great sensitivity, and as we begin to deepen our first-hand experience of the expressive forms of sculpture, the more we are able to see in their work. But, paradoxically, the more we learn to see in photographs the less satisfactory they become as a substitute for the real thing.

MASS AND SPACE The three-dimensional nature of sculpture may be viewed in two different ways. On the one hand we may consider a work of sculpture as an assemblage of solid, opaque pieces of material that displace or inhabit space, and concern ourselves with its internal structure (Fig. 4a). On the other hand we may consider the way in which the sculpture enters into relations with space —extending into it (Fig. 4b), enfolding it (Fig. 4c), and relating across it (Fig. 4d). Here it is not the material components of the sculpture that are the chief concern but the ways in which they are related to each other and to their surroundings. Taking the surface of the sculpture as a boundary, we may concern ourselves either with the way in which the sculptor has shaped the material inside that boundary or with the way in which he has articulated the space outside it. These two ways of viewing sculpture as three-dimensional constructs are, of course, separable only in analysis; all sculptures must have some kind of material components and these must exist in space. The relative importance of each aspect is, however, extremely variable, and it is possible to produce sculptures in which the interest is almost entirely limited to the one or the other. A straightforward representation of a human head or torso, for example, or one of Brancusi's single volume sculptures is just a single 15, 97 solid piece of material. Its interest lies in its internal structure and it is as solid form that we judge it. But a sculpture like one of Gabo's perspex and nylon wire or sheet-metal constructions 16 lacks almost any suggestion of mass or solidity—it may even be transparent—and its interest lies in the way the sheets and wires move in space, relate across it, and enfold it. The material components exist mainly in order to articulate space. In other sculptures our interest may be more or less equally divided between both aspects. Notable examples of work of this kind are some of the reclining figures and helmets of Henry Moore, 27, 28, in which the design of solids and voids is closely integrated, and some Baroque and Mannerist sculpture as for instance Giovanni Bologna's *Rape of the Sabines*, in which the spiralling 17 in space and the balance of solids and voids are of great importance.

Few people have any difficulty in understanding what the

Fig. 4

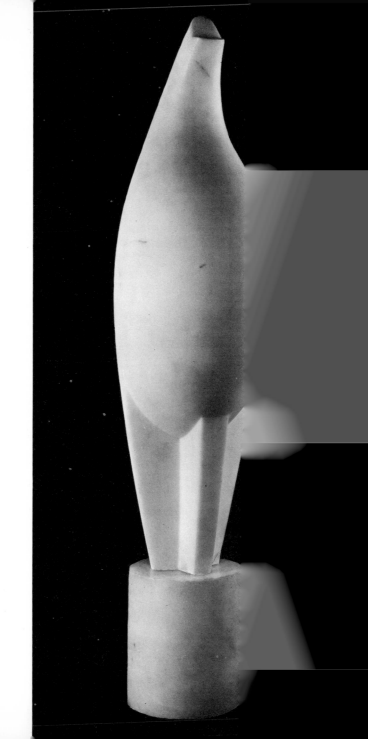

15 BIRD (1912) by Constantin
Brancusi; marble, 62 cm. *The
Louise and Walter Arensberg
Collection, Philadelphia Museum
of Art*

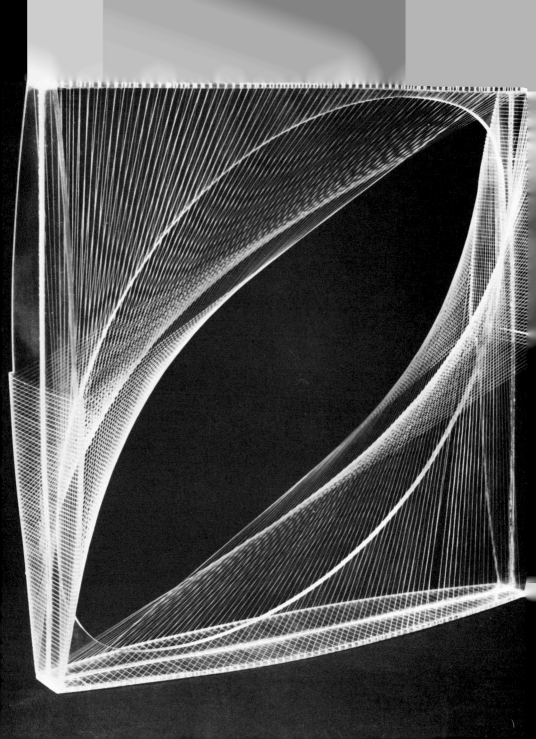

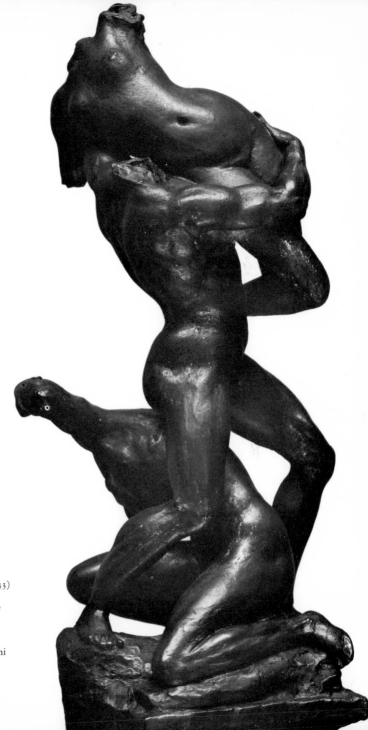

left
16 LINEAR CONSTRUCTION (1943)
by Naum Gabo; plastics,
$13\frac{1}{4}$ in. \times $13\frac{1}{4}$ in. *Tate Gallery*

right
17 Sketch for the RAPE OF THE
SABINES (*c.* 1579) by Giovanni
da Bologna; wax, 12 in.
Victoria and Albert Museum.
Crown Copyright

a

b

c

d

e

Fig. 5

term 'mass' means in relation to sculptural form, but many find the notion of 'space' ambiguous or confusing. Mass is visible and tangible and we have no doubt about its reality. But space is elusive and sometimes we are not sure how real it is. It may help if we establish a clear distinction in our minds between *spaces* and *spatial relations*.

Spaces are the voids that may exist among the material components of a piece of sculpture. They include holes (Fig. 5a) and cavities (Fig. 5b) in the components themselves and any gaps there may be between them (Fig. 5c). They are, as it were, portions of space that have a certain size and shape, like the interior of a room, the inside of a cup, or the hole in a doughnut. Spatial relations, however, exist *in* space where space is regarded as a kind of universal receptacle or matrix. The spatial relations of the components of sculpture are their relative directions and positions in this receptacle or matrix. They come into being across space between components that are not physically connected and give rise to tensions between them (Fig. 5d). They also exist between components that are physically connected with each other, in which case they give rise to a movement of the forms in space (Fig. 5e).

Most of the sculpture of the past is primarily concerned with the ordering or structuring of mass, that is with solid form. There is never any doubt in our minds when we look at African, Indian, Greek, Mexican, Egyptian, medieval, and Renaissance sculpture that the shaping of its masses is what has concerned the sculptor most of all and that it is to this we as spectators should devote most of our attention. Nevertheless, whenever a sculpture consists of more than one solid component the directions and positions of the components relative to each other in space must be taken into account, and whenever there are gaps between them or holes or cavities within them the balance of solids and voids must be considered as part of the design of the work. All sculptural compositions have their spatial aspects.

The kinds of sculpture in which mass is most attenuated and the main emphasis is placed on the spatial aspects are recent developments. The material components of this kind of sculpture are those in which there is little or no internal three-dimensional structure. They are made up of linear, one-dimensional components like wires and string or of two-dimensional sheets. These one- and two-dimensional components are made to move

in three-dimensional space, to relate across it, and to enfold or envelop it. We shall consider this kind of sculpture later in the book. It requires for its appreciation a somewhat different kind of sensibility from that demanded by sculpture with solid forms. The greater part of our attention will be devoted to discussing the internal structure and spatial composition of sculpture with masses and the kind of sensibilities that are required for appreciating it.

VOLUME One of the most obvious features of so much of the world's sculpture—so obvious that we take it for granted without giving it much thought—is that it consists of a configuration of solids of different shapes and sizes which are joined together but which we can perceive as distinct units. The most important of these component solids are the main volumes of the sculpture. It is on the character, proportional relations and spatial arrangement of these main volumes and on the manner in which they are joined that the majority of works of sculpture depend for much of their effect.

As has already been said, the single volume is the fundamental unit in our perception of sculptural form, as indeed it is in our perception of fully three-dimensional solid form in general. There is an enormous variety of single volumes among natural forms. Tomatoes, apples, melons, pears, bananas, marrows, 18 parsnips, eggs, nuts, fishes, sponges, mussels, sea-urchins, crystals, pebbles, and boulders are all single volumes. Among man-made forms they include things as varied in scale as cigars and rockets or skyscrapers and matchboxes, and things that vary in character from the hard precision of a steel axe-head to the indeterminate sloppiness of a sack of flour. The main component parts of the bodies of animals and human beings may also be regarded as single volumes. The volumetric structure of the human figure, above all, has always obsessed sculptors. 19

Each of the main articulated parts of the nude figure – head, neck, upper and lower arms, thorax, pelvic region, thighs, and lower legs – may be regarded as a volume with its own specific shape. These main volumes of the figure vary considerably in *Fig. 6* size, in their internal proportions and their proportional relations with each other, and are capable of an almost unlimited range of movements and spatial relationships. Other variations may be introduced by clothing – by concealing the legs within a long skirt, for example, and treating the skirt as one large

Fig. 6

31

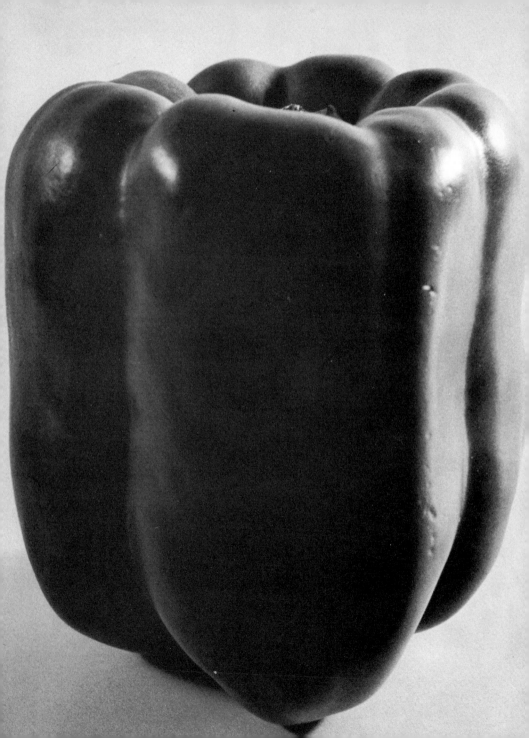

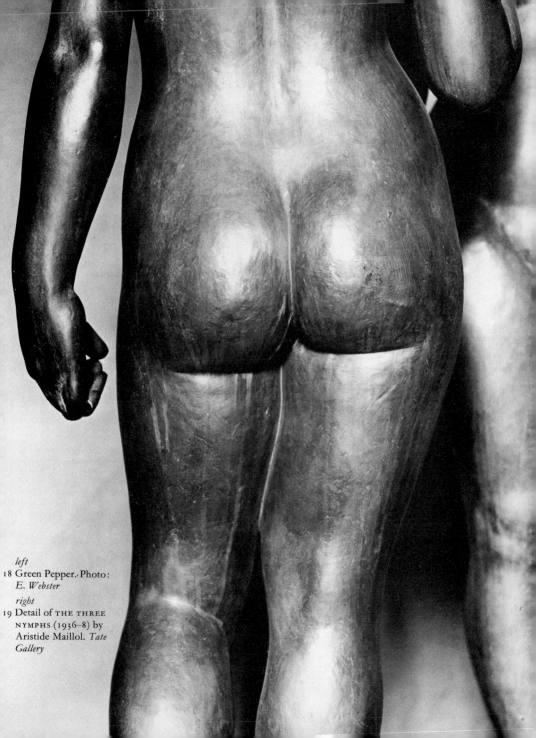

left
18 Green Pepper. Photo:
 E. Webster

right
19 Detail of THE THREE
 NYMPHS (1936–8) by
 Aristide Maillol. *Tate
 Gallery*

volume, or by changing the shape of the volume of the head with head-dresses or by dressing the hair differently.

The forms of the human figure are, moreover, for us the most expressive of all forms, not merely in their gestures, poses, and facial expressions, but in the more subtle qualities of the forms themselves. Even today, when sculptors have marked out for themselves a much wider range of subject matter, there are those who feel, like Moore, that the human figure should still be the main theme of sculpture.

The things that are most easily perceived as fully three-dimensional forms are those that are made up of one simple regular volume, such as footballs, eggs, boxes, barrels, pyramids, and so on. The clear apprehension we have of the forms of these symmetrical objects may be useful to us when we are trying to arrive at a clear perception of more complex forms. It was this use of simple regular forms that Cézanne had in mind when he spoke of treating nature by the sphere, cone and cylinder. By suggesting to somebody that he should try to see a human head as fundamentally an egg-shaped volume, a neck as a cylinder, a chest as a barrel, and the upper and lower arms as tapering tubes we may begin to make these complex parts of the body more visually comprehensible as fully three-dimensional forms. From there it is possible to go on to get a fuller grasp of their subtleties, seeing them as variations on or additions to these basic shapes. As this ability grows, it becomes possible to apprehend in-the-round volumes of increasing subtlety and groups of volumes organized into complex structures.

It may perhaps be worth pointing out that an abstract intellectual concept of the geometrical structure of regular solids should not be confused with an apprehension of their visual properties as three-dimensional forms. The ability to define a three-dimensional form in geometrical terms or to describe exhaustively the measurement of all its angles, faces and curves has little or nothing to do with the ability to apprehend it in 'its full spatial completeness' in the way described by Moore.

Part of what is involved in appreciating sculpture is noticing the variations that occur on the surfaces of the volumes, but, far more importantly, it involves relating those variations and building them into an apprehension of the volumes as completely three-dimensional expressive forms. This is not simply a matter of being aware of the external features of the volumes

as a series of events, so to speak, that are related around the surface. In fact one kind of unsatisfactory sculpture is that which consists merely of surface changes. What is present in the most highly regarded sculpture is an *internal structure*. The changes in the surface connect *through* the volumes as well as round their surfaces. They are suggestive of the operation of internal forces or the presence of internal shapes which are responsible for the particular conformation of the surface. Sculptural masses that have been thought of from the outside as a mere aggregation of surfaces or surface features are quite different in character from those which have been conceived from the inside and whose surfaces are the outward manifestation of a structure that must be thought of as continuing through the mass.

Some sculptures are so complex that they defeat our attempts to perceive them in the way I have just described. We cannot make our separate experiences add up to any coherent whole. Sometimes this inability is due to the complexity of the organization of the forms. The pattern is there but it is we who fall short either because our sense of form is deficient or because we have failed to grasp the principles that underlie the organization of the kind of form we are dealing with. The first failure is like that of somebody who cannot make anything of a difficult fugue although he has some grasp of the principles of polyphonic music. The second failure is like that of somebody who is baffled by oriental music because he has no idea of the kind of musical structures that it involves. On other occasions, however, our inability to apprehend a complex three-dimensional mass is not due to our deficiencies but to its lack of any intelligible structure of ordered relations. It is just bad sculpture.

SOLIDITY: SCULPTURE AND POTTERY COMPARED

The notion of solidity as applied to sculpture may seem puzzling and require explanation. Like all the properties of sculptural form that concern us here, solidity must be regarded as a perceptual quality, one that belongs to the form as we experience it in perception. Everyone, for example, knows that all bronze sculptures but the smallest are in fact hollow. But this does not matter; we perceive them as having the properties of solid form.

The perceptual experience of solid sculptural form can be tellingly illustrated by contrast with the forms of pottery. The

hollowness and space-containing properties of pottery are essential to it—pottery is an art of hollow form. Pots contain and define *a volume of space*. Indeed the provision of a space that may be filled is the basic functional requirement upon which the art of the potter has developed. In folklore, myth, and metaphor pots are the prototypes of all containers. Even God has been thought of as a potter making human vessels which are empty until they are filled with the breath of life.

Sculpture, on the other hand, is typically solid and contains *a volume of mass*. It is not something formed around a space, holding and defining it, but something which occupies space and displaces it with its own substance. The surface of sculpture is the outside of the solid, the limit of its mass, and the shape of the surface is determined by the structure of the mass inside it.

The substance of a typical pot is a shell or a wall—potters, in fact, speak of the 'walls' of a pot—and as such it has two sides, or surfaces: an external one and an internal one. These meet at the rim or lip, a feature of great importance in the majority of pots. It is the shell or wall of the pot as a whole, not its external surface alone, that contains the volume of space. The shell, moreover, has its own structure, its varied thicknesses and internal tensions.

A moment's reflection on the way in which potters and sculptors manipulate their material in order to give it shape will make the differences somewhat clearer. A potter shapes his clay, whether he works on a wheel or by hand-modelling, by pinching or squeezing it between the fingers and thumb of one hand or between the fingers of both hands. Pressure is exerted on both sides of the wall. While he is creating this wall he must bear in mind the actual structure of the wall itself, the volume of space that it encloses and the external shape. A sculptor, however, works mainly either to build up a solid mass by adding pieces bit by bit to the surface of the clay or he achieves his form by carving layers or pieces off the surface of a solid mass.

There are, of course, pots that are like sculpture and sculptures that are like pots, but at their most typical these two arts appeal to different aspects of our sense of form.

SURFACES The surface is an important feature of both sculpture with masses and spatial sculpture, and some visual awareness of the properties of different kinds of surfaces is fundamental not only

36

to the appreciation of sculptural form but to the understanding of three-dimensional form in general. The sheet forms of spatial sculpture are almost nothing but surfaces; solids are entirely bounded by surfaces; it is the surface which is the point of arrival of both the modeller and the carver, who work towards it from different directions; and it is the surface that we as spectators actually touch and see and from which we must derive any clues that there may be to the sculpture's internal structure.

Types of sculptural surfaces Surfaces are usually considered to be generated by the movement of a line, and they are divided into two main classes: (1) *ruled surfaces*, which may be generated by moving a straight line, and (2) *double-curved surfaces*, which can be generated only by moving a curved line.

There are three groups of ruled surfaces, each with different visual properties: (a) *plane surfaces*, including flat sheets and the Fig. 7 surfaces which bound such simple solids as pyramids, prisms, cubes, and other rectilinear boxes; (b) *single-curved surfaces*, which as their name implies are curved in only one direction and include the surfaces of such simple solids as cylinders and cones and any surface that might be formed by bending a flat sheet in one direction; and (c) *warped surfaces*, which may be generated by moving a straight line which is constantly changing direction so that no two consecutive positions are parallel or lie in the same plane. These include hyperbolic paraboloids, conoids, and helicoids.

(d) *Double-curved surfaces* are curved in all directions so that it is impossible to draw a straight line anywhere on them. They include the surfaces of such simple solids as spheres, ellipsoids, and paraboloids, and the more variable and complex surfaces of hilly landscapes and the human body.

Surfaces that are plane or single-curved are *developable*, that is Fig. 8 they may be laid out flat without tearing or distorting them or, conversely, they may be constructed by bending or folding a flat sheet. Paper sculpture, with all its plastic limitations, is made up of plane and single-curved surfaces. A great deal of sheet metal sculpture, which in the 1960s became a popular medium with young British sculptors, is made up entirely of plane and single-curved surfaces. This gives it a somewhat arid and mechanical quality. The plastic possibilities of sheet-sculpture, whether in paper, metal, perspex, or timber, are restricted by

a

b

c

d

Fig. 7

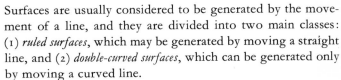

Fig. 8

Fig. 9
THE GUITARIST (1918) by
Jacques Lipchitz; bronze,
30 in.

the nature of the material and the methods of working it. The construction of more plastically interesting surfaces from these sheet materials is a laborious and technically difficult process. Mass sculptures with a similar 'dry' quality, consisting of an abundance of plane, cylindrical, and conical surfaces, were produced in great numbers under the influence of Cubism by such sculptors as Lipchitz, Laurens, Zadkine, and by many other less distinguished followers of the movement. *Figs. 9*

Double-curved surfaces are *non-developable* and can only be made by plastically free methods like carving, modelling, and related processes, or by actually distorting a plane surface. The difficulties that geographers have over arriving at suitable map projections for the double-curvature of the earth's surface are a well known indication of the character of this type of surface. In general, double-curved surfaces are more difficult to make in sculpture than single-curved surfaces because they curve in all directions and offer no points of reference along a straight line. A constant reference can be provided for one direction of a single-curved surface by holding a straight-edge against it.

Perhaps the different character of forms with plane or single-curved and those with double-curved surfaces is best brought out by the contrast between the typical products of the tin-smith and silversmith. The tinsmith works mainly from the flat sheet, which he cuts and bends and joins by soldering. The silversmith, on the other hand, uses the malleability of the metal and actually moves it about by hammering as he raises (to use the technical term) his forms in three dimensions. His work involves stretching and distorting the sheet of metal, not merely bending it, and makes possible a much greater variety and subtlety of curvature.

Warped surfaces are also non-developable but, unlike double-curved surfaces, they may be constructed from straight linear components each one of which corresponds to what is called an *element* of the surface, that is any single position of the generating line. The possiblity of constructing complex twist-ing curves entirely from straight linear members is of great importance to architects and constructional engineers. The most well known building structure in this category is the dramatic hyperbolic paraboloid roof vault. The welding tech-nique that Antoine Pevsner uses for constructing his sculptures *20, 41* is specially suited to exploiting the character of warped surfaces. The complex curvature of his constructions is built up almost

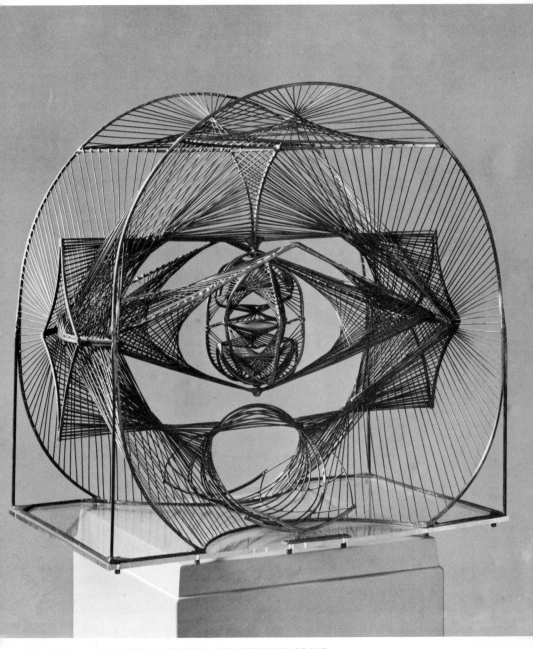

20 MAQUETTE OF A MONUMENT SYMBOLIZING THE LIBERATION OF THE
SPIRIT (1952) by Antoine Pevsner; bronze, 18 in. *Tate Gallery*

entirely from straight metal rods. It is only the components of the main skeleton of his sculptures, which correspond to what are called the *directrices*, and which in the finished sculpture are simply the edges of the surfaces, that are sometimes curved.

It is only recently that sculpture made up entirely of plane, single-curved, or warped surfaces has been produced. Traditionally sculpture has been the most plastically free of all the three-dimensional arts and crafts.

The expressive qualities of sculptural form depend very much on the types of curvature of its surfaces. The volumes of sculpture may be bounded by any type of surface or any combination of types. Even in very simple bi-symmetrical solids the possible combinations are unlimited. To what extent is the ability to recognize such differences relevant to the appreciation of sculpture? Is it necessary to know that a surface is single-curved or that its curvature is parabolic or elliptical? These are questions similar in kind to others that are raised whenever the 'analysis' of works of art is under discussion. There is absolutely no doubt that when we are looking at sculptural forms it is necessary to be aware of the expressive qualities of different kinds of curvature and to realize, say, that surfaces which curve in all directions have different qualities from those which curve only in one; and it is useful, but not necessary, to be able to name these constantly recurring types of curve and surface. But it is not relevant at all to the appreciation of sculpture to know, for example, that a parabola is 'a plane curve generated by a point moving so that its distance from a fixed point, the focus, is constantly equal to its distance from a fixed straight line, the directrix'. It is the perceptual character of the curve, the effect of its geometric structure in the expressive forms of sculpture that we appreciate. We apprehend its structure as something presented to the senses, we learn that there are certain curves that have a particular *look* which is different from the looks of other curves, and for this the elaborate vocabulary and definitions of descriptive geometry are unnecessary.

In addition to being single- and double-curved the surfaces of solids must also be convex or concave. The interaction of these two characteristics gives rise to some of the most fascinating and important properties of sculptural forms. In the first place it provides us with a division of curved surfaces into five main types, each of which has a somewhat different visual character:

(1) double-curved surfaces that are completely convex; (2) single-curved convex surfaces; (3) double-curved surfaces that are completely concave; (4) single-curved concave surfaces; and (5) surfaces that are both convex and concave. We shall consider some of the properties of each of these, paying special attention to their properties as surfaces of single volumes.

Convex surfaces The most common type of surface in sculpture is the double-curved completely convex one. Single volumes that have such surfaces are the most positive shapes in sculpture. They give an impression of fullness and completeness. They appear self-contained. Their surfaces seem to hug and contain their mass and to be related to the interior of the volume. They may also give the impression that internal forces are or have been at work shaping the surface, pushing against it from inside so that it is like a skin under tension holding these internal forces in control. Such single-volume sculptures possess, to use a somewhat metaphysical but none the less apt phrase, a 'fullness of being'.

Fig. 10

Sometimes these pressures seem to push upwards or outwards from the centre of the volume, giving a feeling of growth or lightness. At others they seem to be pushing downwards in response to gravity, giving the impression that the form is spreading or sagging and is soft, flabby or heavy. Anyone who has looked at the qualities of young and ageing flesh will be aware of the differences between the shapes that result from the supremacy of inner forces thrusting outwards and those over which the force of gravity is beginning to prevail. The differences between the heavy, sagging volume and the buoyant, lifting one are due partly to the obvious fact that the weight is at the bottom of one and at the top of the other and partly to the quality of their curvature. The two shapes shown in Fig. 10 are in fact identical. They illustrate the complete change of character that a three-dimensional form may undergo when it is reversed. In a very simple way they show that the expressive qualities of a sculptural volume are not entirely dependent on its shape alone but may change radically when its position is changed.

The most simple double-curved surface is that of a sphere. Its curvature is completely uniform; all the forces or tensions within it seem to cancel out and the result is a state of complete equilibrium or stillness. Taking the sphere as a starting point

Fig. 11

Fig. 12

we may consider some of the more visually important changes that may take place in such a double-curved surface.

First, its curvature may change in such a way that it tends towards the creation of a point, as though the sphere were transforming into a cone. The egg is an obvious example of this. So in general are the forms of buds and of the human head, *Fig. 1* which comes to a point at the 'point' of the chin. In these forms there is a thrust or movement in one direction concentrated on the point, and the changes of curvature are focused on it. The stillness of the sphere is disturbed and the shape becomes more dynamic. In the egg, the head, and the bud it is the whole mass of the volume that tends towards a point. On a smaller scale such *focuses of thrust* may occur in the form of protuberances or bosses on the surface of a volume. Some of these may appear as gentle bulges or swellings over a fairly large area of surface, *Fig. 1* others as definitely located protrusions—concentrated thrusts from the inside. Shapes of this kind occur in many places in the human figure and are often exploited as an element in the design of figure sculpture. In draped sculpture in particular the breasts, elbows, and knees often act as focal points for the *Fig. 1* movement of draperies, which tend to pull tight over them and to radiate in creases or folds away from them. They also have a strong directional quality—that is, not surprisingly, they *point* in a definite direction. In some African sculpture such *Fig. 1* 'rounded points' are all-pervading and it is not uncommon to see abdomens and buttocks and even the calf muscles of the legs interpreted in this way. They are also common in abstract sculpture, in the work of Arp and Moore, for example. Since 21, 28 they tend to suggest growth, as though something inside were pushing against the surface or as though the mass of the volume were moving or developing towards a point, it is not surprising that they occur most frequently in the work of sculptors who are primarily interested in organic forms.

Fig. 13
Ancestor Figure, African
(Dogon); wood, 24¾ in.

Fig. 14a

Fig. 14b

Fig. 14c
Detail of the Ludovisi Throne,
Greek, *c.* 465 BC; marble

42

a

b

Fig. 15

Fig. 16

a

b

Fig. 17

The second important way in which the perfectly even, double-curved surface of the sphere may change is by tending towards the creation of lines and planes. The term 'plane' has a number of uses in connection with sculpture. In the present context it is used in a special way. Strictly speaking a plane surface is a flat one like the faces of a cube or pyramid, but sculptors use the term also for any area of a surface which is distinguishable as a separate part and which faces in more or less one direction even though it is not completely flat. It is in fact quite common to speak of 'curved planes' and it is in this sense that we shall refer to the planes of a double-curved surface.

The changes of curvature or changes of plane in completely convex surfaces may take place sharply along an edge, which *Fig. 15* then shows up clearly as a line, or they may be diffused over a more or less rounded area of surface. In the latter case the *Fig. 16* change of direction still culminates in a curved line, which I shall call the *highline,* on each side of which the surface faces in a different direction. The varying degrees of sharpness or roundness in these changes of direction of the curvature impart different visual characters to the forms. Among other things they affect the way in which the surface catches the light. If they are rounded, changes of lighting will be spread over an area; if they are sharp, the contrasts of lighting will be more abrupt and dramatic. On polished surfaces these highlines and edges will tend to catch the light and show up as highlights.

Each double-curved plane has a point somewhere on it which is higher than the rest. This is usually called its *highpoint.* These *Fig. 17* highpoints provide a focal point for the whole plane, which may be thought of as radiating away from them in the manner indicated on a contour map. The position of a highpoint on a curved plane affects its visual character considerably, concentrating the movement of the surface either towards its centre or to some point nearer its edge. In carving these highpoints are of special importance because they are reached first and the rest of the surface has to be carved away from them.

It is largely the qualities and relations of the varied curvatures, highlines, edges, protuberances, and planes that determine the expressive character of sculptural volumes and suggest the existence of an internal structure. As we have already noted, these features may be organized in such a way that they are not just a series of isolated events that take place upon the surface

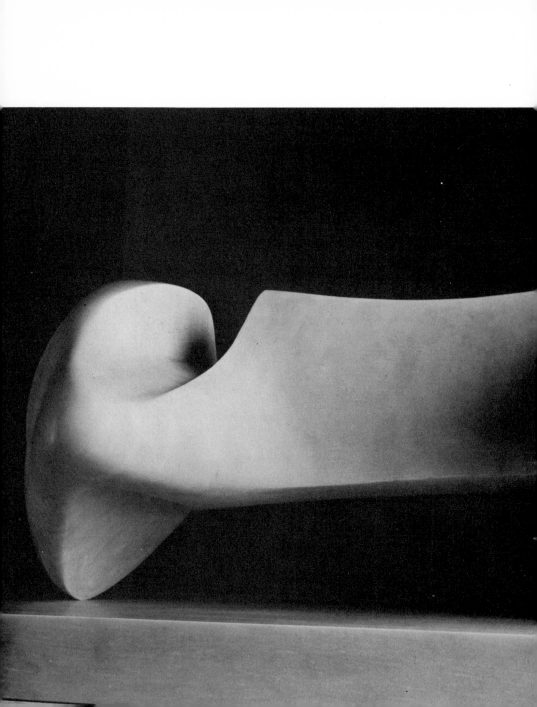

21 RECLINING FORM (1966) by
Henry Moore; marble, 43 in.
Photo: *Marlborough Fine Art.
London*

Fig. 18

Fig. 19

of the sculpture but are connected through its interior so that what happens in one part can be seen to be related to what happens in another and we are thus able to perceive the character of the sculpture as a total volume and not merely its surface features. In sculptures made up of a number of connected and impacted volumes this internal structure may become extremely complex, as will be seen later. At the moment it will be sufficient to show how these surface features may be organized to give an inner structure to a single volume and how this structure, in combination with the particular qualities of the surface features, may contribute to the expressive character of the volume as a whole.

The highlines, highpoints, and planes of the curved single volume in Fig. 18 can easily be seen to be organized around a cube and we can readily imagine the cube inside the volume. We can relate these surface features through the interior and see quite clearly how the changes of section, the rounded corners, and the highpoints of the six faces are related to each other. Largely on account of its all-round symmetry it is easy to apprehend its complete structure as a volume in-the-round.

The volume in Fig. 19 has a structure that is more complex and less symmetrical than that of the volume in Fig. 18, and the planes, highpoints, and highlines in it are more numerous. Its structure as a total volume is therefore more difficult to grasp. A comparison of this volume, which is like a tailor's dummy, with the volume of the thorax of the Greek Kore will 22 show what variations and subtleties a masterly sculptor can introduce into a volume with a fundamentally simple basic structure. The main planes of this volume are more or less the same as those in the diagram. There is a general squareness about it, but because of its subtleties the form appears firm rather than hard. Look at the broad unbroken plane at D, the slight bulge around the form at A, the quality of the curves Fig. 2 radiating from the points of the breasts at C and the way in which this curvature recedes to the shoulders and is emphasized by the lines of the hair which fall across it. The fullness of the side of the breast at E, over which the middle strand of hair falls, echoes the fullness at A and is linked to it by the line of the hair and the folds of the garment. These features, among others, give the shape a youthfulness and uncomplicated expansiveness that go with the quiet smile and the generally untroubled air of the whole statue.

46

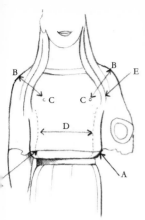

Fig. 20

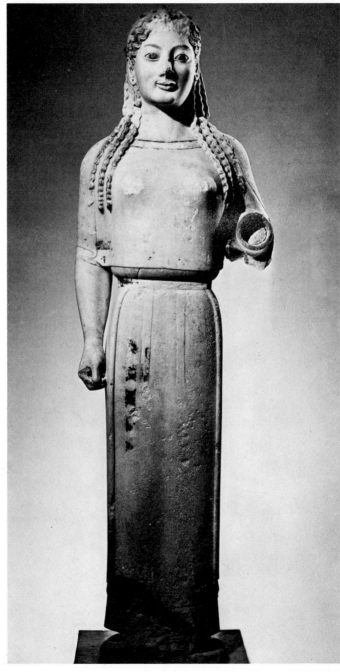

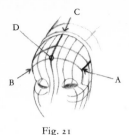

Fig. 21

The curvature of the forehead of the African Baluba figure *Fig.* has a quite different character, suggesting a hard boniness. This impression is largely given by the tautness of the changes of curvature at the temples (*A*), along the highline *B*, which projects like a hard ridge, and along the centre line at *C*. The radiation of the curvature from point *D* also plays a part. The torso of this figure is a clear example of a volume that focuses to a point, in this case at the navel. The whole of this carving is in fact a superb example of the plastic freedom that Roger Fry attributed to African sculpture; the boldness, variety, and inventiveness of its forms are astonishing.

Each of the main volumes of the human figure has its own special surface features which result from its internal structure. These differ in expressive character in different types of figure. The most striking contrast is that between the roundedness, soft swellings, gentle curves, and diffused highlines of the mature female figure and the hard flatnesses, sharper highlines, and general squareness of the mature male figure. These differences are so powerfully impressed on our minds that we tend to project the character of masculinity and femininity into the whole realm of three-dimensional form.

Fig. 22

Volumes with single-curved convex surfaces do not have the *Fig.* full richness of form which is often manifested by those with double-curved surfaces. The straightness of the form in one direction introduces a hardness, a somewhat mechanical simplicity and a lack of subtlety. The curvature in one direction may, of course, be of any kind at all, but its possible changes are much limited by the straightness of the surface in another direction. Nor is it possible for such volumes to have the simple completeness and continuity of surface that is possible in volumes with completely convex double-curved surfaces. In point of fact a continuous single-curved surface cannot enclose a volume. A cylinder has to be closed at either end and a cone at one end by another surface.

Single-curved surfaces are most often found in machine-produced forms and, as I have already suggested, a predominance of these surfaces tends to occur mainly in sculpture made from sheet materials and in other types of sculpture only when a rigid, mechanical character is aimed at. When they do occur in sculpture with masses they generally play only a subordinate role in conjunction with other types of surface, or are introduced for special purposes or effects. Very often the surface of a

48

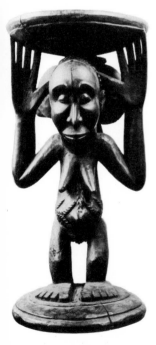
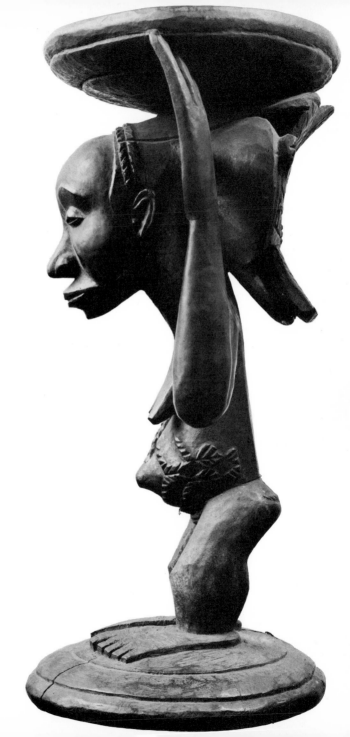

23 Chief's Stool, African (Baluba);
wood, 55 cm. *Musée l'homme,*
Paris

sculptural volume which approximates to a single-curved surface will incorporate slight variations from the rigid straight- 32 ness. These may not be very significant in terms of measurement but perceptually they are of enormous consequence because they introduce movement and subtle changes into what would otherwise be dead and mechanical.

Concave surfaces

a

b

Fig. 23

Concave single-curved surfaces and double-curved surfaces that are concave in all directions usually appear to have resulted *Fig.* from the operation of external forces. They often suggest deprivation or collapse and seem to have been cut away, eroded, abraded, pushed in, or dented. If, as we have already noticed, convex surfaces appear to be related to the *inner* space of a volume, concave surfaces are related to the space outside. They allow the mass of the sculpture to be encroached upon by space. They are always incomplete, open surfaces and by their very nature cannot become continuous so as to enclose a volume of mass. If a concave surface is extended so that it becomes closed, what it encloses is a volume of space. Most architecture has such a positive and negative aspect. It can be viewed from the outside as a composition of solid volumes or from the inside as a composition of enclosed spaces.

The variations of curvature and other surface features that are possible to convex surfaces are also found with concave surfaces, but in reverse. A pointed projection becomes a pointed cavity or hollow; a highline becomes a change of direction in the surface of a hollow; the highpoint of a convex area of surface becomes the lowest point of a concave one.

One of the most important functions of concave surfaces in sculpture is to provide shadows that contrast with the highlights of the convexities. This is particularly noticeable in the sculptural use of drapery, which depends for a great deal of its effect on the interplay of light and dark in the convexities and concavities of its folds. In primitive sculpture this contrast of surfaces is frequently used in a very effective way. In many African masks, for example, the whole face below the eyebrows *Fig.* is scooped out in one great sweeping hollow which contrasts dramatically with the full convex rotundity of the forehead. The other-worldly character and intense brooding vitality of so much African sculpture is partly due to its use of contrasting convex and concave surfaces.

The concave forms of African sculpture are inventions suit-

Fig. 24

50

able for the forms of spirit-beings and for enhancing the expressive qualities of the sculpture. But in the actual human figure complete concavities are deformities which occur only as a result of extreme age or malnutrition. A healthy human body is made up almost entirely of double-curved convex surfaces. What sometimes appear to be concavities are in fact something very different, which it is important to distinguish if we are to understand the particular character of most Greek and Indian nude sculpture and of a great deal of organic abstract sculpture. There is all the difference in the world between on the one hand a hollow which is surrounded by convex surfaces and seems to have been left behind by their growing together around it and on the other hand a concavity which appears to have resulted from the cutting away or pushing in of a convex surface. Sculpture students modelling from the living model used to be told to take care of the positive forms and leave the negative ones to take care of themselves. They would arrive at the hollow of an armpit or a navel or the channel of a spine by building up the convex shapes that surround them. By working in this way they would come to see more clearly

24

Detail of NEPTUNE AND A TRITON (*c.* 1620) by Giovanni Bernini. *Victoria and Albert Museum. Crown Copyright*

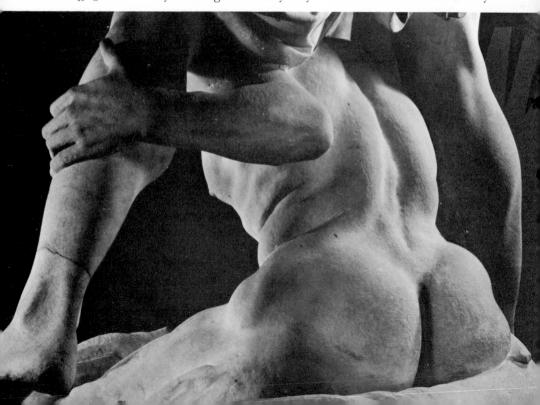

Fig. 25

that these hollows are not concave at all but are formed by the grouping of convex forms which are blended together by the 24 unifying effect of the skin. By interpreting the hollows in this way and making all the surfaces of the figure convex both the Greeks and the Indians, in their different ways, achieved astonishing richness and organic vitality. Most of the hollows in living organisms are formed in this way and in good sculpture such forms usually appear to have an organic quality.

Convex–concave surfaces

a

b

Fig. 26

Volumes with surfaces that are concave in one direction and convex in another do not give the impression that their mass has been encroached on by space. Nor are they self-contained and closed in upon themselves like single volumes with convex surfaces. They have a positive and negative aspect which make their internal dynamics extremely interesting. They seem to grow or expand towards their extremities and to be drawn in *Fig. 2* at their thinnest part like a waist. This is why they are frequently used as transitional shapes to connect one volume with another. By expanding or flaring out at their ends they can blend smoothly into two positive volumes and provide natural, easy *Fig. 26* transitions between them. Transitions of this sort may create an impression of structural strength. The weakest part of any composition of solids tends to be where the solids intersect and if breaking occurs that is where it is most likely to be. For this reason many natural forms which are submitted to strain and many architectural and engineering forms thicken at these joints and their parts blend smoothly into each other instead of coming together abruptly. The 'necks', 'waists', and handles of pottery often exemplify this principle, and such forms are common in the junctures of bones, where they pro- 25 vide extremely strong and subtle passages from one joint or process to another, and at the joints of tree branches with the trunk.

a

b

Fig. 27

Another type of structure combining convexity and concavity occurs in the surfaces of volumes whose axes are bent so that the whole volume, not merely its surface, is curved. In *Fig. 2* these shapes the convex and concave curvatures are complementary. The head-dress of the bronze Benin *Mother Goddess* 26 and the neck and head of Brancusi's *Bird* are beautiful examples 15 of this kind of form in scultpure.

One of the main qualities of these combined positive and negative surfaces is their ability to integrate spaces and masses

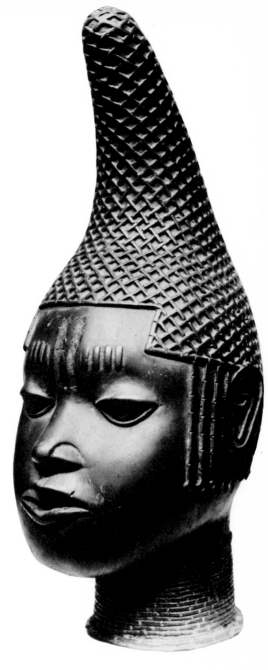

left
Bone of sheep. Photo:
E. Webster

right
MOTHER GODDESS, African
(Benin), 16th century; bronze,
8–9 in. *British Museum*

into a unified design without relegating either to a subordinate position. They make it possible to design spaces through a solid sculpture without giving the impression that the spaces have been excavated or hollowed out of the solid. They are perhaps the most characteristic forms in Moore's mature work. Nobody 27, 28 has integrated mass and space so completely, in such a variety of ways, as Moore and it is not surprising that these combined concave and convex surfaces should play such a prominent part in his work. But we are anticipating something that will be dealt with at greater length later. Indeed it is indicative of the central importance of these forms that it is barely possible to discuss them at all on their own without raising other important aspects of sculptural form that are connected with them.

Surfaces that are convex in one direction and concave in the other include as a special group such warped surfaces as conoids, hyperboloids, and hyperboloic paraboloids. The fact that these are ruled surfaces which can be built from straight members is, as we have seen, important both structurally and constructionally to some modern sculptors, especially the Constructivists. In sculpture with masses, however, they may be classed with convex–concave surfaces in general, their main point of difference being that they usually look particularly strong.

The plastic freedom allowed by such processes as carving and modelling makes it possible to create surfaces of infinite variety. The general classification of surfaces which I have outlined provides useful fixed points—types of surface to which those of sculpture may approximate. Most of the surfaces of sculpture are curved, and this is not surprising. For while plane surfaces are all equally flat, there is no limit to the variety of the curvature of curved surfaces. If we consider a whole range of surfaces from the spherical convex to the spherical concave, the completely flat surface is only one in this infinite series. Visually even the slightest curvature is of great importance; we are extremely sensitive to the slightest sagging or bulging of a surface.

Plane-sided volumes have a hardness and rigidity, a uniform flatness in all directions. Whenever a feeling of power or massiveness is required, sculpture will tend to approximate to something block-like. The block may be extremely complicated, that is multifaceted, but blocks always lack subtlety and

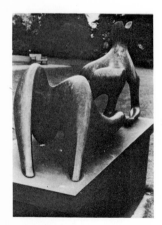

above and facing page
27 Three views of RECLINING FIGURE (1951) by Henry Moore; bronze, 90 in. *Arts Council* (photo: *W. Walker*)

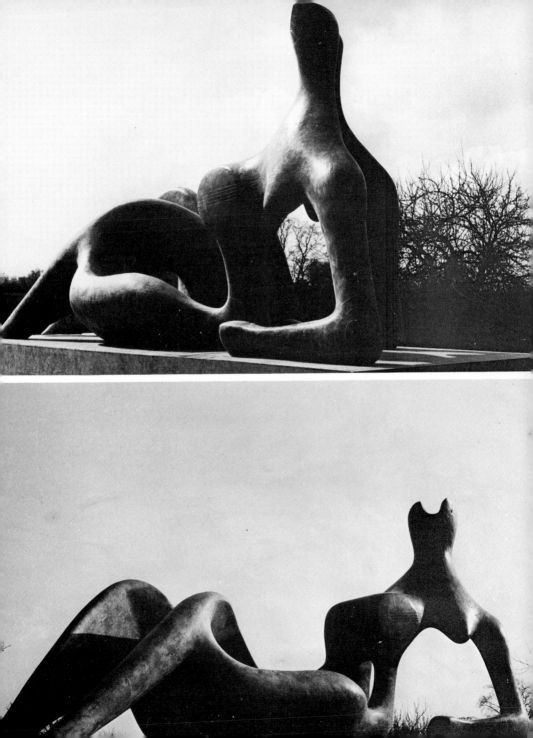

their forms are not difficult to apprehend. In combination with other kinds of surface they may impart a feeling of strength to the sculpture. Some Mexican and Egyptian stone carvings are among the most powerful sculptures in the world and they owe much of this to the presence in them of plane surfaces and to their overall block-like character.

SECTIONS One of the most useful aids to the description and perceptual understanding of three-dimensional form is the idea of the *section*. This concept is employed whenever it is necessary to describe or draw attention to the shapes of solids—in engineering, architecture, anatomy, botany, and carpentry as well as in sculpture. A section is an imaginary cut through a solid by a plane. It is, of course, possible to take sections in any direction through a solid and for this reason when sculptors are talking about sections they usually point them out and refer to the section 'through this way' or 'through this part of the form'. The main sections through a solid, that is, the ones most often used and referred to, are those which are related to its axis in the way shown in Fig. 28.

The main value of the idea of a section in the appreciation of sculpture is that it helps us to link the parts of a surface through the volume and enables us to relate the changes in one part of the surface to those in another. It helps us to develop a capacity for being simultaneously aware of all the aspects of a volume.

The main sections of a solid may differ considerably in shape. A simple and obvious example of this is the cylinder, which is circular in its horizontal and rectangular in its vertical sections. And it is possible for volumes which are of quite different types to have one of their sections in common. An egg and a cylinder, *Fig.* for example, are both circular in one main section. The cylinder is also related to the cube in one of its sections but the egg is not. The possibilities of such coincidence of sections, arising from the fact that volumes have main sections in three directions, are often exploited by sculptors as a way of achieving unity or congruence among the components of their work without the dullness that would result from a complete similarity of shape. This is especially common in African wood-carving.

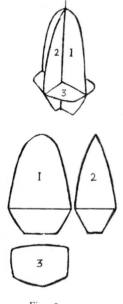

Fig. 28

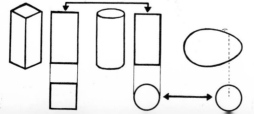

Fig. 29

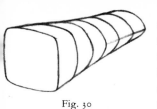

Fig. 30

One can imagine a whole series of sections taken through a solid like slices in a loaf of bread. The cross-sections through a cylinder would be identical circles while its longitudinal sections would be a series of rectangles of different widths. Though not as simple as the sphere and cube, the cylinder is a very simple volume. In more complex volumes the shapes of the *Fig. 30* sections may change constantly all the way through, as they would for example in a volume that gradually changed from a round section at one end to a square one at the other.

The gradual transitions from one section to another throughout the length of a volume can be among the most elusively subtle and appealing features of sculptural form. When we encounter them in the human figure along a thigh or a forearm or taking place between the squareness of a chest and roundness of the waist, or in the bodies of birds and fishes or in such manmade forms as the keel of a boat, they strike us as being 'right', 'natural', or 'logical'. They seem to change according to some inner law or principle which is embodied or revealed in their visual form. This perception of the structural 'rightness' of a form is often confirmed nowadays by refined methods of structural analysis. Such analysis describes in mathematical terms part of what may be directly appreciated through our perceptual awareness of the expressive qualities of the forms. What we perceive as a strong or taut curve is usually in fact strong and taut, and a change of section that seems 'right', 'natural', 'economical'—or any other of those terms that we use to characterize the special quality which we perceive—often turns out to be the best formal solution to the structural problem involved. Of course, before modern methods of calculating stresses and strains were developed, engineering and building craftsmen relied solely on their own structural intuition along with the accumulated experience of their predecessors.

Sculptural volumes, however, are not structural forms in the way that the forms of engineering or boat-building or aeroplane manufacture are. They are not actually under tension; the bow of a bronze Herakles is not really taut. There are no actual physical forces pushing from inside the tightly drawn stone draperies over the knees of a seated figure. The forms of sculpture are not arrived at by man or nature as the solutions to structural problems. Nevertheless it is possible for a sculptor to create forms which *look* as though they have come into being

in this way and which give an impression of structural 'rightness'. One of the main ways of doing this is, as has already been mentioned, to give them an apparent inner structure by means of organized planes, highlines, changes of curvature, protrusions, and so on. The implications of this in abstract sculpture are rather interesting.

A good deal of so-called non-figurative sculpture is not strictly abstract in the sense of being entirely non-representational. True, it may not represent a particular object—a man, a horse, etc.—but it may still be representational in a more general way. The form of the sculpture may suggest the operation of forces within it which are responsible for its visual structure. These tensions, thrusts, gravitational pulls, and so on are not actually present in the sculpture but are only perceived by the observer *as if* they were present. In this general sense a great deal of 'abstract' sculpture is representational—it contains forms whose characteristics are those of forms that have been moulded or are being moulded by the operation of physical forces other than the physical forces actually operative in the sculpture. While natural forms are genuinely structural—that is, their form actually reveals their structure—those of a great deal of abstract sculpture are imitative in a general sense of genuinely structural forms. It is partly this impression of law and order inherent in certain kinds of abstract works that distinguishes them from incoherent lumps of matter.

One feature in sculptural forms that can help to convey this impression of structural rightness and satisfy what is often called our intuitive sense of structure is the controlled transition from one section of a form to another.

An example of such a change of section occurs in the upper part of the torso of the typical Indian figure. The section Fig. 31 through the thorax taken at the joint of the arms (*A*) changes very subtly to the section at the waist (*B*). This change is effected by a broadening and flattening across the chest and shoulder-blades and by a change of plane that takes place along the curved highline of the pectoral muscles at *C*. In the male figure this curve sweeps forwards and downwards and terminates at the nipple; in the female figure it is lost behind the hemispherical attachment of the breast. In addition to marking a change of plane from the upper front part of the chest to the side, the highline of the pectoral muscle provides by its curvature across the thorax a definite location for the beginning of

Fig. 31

the upward sloping plane that leads to the intersection of the neck with the shoulders (D). It also links with the lowest curve of the elaborate diminishing rings of the collar which lead up to the circular section of the neck. This last feature is an interesting example of the way in which form and decoration can work together.

Indicative of the importance of sections in the sculpture of Henry Moore is the large use he makes of them in his drawing. He draws the whole surface of his projected sculptures rather than merely their outlines, usually employing a method which is a fusion of two traditional graphic techniques for showing three-dimensional form—modelling with tone and the use of section lines. A section line is a line drawn in a plane round a shape—the perimeter or part of the perimeter of a true section, in fact. Moore uses these lines to show the sections and sectional changes of his forms and he combines them with the more usual use of tone, which gives a feeling of weight and atmosphere. This fusion of the two methods is capable of evoking a clear idea of the form of the sculpture on a two-dimensional surface.

In classes where students learn to model from the figure it is not at all uncommon for the teacher to draw section lines or to hold string round the model in order to give them a better appreciation of the changes of section in a limb or torso. Obviously such an awareness of sections is of paramount importance to a sculptor. For the observer, who is concerned with appreciation rather than creation, some awareness of them leads to a fuller visual grasp of the depth dimensions of the sculpture. To switch one's attention from the profiles of sculptural volumes to their extension in depth is to become more vividly aware of their existence in three dimensions.

TRANSITIONS Each of the component volumes of a sculptural composition is usually connected in some way with its neighbour or neighbours. They may, for example, be simply abutted so that they appear to be two separate forms with parts of their surfaces touching, perhaps lying side by side or resting one on the other (Fig. 32a). Or they may be joined in such a way that one appears to grow out of the other, as the neck does from the shoulders or the trunk of a tree from the ground (Fig. 32b). Or, again, they may appear to be impacted so that one looks as though it is partially embedded in the other (Fig. 32c). The minor forms (see p. 68 ff.) also are connected to other parts of the sculpture.

a

b

c

Fig. 32

They are attached in some way to the underlying volumes and frequently meet and overlap each other.

The places where these connected forms meet are particularly important since our impression that a work of sculpture is an articulated structure of solid forms and not just a structurally incoherent lump depends very largely on what happens there. Moreover the expressive character of sculpture too is determined to a considerable degree by the way in which the passage from one form to another—usually referred to as a *transition*—is effected at these joints.

When two solids are joined in such a way that one appears to pass into the other or to fit completely against it rather than rest upon it, the joint is called an *intersection*. Two solids of a given shape do not intersect, that is their surfaces do not make contact, in a haphazard or indeterminate way. They meet at a line—the line of intersection—which has its own definite and characteristic shape. For any two areas of the surfaces of solids meeting at a given angle there is only one line of intersection. The junctions of pipes or the connection of a spout with the body of a teapot are simple everyday examples of intersections. Those that occur among the forms of sculpture are usually much more complex and subtle. They may be extremely difficult to conceive clearly and to model or carve well.

The matter may be made clearer by considering the way in which a silversmith has to work out the correct intersection of a spout with the body of a teapot or coffee pot. If the shapes are regular geometrical ones, it is possible to calculate the intersection mathematically and to develop it. But the shapes of silverware are usually more subtle and organic than this and empirical methods have to be used. First the silversmith will raise the body of the pot until its form is complete and definite, or he may make a full-scale plaster model of it. Then, using cardboard templates and a plastic material such as Plasticine, he will work out the complex three dimensional curvature of the section at the base of the spout that will marry perfectly with the curvature of the surface of the body to which it is to be joined. This is a tricky process and may involve making numerous adjustments by filing and cutting the edge of the metal until the exactly right three-dimensional space-curve is arrived at.

The problem of a stone-carver working, say, on the junction of a neck with the head or shoulders, or on any similar transition

Fig. 33

between abstract or representational forms, differs only technically from that of the silversmith. He has to arrive at the shapes of the volumes and at the intersection between them by carving into a block of solid material, not by constructing the volumes separately and making adjustments. Unless he thinks clearly about the total shapes of the volumes, including the *Fig. 33* parts of them that pass through each other, and about the way in which their curved surfaces will meet, he will not arrive at a convincing and structurally correct line of intersection. He will tend to distort the surfaces of the volumes as they approach the joint and they will not look as though they fit together properly. They will lack the kind of rightness that is sometimes called the 'logic' of form.

It is important to realize that this rightness of a transition is something we appreciate visually. It has nothing to do with our intellectual knowledge of the geometry of intersections but arises from our intuitive grasp of their visual structure. This is an extremely difficult aspect of sculpture to describe in a meaningful way to anyone who has no direct experience of it; and if what I am saying appears confusing or unintelligible, I must ask the reader to try to see through the words to the kind of experience I am describing, because that is important and unmistakably real and vivid.

One of the most visually important ways in which transitions may vary in quality is by being more or less smooth or abrupt. An *abrupt transition* is one in which the intersection of the forms *Fig. 34a* shows as a clearly defined line and leaves us in no doubt about where one form ends and another begins. Where such transitions predominate the sculpture is readily seen as a group of interconnected but visually separable components.

Smooth transitions are those by which one form flows or is *Fig. 34b* blended into another without any sudden interruption in the continuity of the surface or contour. This is, of course, a matter of degree and may vary from a slight softening of the joint between two forms which are still obviously separable visually to a complete blending of surfaces which leaves us in doubt precisely where one form ends and another begins. One form grows out to meet another so that the transition becomes a concave curve rather than an angle—we have already seen how useful in this connection the concave–convex surface can be; or each form changes the angle of its surface so that it glides into the other almost imperceptibly; or the edge where two forms

a

b

Fig. 34

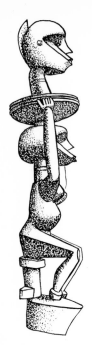

Fig. 35
Wooden Head-dress, African
(Bende Ibo); 30 in.

meet as they do on the outside of an elbow or shoulder may be softened into a convex curve.

The transitions between the volumes of the so-called primitive wood sculpture of Oceania and Africa are almost without exception abrupt and each major part of the sculpture is carved *Fig. 3* as a separate, self-contained, and clearly delineated volume. This discontinuity, together with the abrupt changes of direction of the surfaces and the equally abrupt changes of scale in adjacent volumes, imparts a jaunty and staccato flavour to many of these carvings, a liveliness which is characteristic in particular of African sculpture.

The capacity of African sculptors to conceive the sculptured figure so completely in terms of volume is one of the things that makes their work so exciting to twentieth-century European sculptors. A great deal of African carving is not only 23, 58 extraordinarily inventive but also possesses a completely lucid visual structure. The transitions in particular are usually carved in the most decisive way and are structurally convincing. This translation of the human figure into a structure of clearly articulated volumes is achieved apparently without any need on the part of African artists to overcome a tendency, such as may be observed in the history of European sculpture, to approach the three-dimensional through the two-dimensional by conceiving volume as an extension into depth of the visual projection— a practice that received its clearest theoretical formulation in the 'relief principle' of the nineteenth-century sculptor, Adolf Hildebrand (cf. p. 169).

The minor forms of African carving are also usually sharply 36, 58 outlined where they meet the underlying main forms. There is no attempt to render the musculature of the body. The most important minor forms are the features of the face, the breasts, *Fig. 3* navel, and genitals, that is, the parts which in the human body have the greatest emotional significance.

Since three-dimensional form is revealed to vision by the way light and shade are distributed over its surface, these abrupt transitions, like the edges between convex and concave parts of the surface, give rise to dramatic shadows and highlights and thus become one more feature that contributes to the enormous vitality of African sculpture. The full effect of this aspect of tribal sculpture is not apparent when the works are inspected in a museum showcase. The masks are intended to be seen in motion in the tribal ceremonies and dances; and no doubt the

variety of surface in the figures also reads to the best advantage in natural African daylight or in the constant movement of flickering firelight.

We must be careful, however, in making generalizations about African sculpture. Within the incredible variety of tribal art exceptions may be found for almost any general statement. But the exceptions to the characteristic features of African wood sculpture which I have indicated should serve to show more clearly the expressive qualities of the majority of works, in which these features do occur.

Perhaps the most extreme contrast to the abrupt transitions of African art is offered by the work of such twentieth-century sculptors as Arp and Moore. In many of Moore's works there are no abrupt transitions at all; each form blends with its neighbours to provide a rhythmic continuity of surface and contour. There is nothing even approaching a line at the junctures of the forms of Moore's *Recumbent Figure* in the Tate Gallery. Look, 28 for example, at the blending of the neck with the head and shoulders. Notice, too, how the hands have disappeared and the arms are smoothly blended into what remains of the hips. The carving of the inside of the elbow, of the armpits, and of the arches that are derived from the back of the knee—all places where there would actually be abrupt changes of plane and sharp angles or folds in the flesh—has been stopped short and the surface carried round in smooth curves that fuse solids and voids in one continuous rhythm. Moore's translation of so many of the volumes of the figure into sculptural forms which have the convex–concave surfaces we have already discussed is largely instrumental in the achievement of this continuity.

In some of his more open and complex figures Moore has put together a number of forms whose varied directions, sizes, and sections are unified by smooth transitions within a continuous flowing surface. The absence of sharp divisions, together with a lack of minor forms which might interrupt the smooth flow of the surface, gives these sculptures the look of something that has been eroded into a timeless anonymity by the elements. All their details, angles, and edges have been worn down and rubbed smooth and their soft parts have disappeared, leaving only the harder skeletal structure.

Neither Moore nor the African carver bothers with the surface anatomy of the body; this aspect of the structure of the figure does not serve their expressive needs. In some styles of

sculpture, however, the surface anatomy, particularly the musculature, is a powerful instrument of expression and a great deal of the character of some works in these styles depends on the way in which it is treated. This includes among other things the treatment of the transitions between neighbouring muscles and between the muscles and the underlying volumes.

The subtle convex forms that makes up the surface anatomy of the classical female nude statue pass smoothly into each other without any clear-cut boundaries and are blended together by a 'skin' that softens all the transitions. The result of this in marble, when the carving is sympathetically lit, is a soft diffusion of varied tones over the surface, which enlivens without fragmenting the main volumes of the figure. In bronze the result is a flowing continuous pattern of highlights and shadows which varies gently as we walk round the sculpture. A similar plastic continuity of rounded forms in which the transitions are softened is apparent in the *Hermes* attributed to Praxiteles and in the bronze *David* of Donatello. It gives these two figures a somewhat soft and effeminate look.

28 RECUMBENT FIGURE (1938) by Henry Moore; green Hornton stone, 54 in. *Tate Gallery*

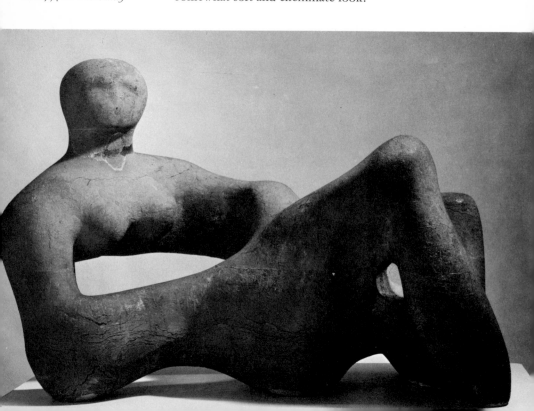

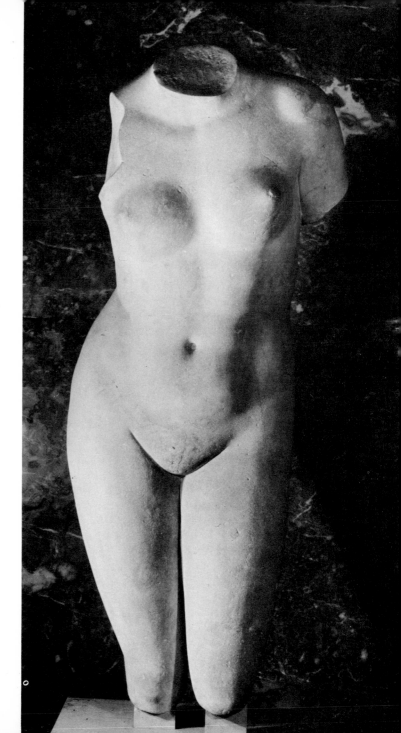

Torso of VENUS OF CNIDUS,
Greek, *c.* 360 BC, copy of the
original by Praxiteles; marble,
47 in. *Louvre, Paris*

Fig. 37
Detail of YOUTH MAKING A
GIFT, Greek, late 5th century
BC; bronze

In the majority of classical male nude figures the surface anatomy is treated as a complex three-dimensional jig-saw puzzle of highly schematized, clearly defined minor forms. In extreme cases these forms are outlined by clearly marked channels which create a strong linear pattern and separate each form from its neighbours. The copies of the work of Polyclitus show these qualities in a marked degree. They are also present in *Fig.* the *Dionysus* from the Parthenon, where the movement from the 30 nearly horizontal abdomen to the nearly vertical chest is accomplished by means of a series of minor forms, each of which moves slightly in relation to its neighbours, the whole adding up to a continuous but clearly articulated movement.

The articulation of forms and the transitions from one form to another are among the most subtle aspects of sculpture, extremely pleasing when well executed but often a source of weakness. In particular, attempts to run forms smoothly together may easily degenerate into structureless, disorganized surface slithers in which all sense of a natural and convincing passage from one form to the next is lost and indications of the existence of an internal structure are obscured. Nothing is easier to produce or more superficially (literally) pleasing to an undiscriminating eye than an attractive piece of wood or stone that has been carved more or less at random to give it a variety of surface features and then polished so that there is no break in the smooth but plastically incoherent flow of its surface. To anyone who has learned to appreciate real sculpture these collections of surfaces are meaningless and opaque. They lack a visually intelligible structure. The intelligent eye cannot see beyond the surface and its attempt to apprehend an underlying structure of sculptural forms which continues through the mass is frustrated. These superficially attractive lumps of material, of which there are many masquerading as abstract sculpture, are related to real sculpture as the aimless but not unpleasant strumming of a guitar or piano are related to real music or as a no more than attractive coloured surface is to real painting.

While the desire for mere smoothness or blended surfaces without the ability to achieve a convincing structure results in surface slithers and an unctuous superficiality, the desire for sharply delineated form without the ability to achieve subtlety and variety may easily result in a spurious clarity, a hard, mechanical obviousness. This last quality is particularly noticeable in some late Hellenistic and Classical Revival figures, in

66

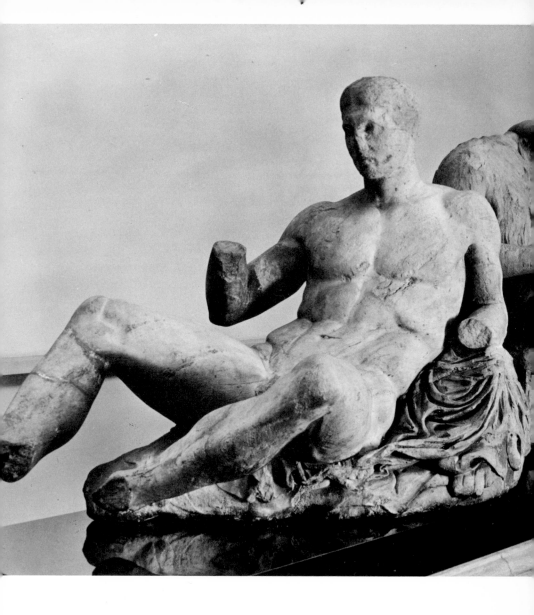

30 DIONYSUS (*c.* 440 BC), from the east pediment of the Parthenon; marble,
H. 130 cm. *British Museum* (photo: *Edwin Smith*)

which the schematic musculature of classical Greek male figure sculpture has degenerated into a cliché repeated by craftsmen who have lost, or never had, any notion of the expressive needs for which it was evolved.

MINOR FORMS It is only in the sculpture of our own time, in the work of Arp and Brancusi for example, that the surfaces of sculpture have 15, 97 been left bare. In the sculpture of the past they are usually overlaid by various kinds of minor forms and decorative details. Sometimes these details become a luxuriant growth that overwhelms the volumes, for this is a disease to which sculpture easily falls victim. In some of the later styles of Indian sculpture, for example, the figures are engulfed by a veritable jungle of small decorative forms. A similar fate overtook some of the late northern Gothic altar-pieces. And Moore has remarked that 'since the Gothic, European sculpture had become overgrown with moss, weeds—all sorts of surface excrescences which completely concealed shape'. He goes on to say that 'it has been Brancusi's special mission to get rid of this overgrowth, and to make us once more shape-conscious'.[1]

Many of these minor forms are merely textural or linear additions to the surfaces of the main forms; others are small, solid components which we see as separate forms attached to the larger forms as to a ground. Our seeing these minor forms as additions to the main volumes and not as part of the structure of the volumes themselves depends partly on their smallness and partly on their being clearly delineated and shaped in such a way that the surfaces of the underlying volumes seem to continue beneath them. The perceptual conditions under which we tend to see minor forms in this way are analogous to some of those which Gestalt psychologists have investigated in two-dimensional shapes under the headings of 'overlapping' and 'figure and ground'.

The possibility of implying the continuation of the surfaces of the main volumes beneath the minor forms is of considerable importance in some styles of sculpture. In the Classical interpretation of the male human torso the sculptor has to visualize an underlying structure of two main volumes, pelvic and thoracic, *Fig.* 4 overlaid by a complex pattern of three-dimensional minor forms derived from the musculature of the body. The underlying forms move in relation to each other but in themselves

[1] 'Notes on Sculpture.'

68

they are inflexible and unalterable. The minor or secondary forms, as they are sometimes called, are within limits variable, although the position of their attachment to the main volumes does not change. The ability of the Greek sculptor to create clearly articulated movements of the human body depended very much on this conception of the figure as a structure with both constant and limitedly variable features. And our appreciation of his achievement depends on our ability as spectators to penetrate the surface of the sculpture and to follow the underlying movement of the main symmetrical volumes over which the minor forms are fitted and which explain and impart unity to their variations and asymmetry. This twofold structure of main volumes and minor forms makes the figures of the great masters of Classical sculpture completely transparent to our 30 sense of form; they are wholly intelligible to our powers of perception.

Minor forms are usually carefully shaped and grouped against the main volumes. This is perhaps best illustrated by reference to the features of the face. The shapes of the individual features and the pattern they make together on the front of the head are given careful consideration by every competent sculptor, but in African and Oceanic sculpture, where the head is the most important part of the sculptured figure, the art of the mask has been developed with greater refinement and more inventiveness than anywhere else. The creative imagination of the tribal sculptor seizes upon the features of the face and transforms them into an endless variety of marvellous patterns of three-dimensional forms. Some of the elements which undergo _Fig. 38_ these transformations are: the curve of the eyebrow, which often echoes the curvature of the outline of the mask and links with the curve of the cheek-bones and the centre line of the nose; the planes and outlines of the upper and lower eyelids and the shape of the eye between them, all of which form an over-all shape that fits into and probably echoes the shape made by the curves of the eyebrow and cheek-bones; the planes of the nose and the line of its intersection with the plane of the face; the nostrils, which frequently echo the shape of the eyelids; the upper and lower lips and the gap between them; the muzzle and its intersection with the plane of the face.

In the entirely different world of European naturalistic sculpture we may notice how the minor forms of the head may be pervaded by a common quality which gives the head a unity

Fig. 38

69

of character. This is particularly marked in the head of Michelangelo's *David*, in which all the features have clearly defined 31 planes and edges and share a breadth and crispness of treatment. These are the qualities that have caused the features of this head to serve as models for generations of art students. I myself can remember modelling copies of plaster casts of an eye and the nose of this carving at the age of nine or ten as an exercise at school.

THE INTERPLAY OF
SOLIDS AND VOIDS

Many sculptures are completely solid, compact masses with no internal spaces at all. They simply occupy space without entering into any intimate relationship or communion with it. Stone sculptures in particular tend to be like this on account of the hardness of the material and its lack of tensile strength. There are numerous examples of such compactness among Central American, Mesopotamian, and medieval sculpture, but Egyptian stone carvings, above all, have this character. The compression of the figure so that all its volumes pack into one completely solid mass is one manifestation of what Cyril Aldred has aptly called the 'claustrophilia' of Egyptian art. The most extreme examples are those in which a head surmounts a cubic block 32 which has been slightly modified in order to suggest the general form of a crouching figure.

Other sculptures, while preserving their main character as sculpture with masses, are invaded by space. Their masses are opened up and hollowed out into cavities or penetrated by holes. Some of the holes are spaces between volumes; they arise when volumes are put together to make a composition. We shall consider these separately. For the moment we shall consider the spaces that occur within the volumes themselves.

A concavity is the first inroad made by space into the solid volumes of sculpture. If a concavity is made really deep and the solid shape is hollowed out beyond a certain depth, the hollow thus formed may strike us more as a void, or interior space, than as an inward-turning concave surface; the mass will seem to us to enfold and perhaps almost to enclose a space. If this hollowing out is carried to an extreme, the solid part of the sculpture may be perceived as a shell enfolding a void, that is, as a pot-like or laminar form rather than as a hollowed-out volume. The work would then tend to fall into the category of spatial sculpture, in which space is the main consideration and the solid components are used primarily in order to define space. It must

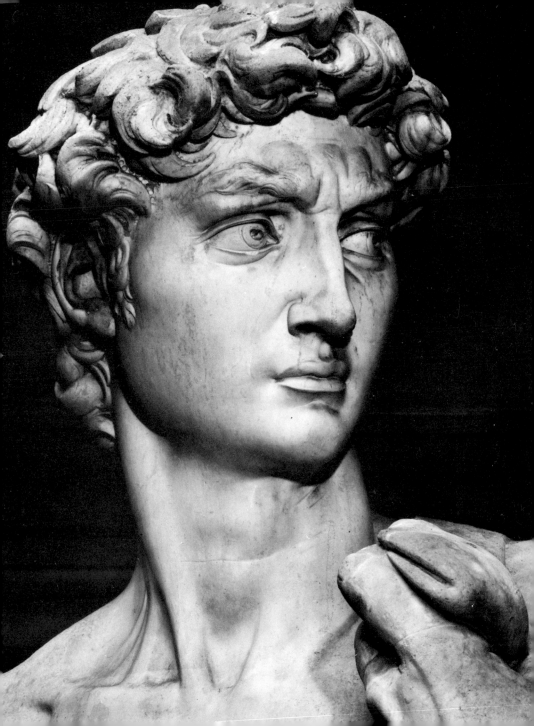

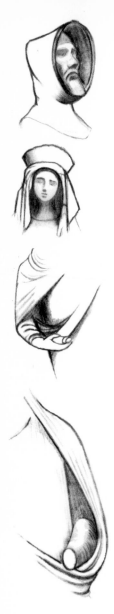

be stressed, however, that there is no hard and fast line between these two kinds of work; one kind shades off into the other.

Cavities occur in many Gothic, Renaissance, and Baroque sculptures, where they are usually created by draperies that fall or crumple into deep folds or hang away from the volumes of the body. This effect may be seen notably in the cowls, hoods, cloaks and sleeves of late northern Gothic sculpture. The main *Fig.* function of such cavities is to act as deep pools of shadow against which the light-catching positive forms of the sculpture will be thrown into prominence. Cavities which have been considered as 'negative volumes', that is as definitely shaped spaces, are a rarity in any but modern sculpture, although they do occur occasionally in African and Mexican sculpture.

The most extreme inroad that space can make into a solid volume is to penetrate it completely and make a hole right through it. 'The first hole made through a piece of stone', according to Henry Moore, 'is a revelation. The hole connects one side to the other, making it immediately more three-dimensional. A hole can have as much shape-meaning as a solid mass.'[1]

The interior spaces of sculpture may have surfaces whose curvatures are as diverse as those of its exterior. They may have the mechanical, drilled-out look of single-curved surfaces or the hollowed-out, cave-like quality of completely concave surfaces. Holes that are surrounded by convex–concave surfaces form a special group with important visual properties.

Holes which are surrounded by single- and double-curved concave surfaces suggest that the mass has been penetrated or cut through by something. They are essentially negative and appear to have been made by some external agency working into the passive solid. Holes with convex–concave surfaces, on the other hand, tend to look as though they have come into existence by being left behind by the growth of solid matter around them. The solid appears to be intact and the hole does not look as though it has been cut through it. The character of these shapes is quite different from that of the others. They have an organic quality and convey an impression of growth, as 33 though they have resulted from some inner activity.

These convex–concave surfaces belong equally and at the same time to both the negative and the positive aspects of sculpture; their convexity contains the fullness of a solid volume

Fig. 39

facing page
32 SENNEFER, Egyptian, *c.* 1500 BC; black syenite, 33 in. *British Museum* (photo: *Edwin Smith*)

[1] 'Notes on Sculpture.'

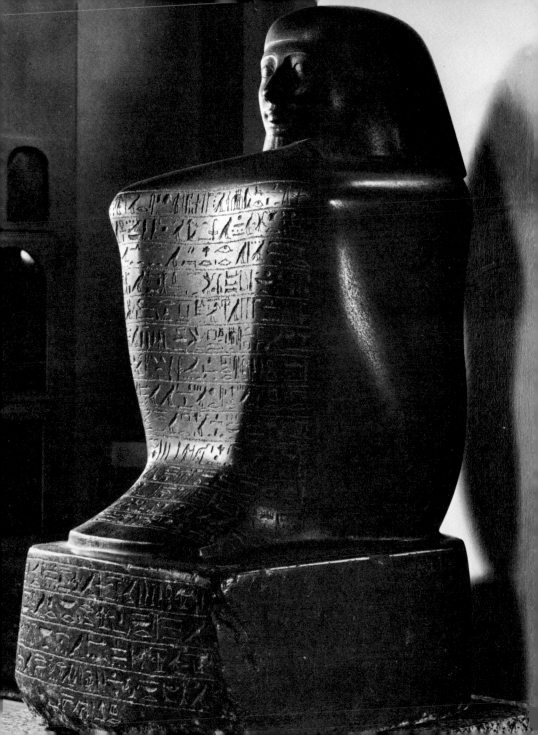

Fig. 40

while their concavity encompasses a void. They make it possible to create combinations of solids and voids which have a continuous surface. The simplest example of this is the torus, which *Fig. 4* is one continuous surface that creates both solid and void. This continuity of surface is an important property, especially from the tactual point of view. It makes it possible to create compositions of solids with surfaces that offer no sudden checks to the hand running over them and also to provide spaces for the hand to explore which would not be possible without such surfaces.

The meeting of any other kind of surface of an interior space with the exterior surface of a volume creates an edge—a fact of considerable importance, obvious though it may be. Edges may 9, 35 be softened or left sharp but in either case they introduce a linear element into the sculpture. The line created by such meetings of surfaces is not a mere decoration superimposed on the surface of a volume. It can be arrived at and perfected only by perfecting the curvature of the two surfaces whose meeting gives rise to it. Such lines are an integral part of the three-dimensional form of the sculpture and not something drawn on it or draped round it.

In the development of twentieth-century sculpture it was the Cubists—Picasso, Lipchitz, Laurens, and Archipenko—who first broke into and opened up the interiors of sculptural volumes. We have grown so accustomed to what they did that we sometimes forget how bold a step it was to make sculpture in which the interplay of convex and concave surfaces and of solids and voids was pursued for its own sake. They used the forms of the human figure merely as a starting point from which to develop compositions whose forms were for the most part invented. Among other changes, they imposed concavities on the forms of the figure where they did not exist and penetrated its solid volumes with holes. Archipenko was one of the first, if not the first, sculptor in the twentieth century to cut right through the volumes of the figure. Like most of the forms in Cubist sculpture, these holes tended to be inorganic in quality, with a predominance of mechanical single-curved surfaces. This is particularly noticeable in the spaces in the head and in the holes through the chest of the *Standing Figure* of Archipenko. 34

The sculptor who more than any other has exploited the possibilities of interior spaces in single volumes is Barbara Hepworth. She has opened up the interior of her sculpture, creating cavities and holes that are as carefully considered as the

74

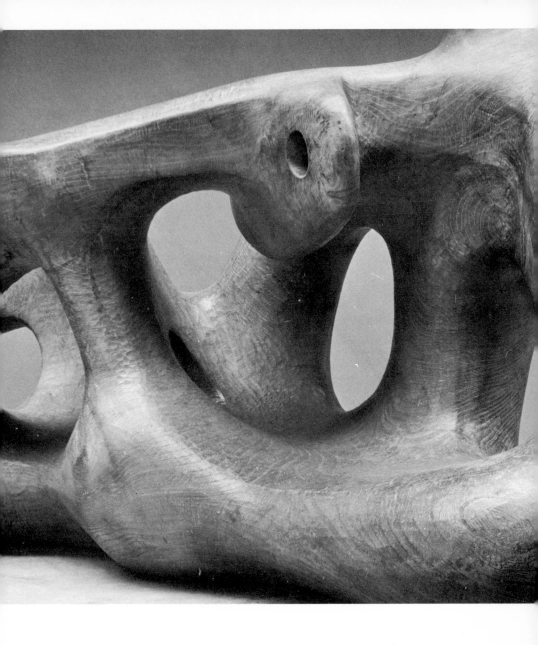

33 Detail of RECLINING FIGURE (1939) by Henry Moore; elmwood, 81 in.
Detroit Institute of Arts

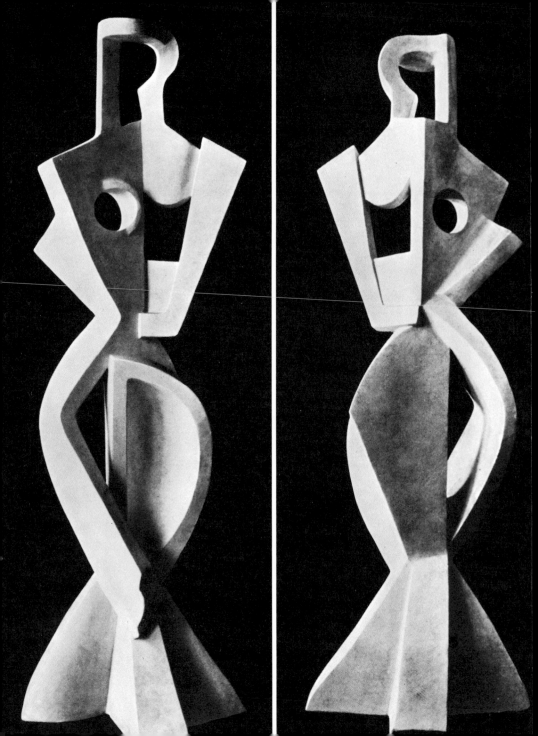

exterior shapes. In such works as *Wave, Icon, Delos, Pelagos*, and
Corinthos she has painted the interior surfaces in a pale colour
(mostly white) partly to contrast with the natural wood, partly
to bring light into its cavities, partly to emphasize the linear
movement of its carefully considered edges, and partly, no
doubt, out of a desire for clarity and to express something of the
special light and colour of the marine landscape of Penwith.
Most of these interior spaces are completely concave and the
contrast between them and the exterior surfaces is sharp. These
sculptures contain their spaces within the envelope of a single
volume and this contributes greatly to their complete, self-
contained stillness. This is a very different quality from that of
Brancusi's single-volume sculptures—*The Newborn, Torso of a
Young Girl, The Beginning of the World, Bird*—which are entirely
positive forms with surfaces that imply a contained energy, an
inner dynamic structure. Hepworth's are quiet, reflective, pas-
sive. They have evolved like a seashell or have been worn down
like a boulder rather than filled out like a fruit.

The hollowing out and creating of voids within the mass of
the actual component volumes themselves is one way in which
space may be made to penetrate and open up the solidity of
sculpture. It is not a way that has been used very much in the
sculpture of the past since most of it has been based on figures
and animals and the component volumes of these do not have
holes in them. The spaces in most figurative sculpture are of a
different kind; they come into being when volumes are put to-
gether and exist *between* the solids rather than *in* them.

The compression of the figure into a solid mass that occurs in
Egyptian and other styles of sculpture has its counterpart in
very few of the poses of the actual human body. People do not
often stand or sit with their arms pressed tightly against their
bodies or with their knees held tightly together. The range of
expression possible with such poses is extremely restricted.
Most sculptors have sought a more organic and natural relation
between space and the solid forms of their compositions and
have tended to use spaces where they would naturally occur in
the figure. Arms are separated from the body, there are gaps
between the legs, seated figures are posed so that there is a space
between their legs and the upright front face of the seat, re-
clining figures have spaces between the parts of their bodies
and the ground on which they rest. In the majority of sculptures
from the past these spaces have not received much attention

from the sculptor, and he has certainly been very far from considering them as shapes in their own right meriting the same thought and care as the solids. Even when the sculpture has been opened up so that the space counts a great deal, as it does in Baroque and Mannerist sculpture and in such extremely complex compositions as the once famous *Laocoon*, the shapes of the voids have been considered only secondarily, as something that just happens when solid forms are related in space.

The high degree of abstraction in the treatment of the forms of human figures, animals, and masks in African and Oceanic 36 wood-carvings and in some Mexican stone-carvings enables the sculptor, when for some reason he wishes or is required to do so, to design their spaces as carefully as he designs their masses. In this respect some few primitive sculptures are like a great deal of modern sculpture in which a new conception of the relations between mass and space has been arrived at.

In order to create representational sculpture in which the voids are as carefully designed as the solids, some freedom from a naturalistic attitude towards the forms of the animal or human figure, or whatever else is represented, is necessary. In primitive sculpture this freedom is enjoyed unquestioningly. But the modern sophisticated sculptor has had to overcome the in-

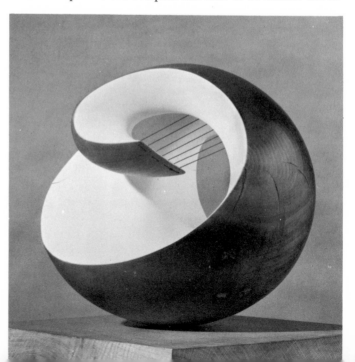

35 PELAGOS (1946) by Barbara Hepworth; wood with colour and strings, 16 in. *Tate Gallery*

hibitions of a long history during which anatomically correct proportions and shapes have been considered to be an essential feature of serious sculpture. It was largely the example of primitive sculpture that gave artists in the early part of the present century the courage to break free from the restrictions of naturalism.

A restrained example of such freedom, and a useful example for the purposes of comparison, may be seen in the Mexican stone figure from Tamuin (Fig. 42). The holes between the arms and the body of this figure have been treated as shapes in their own right and have been given the same careful consideration as the solid forms. The similarly placed space between the arm and body of Donatello's *David* has not been given this kind of consideration. The requirements of anatomical correctness, which did not concern the Mexican sculptor, prevented Donatello from thinking of the space as anything but a gap between the solids. *38, Fig. 43*

In the work of a great many modern sculptors, including Archipenko, Arp, Lipchitz, Hepworth, and Moore, solids and voids are given equal consideration and become so interdependent that it is impossible to discuss them separately. The notion of an inner space inhabited by a structure of solids and *33, 34, 35 Figs. 9, 41*

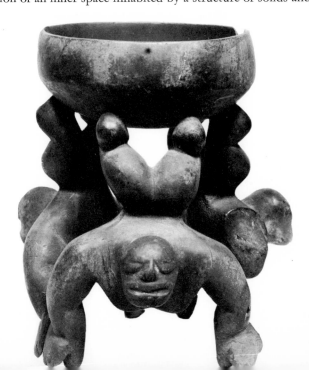

Wooden Bowl, Hawaii; 8 in.
British Museum

an outer space surrounding the sculpture no longer applies; the complete penetration of the composition by space and the intimate union of solids and voids make nonsense of it. There have been sculptures in the past, such as the Malanggan carvings 37 from New Ireland, which have shown a really positive awareness of space as an element in their design; but never before the twentieth century has the union of space and mass in sculpture been exploited so deliberately and thoroughly.

The one thing that everybody knows about the work of Henry Moore is that holes are a special feature of it, and it is certainly true that Moore's exploration of the possible relations 28, between solids and spaces has been more thorough than that of any other sculptor. There are twentieth-century sculptors who have gone much further than Moore in the development of spatial sculpture but they have done so by giving up the idea of sculpture as essentially an art of solid form. Moore has never abandoned this traditional conception of sculpture and the spatial qualities of his work are never achieved through a diminution of the mass of the sculpture to a point where we cease to regard it as a composition of solid forms.

A comparison of the arms of some of Moore's figures with *Fig.* the arms of the Donatello and Mexican figures will show how *Figs.* far Moore has gone in modifying the shapes of the human body in order to achieve an integration of solids and voids.

The relation between solids and voids in sculpture is analogous to that between areal shapes and background in the two-dimensional arts. When attention is focused on the drawing or painting of the objects in a picture, the spaces between them may tend to be neglected or, at least, to be regarded as relatively unimportant. Beginners at painting and other kinds of two-dimensional design have to be constantly reminded to look at the shapes between things and to divide their attention between the figure and the ground, so that both are designed with the same care. In some kinds of painting and graphic work the shapes of objects are 'distorted' in order to make their contours yield a satisfactory shape both inside the object and outside it, just as Moore's figures are 'distorted' in order to achieve a unified design of solids and voids. Lines in two dimensions may become boundaries that define the shapes of objects and the shapes of the ground behind them. Similarly, surfaces in three dimensions may become boundaries defining volumes of mass and volumes of space—so-called negative volumes.

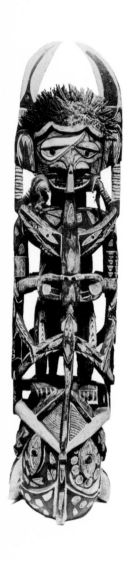

37 Malanggan Carving, New Ireland; wood. *British Museum*

Fig. 42
THE ADOLESCENT, Mexican
(Huastec); stone, 3 ft. 10 in.

Fig. 43

(a)

Fig. 44

(b)

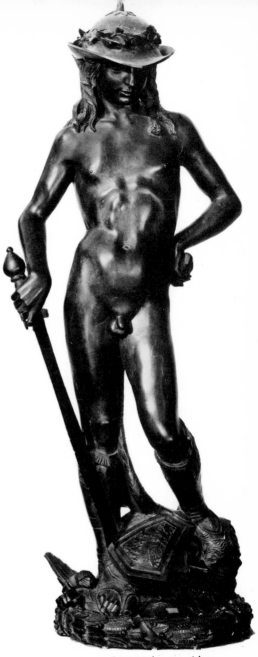

38 DAVID (*c.* 1430–2) by
Donatello; bronze, 158 cm.
Museo Nazionale, Florence

The cavities and holes in sculpture have their own expressive qualities which they add to the whole range of expressive possibilities of sculpture. Some of the expressive qualities that are due to differences in the quality of curvature of the surrounding surfaces have already been mentioned, but there are a great many other ways in which the character of these spaces may vary. The interior space of Moore's *Helmet Head*, for example, 39 is dark and secretive and there is something sinister—we are not sure what, but we know it is anti-human—lurking inside it. The thickness, the metallic quality, and the strong domed shape of the surrounding shell-helmet-head, together with its mechanical eyes, make the sculpture an image of aggression evocative not only of helmets and heads but of the turrets of tanks and aeroplanes and the carapaces of aggressive arthropods. The interior spaces of the same sculptor's *Three Rings* are quite 40 different. They are completely open; there are no hiding places in them and they clearly conceal no threat. The spaces are not dark and enclosed but wide open, enabling us to see right through the sculpture and spreading light through it. The overwhelming effect is one of spaciousness and, unlike the *Helmet Head*, which keeps us at a distance and stands opposed to us, the *Three Rings* as it were invites the observer to penetrate within the sphere of its ambience.

SPATIAL SCULPTURE During the last fifty years a type of sculpture has developed in which the spatial aspects have taken precedence over the solid forms and have become the main focus of the sculptor's attention. We owe the development of this spatial sculpture mainly to the Constructivists, especially the brothers Naum Gabo and Antoine Pevsner, who for half a century have been faithful to their idea of a new kind of spatial art—an idea which was first conceived during the wave of intellectual and artistic optimism in the early stages of the Russian Revolution and first proclaimed in the *Realist Manifesto* of 1920.

We have already noticed that all sculpture has its spatial aspects but that their importance varies in different kinds of work. The sculpture of Gabo and Pevsner is probably the most completely spatial of all. One of the first things we notice about 16, 2 it is that it consists chiefly of linear and sheet forms—wires, strings, rods, sheets of metal, perspex, wood, and so on— rather than the usual solid forms. There are good reasons for this. First, these one- and two-dimensional components have

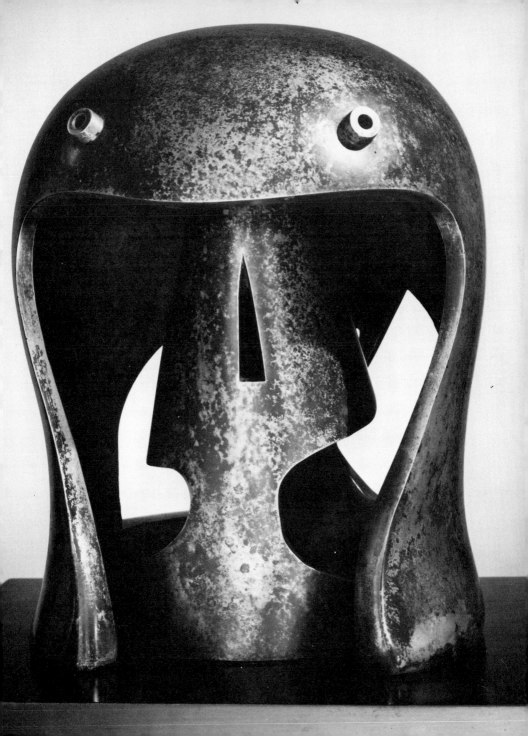

no mass to be shaped, no interior to be structured, and they allow the sculptor to concentrate his attention entirely on the spatial aspects of his work. Second, they do not occupy a significant amount of space; they may exist *in* three-dimensional space but they are not themselves, in any but the most tenuous way, three-dimensional. They move through space, divide it, relate across it, enfold or envelop it, and frame it, but they do not fill it. When, for example, we define a cubic space with twelve straight wires, we have created a space which can be divided and into which things can be put. Again, when we hammer a sheet of metal into a hemisphere that bulges towards us we automatically bring into existence a hemispherical hollow on the other side. These sheet and wire components enter into a much more intimate marriage with space than do solid volumes.

When these material components are transparent or translucent, the sculpture becomes almost completely disembodied. Gabo himself has pointed out how the development of his own Constructivist sculpture has depended to a great extent on the availability of transparent materials like glass and perspex. These make it possible to define spaces without creating visual barriers and to construct sculptures with visible interiors. The sculptures can be completely opened up so that they no longer have an inside and an outside but are a fully visible development 16 in space.

Pevsner has perfected his own extremely effective technique for creating certain types of surface. His most common procedure is to establish related space curves in metal wire or bent rods and then to weld across these a series of straight rods so close together that they add up to a surface. Most of Pevsner's 41 surfaces are warped surfaces for which the space-curved linear components serve as directives and the straight rods as elements. Using mainly this technique he constructs complex spatial patterns with beautiful rhythmic movements of surface. The predominance of ruled surfaces imparts a tautness and strength to these constructions and the fact that the straight, linear elements which make up their surfaces are actually shown gives them a completely visible structure.

The forms of Pevsner's sculpture are not soft and yielding like sheets of cloth that hang loosely or flutter in the wind. They have the tensions of stretched surfaces or surfaces that transmit stresses within a dynamic structure. Cloth takes on forms which

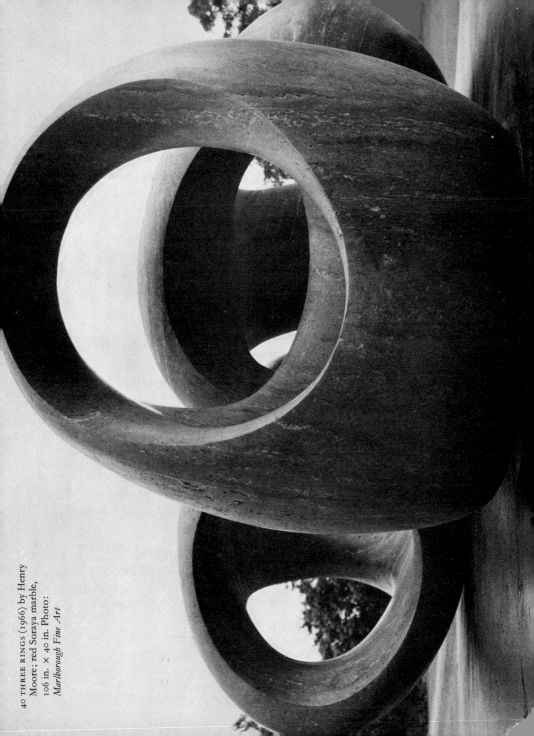

40 THREE RINGS (1966) by Henry Moore; red Soraya marble, 106 in. × 40 in. Photo: *Marlborough Fine Art*

resemble some of Pevsner's when it is under tension—stretched tight and twisted, for example. Then the lines of force tend to become straight like the lines in Pevsner's warped surfaces. In the work of Pevsner we are confronted not with an art of expressive solids but with an expressive art of tensely dynamic surfaces which move rhythmically through space. They exemplify one aspect of the world of three-dimensional form which has little to do with the compact solidity of human bodies. They are more related to such engineering feats as the dynamic vault structures of Gothic architecture and the shells of modern constructional engineers such as Candela and Nervi and to natural sheet-like structures that evolve, twist, or spread in space. They do not directly represent natural objects but they share some of the expressive qualities that are present in leaves, shells, the wings of birds and insects, bones—especially the bones of fishes—flowers, and open seed capsules. 42

Because the appeal to the sense of touch and the traditional solidity of sculpture are sacrificed in most spatial sculpture, some people feel that it is not really 'sculptural'. Such a view is certainly tenable but it puts a somewhat unnecessary limitation on what the concept of sculpture can include. We should be right to regret the loss of solid volume and weight if there were no compensatory extensions of the possibilities of sculpture in this work, but in point of fact the sculpture of Gabo and Pevsner and many other space sculptors appeals to us in ways which are not possible to sculpture with masses. There need be no question of competition. Gabo, in an interesting essay on *Carving and Construction in Space*, writes:

. . . volume still remains one of the fundamental attributes of sculpture, and we still use it in our sculptures as often as the theme demands an expression of solidity.

We are not at all intending to dematerialize a sculptural work, making it non-existent, we are realists, bound to earthly matters, and we do not neglect any of these psychological emotions which belong to the basic group of our perceptions of the world. On the contrary, adding Space perception to the perception of Masses, emphasising it and forming it, we enrich the expression of Mass, making it more essential through the contract between them whereby Mass retains its solidity and Space its extension.[1]

The development of spatial sculpture has kept step with

[1] Quoted in Read and Martin, *Gabo*, p. 168.

developments in modern architecture. In fact many space sculptures look very much like models for architecture. This is the age of space in more senses than one. New materials such as large sheets of toughened glass, steel, reinforced concrete, and plastics, and new habits of living, have given rise to new ways of organizing the space of our human environment. The great modern architects—Frank Lloyd Wright, Le Corbusier, Gropius, Mies van der Rohe—have discovered new ways of manipulating the space of buildings. The rigid distinction between the outside and inside of buildings has become blurred; the garden and landscape have penetrated the building and the building has overflowed into its surroundings. The separating effect of walls has been mitigated by the invention of steel frames and glass curtain walls. We can now see right through buildings; they have lost their opacity and their space has

DEVELOPABLE COLUMN (1942) by Antoine Pevsner; brass and oxidized bronze, 20¾ in. *Museum of Modern Art, New York*

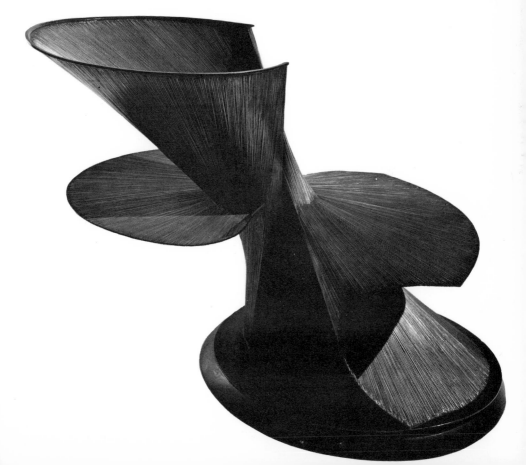

become continuous. They are no longer rooted into the ground, massive and weighty, but float above the ground and are light and buoyant. In addition to all this, new developments in concrete construction associated with the great engineer–architects have made possible the creation of vaults that would have made medieval architects gasp with astonishment. All this is part of a technological revolution which affects engineers, scientists, designers, and artists and is bringing about enormous changes in the space-consciousness of our era. The modern emphasis on the spatial aspects of sculpture is both an effect of and a contributing factor to this revolution.

Another feature of much spatial sculpture which makes it typical of our time is its emphasis on visible structure. This is a very structure-conscious age; we like to show the bones of what we make and to leave it naked and undecorated. We even go so far as to attribute moral qualities such as 'honesty' to things which openly display their structure. In solid sculpture an internal structure may be implied by the features of the surface; in spatial sculptures the structure is often completely revealed so that form and structure are one. They are like the Eiffel Tower, which fascinated and influenced Pevsner when he was a young man.

The appreciation of spatial sculpture demands somewhat different sensibilities from the appreciation of sculpture with masses. But they are not new kinds of sensibility peculiar to spatial sculptors or twentieth-century man. Anyone who can appreciate architecture as a spatial art should find no difficulty in responding to spatial sculpture, although he may find much of it rather dull compared with buildings. And the necessary sensibility is present in anyone who delights in the sheer spatial extension of plants, or who has stood under a tree and been thrilled by the flexible outgrowth into space of its branches, or who has been to a natural history museum and looked through the interior of the skeletons of large mammals and found them exciting as structures in space, or who has enjoyed the delicate translucency of the wings of a dragonfly or a spider's web.

The opening up of the solid forms of sculpture which was accomplished by the Cubists, and the introduction of a primarily spatial kind of sculpture by the Constructivists have together brought about a situation in which modern sculptors feel free to make use of any number of possible approaches to the creation of form in three dimensions. These are so complex

facing page
42 Fishbone. Photo: *E. Webster*

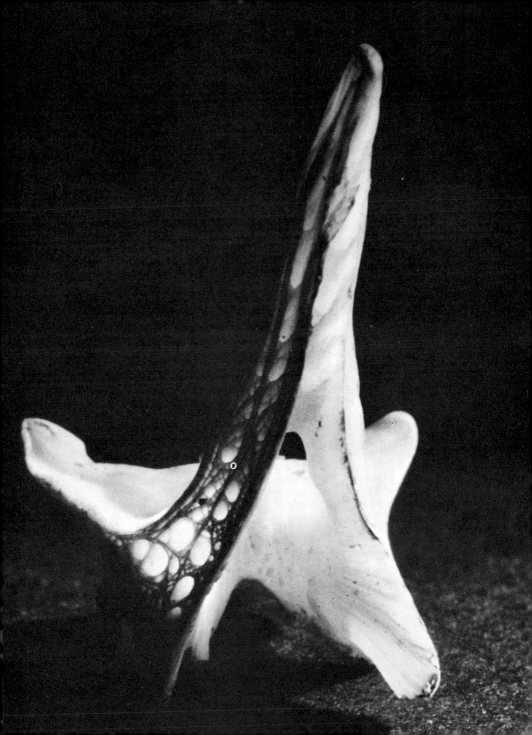

that they defy attempts to classify them thoroughly. It is possible, however, to distinguish five fundamentally different kinds of work:

1. Solid monolithic sculptures that have no internal spaces at all.
2. Sculptures which are basically solid but are hollowed out in varying degrees.
3. Sculptures made up of solid components that are freely arranged in space in an open way so that space enters into the composition as a whole without the individual solids being hollowed out.
4. Sculptures made up of sheet forms.
5. Sculptures made up of linear components, for example wire sculptures, which are a kind of drawing in three-dimensional space.

The development of the last three kinds of sculpture has been closely connected with the development of direct metalwork as a means of producing sculpture. The use of the welding torch in particular has made possible the construction of durable, strong, open, skeletal types of sculpture.

The use of welded iron in sculpture was pioneered by the Spanish sculptor, Julio Gonzalez, in about 1930. Picasso learned the technique from Gonzalez and with his usual inventiveness and extraordinary creative energy produced a large range of work in the medium. The direct working of iron and other metals was subsequently developed, particularly by such American artists as David Smith, Alexander Calder, and Theodore Roszak, until in the 1940s and 1950s its use was so widespread that the period has been referred to as the 'iron age' of modern sculpture.

Iron has been worked directly by hand since the first Iron Age, and the craft of the blacksmith is one of the oldest and most widespread of all the crafts. Some beautiful decorative wrought iron has been produced, and many iron weapons and other implements have a wonderful vigour and strength that comes from the material and the way it is worked by forging with a hammer, but the use of iron as a material for sculpture has been negligible until the twentieth century. As Gonzalez himself said of it:

Centuries ago the Iron Age began, unfortunately, to create arms, among which some were even beautiful. Today it enables us to build

Figs. 46

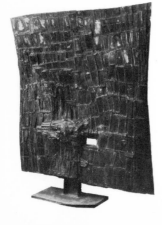

43 LARGE PANEL (1958) by César Baldaccini; welded iron, 98 in. × 69 in. (detail on facing page). The smooth metal plates are fused together by masses of molten metal, showing something of the textural qualities that are possible in the medium. *Tate Gallery*

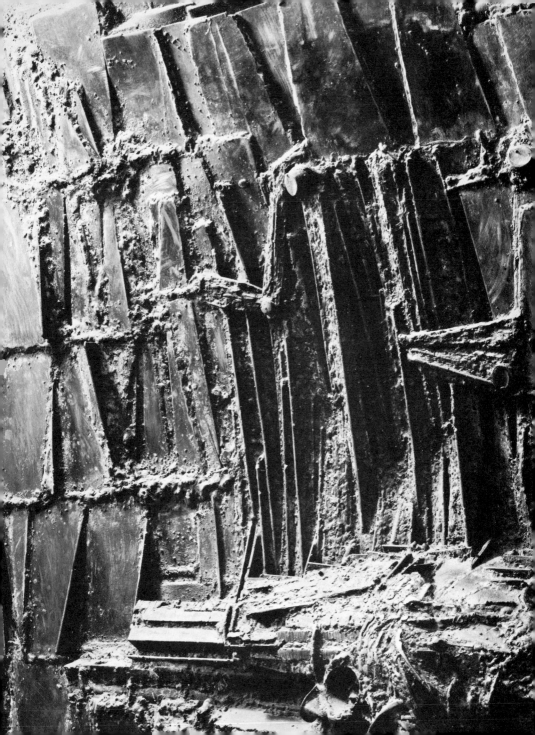

bridges, factories, railways. . . . It is high time that this material stops being murderous or being merely subservient to mechanised science: the gate has now been opened wide so that it may penetrate into the Realm of Art, to be hammered and moulded by the peaceful hand of the artist.[1]

[1] Quoted in Hammacher (ed.), *Gonzalez* (London, 1958).

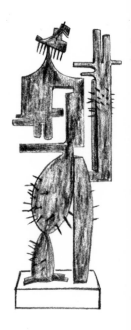

Fig. 45
WOMAN ARRANGING HER
HAIR (1933) by Julio Gonzalez;
iron, 1·68 m.

Fig. 46
CACTUS MAN I (1939) by Julio
Gonzalez; iron, 70 cm.

THE HUMAN FIGURE AS A THEME Most of the world's sculptures do not consist of a single volume but of solid forms comprising a number of volumes joined together to make a sculptural composition, and in the overwhelming majority of cases these compositions are based on the human figure. Next to the human figure the most common subject has been the closely related one of animals. In relief sculpture, for reasons which will concern us in a later chapter, a much wider range of subject matter has been represented than is usual in sculpture in-the-round. In non-figurative sculpture, as the name indicates, there is no directly represented subject matter at all apart from a semblance of organic forms and tensions. As compositions of expressive sculptural forms, however, abstract sculptures may have much in common with figurative sculpture and most of the visual qualities which it is the aim of the present chapter to point out are common to both styles. The main question to which we must now turn our attention is: What is there about the human figure that has made it such an inexhaustible subject for countless generations of sculptors in every part of the world?

In the first place there is, of course, no object in the world that is more important to us as human beings than the human body. We all have a body of our own which is a source of delight, worry, and wretchedness to us, and throughout our lives we are deeply involved as children, lovers, and parents with other bodies. If man is by nature a maker of images, as he appears to be, then it is not surprising that he should make so many of them in the likeness of human beings.

Among most races, well-made, healthy human bodies have been a source of aesthetic delight—although, of course, some peoples have had more opportunity for seeing nude bodies in action than others. Among the Greeks the male human body was a main source of conscious aesthetic pleasure; gymnasia and athletic contests afforded daily opportunities for indulging the delight which educated Greeks took in seeing well-developed bodies in action. Part of the function of dancing in many societies has been to provide the occasion for contemplating well-trained bodies in motion. More obviously, the beauty of the human body as an object of desire has been celebrated

universally in poetry, song, and story. Sexual desire, like the tenderness we feel towards children, can intensify our awareness of the visual qualities of human bodies. In the *Song of Solomon*, for example, the features of the beloved's body are linked by metaphor and simile with a whole range of objects of aesthetic delight.

The relations between sexual desire and the representation of the nude in art are often misunderstood. Some people completely confound their erotic feelings with aesthetic enjoyment; others, anxious to avoid this kind of confusion, claim that the erotic aspects of sculpture or paintings of the nude are irrelevant to their aesthetic enjoyment and should be ignored. The truth, surely, is that when our erotic interest is aroused but immediate satisfaction is withheld we may become more intensely aware on the sensory level of the visual qualities of the human body than we usually are. Certain kinds of feeling, of which sexual attraction is only one and pity, tenderness, and love of a non-erotic kind are others, tend to make us more vividly aware of those sensory qualities of the object of our feelings with which the artist is also concerned, that is, the 'expressive' qualities—sometimes called 'tertiary qualities'— such as lissomness, grace, clumsiness, etc. This subject is a difficult one but it will inevitably arise at some time in the mind of anyone who takes an interest in painting and sculpture. It is certainly too complex to pursue in any detail here and perhaps the best thing to do is to refer the reader to the discussions of the relations between the erotic and the aesthetic aspects of Indian sculpture in the writing of Philip Rawson and to Sir Kenneth Clark's excellent account of the role of the nude in Western art.

Apart from the foregoing reasons for the predominant interest taken in the human figure as a subject for sculpture there are many others connected with the social, political, and religious functions of sculpture. But however powerful such reasons may be, images of the human figure would hardly have proliferated as they have or have achieved such a degree of refinement if the human body had not been intrinsically interesting and powerfully suggestive as a structure of three-dimensional forms. In fact the human body is the most complex and subtle configuration of three-dimensional forms we know of.

We have already mentioned briefly the complexity and subtlety of the component volumes of the figure, their variety

of size, shape, surface features, and sections. We have not yet, however, considered it as a complete structure or directed attention to many of those aspects of its form which are of the greatest importance to sculptors.

The body consists of two main kinds of structure. One, the skeletal substructure, has components that are hard, inflexible, and constant in shape. However much we turn or twist, the shape of the thorax, the relations between the parts of the pelvis, the conformation of the skull, the thickness of the knees, the length of the thigh bones, the distance between the elbow and the wrist, and so on, do not change. Because the bones move as units, they provide fixed relations between points on the surface. For example, the relations between the sacrum, the pubic bone, and the two iliac crests, all of which are easily visible on the surface, are always the same. The larger bone formations—skull, thorax, pelvis—provide some of the main parts of the figure with an underlying bisymmetry which makes their form easier to understand.

The rigid components of the skeleton support the other main structure, which is chiefly made up of muscle and fat. This softer, more fluid part of the figure moves and changes shape when external pressures are brought to bear on it and when any action of the figure brings the muscles into play. The movement of flesh as it tightens and slackens, stretches and crumples, twists, knots, bulges, and relaxes modifies the character and shape of the main volumes; but its variability is always re- Fig. 47 strained by the fixed relationships of the underlying skeleton and the asymmetry that it introduces in the torso is always controlled by the underlying symmetry of the ribs and pelvis.

Each of the main components of the figure is articulated with its neighbours and can be moved in almost any direction, so that the whole system is capable of an unlimited number of different arrangements, or poses. The poses of the figure—seated, reclining, crouching, etc.—are balanced by its own instinctive

Fig. 47

95

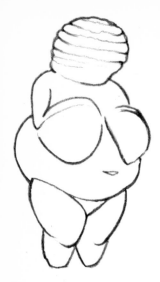

Fig. 48
VENUS OF WILLENDORF,
Austrian, Palaeolithic; stone,
4⅜ in.

adjustments. In standing poses these adjustments are particularly delicate. The weight of the body has to be balanced on the small area of the feet so that even a slight movement in one part of the figure must be compensated for by adjustments of the whole system which give rise to subtle over all changes of rhythm.

The whole surface of the figure is softened and blended by the skin, which follows and creates smooth transitions between all the manifold bumps and hollows of the underlying structures. It stretches over the bony projections and flows gently 45 over the fat and muscle, covering all the diverse surface features that we have noted in a previous chapter—the 'rounded points', hard protuberances, gentle bulges, hard and soft highlines, changes of plane, etc.—and blending them into a unified, complex surface. The complicated underlying structure together with the covering skin creates a surface with great variety and movement and with extremely subtle transitions from one form to another. Anything so complex and subtle may be seen in a number of different ways. Our visual intelligence can extract from it a great many different configurations of three-dimensional forms and surface patterns. This is why the human body offers more scope for invention and artistic expression than any other solid object of which we have experience.

We have so far spoken of the human figure in general, referring only to some of the features that are common to all figures; but of course there are many different kinds of figures and in some respects each individual figure is unique. Consider, for example, the thin, stick-like quality of an adolescent girl like Degas's *Little Dancer aged Fourteen* and compare it with the 44 almost fluid, sagging rotundity of a fat old woman like the *Venus of Willendorf*. Or consider the differences due to age, sex, Fig. and physiological type between a girl such as Maillol might 60 have modelled and an ascetic old man like Rodin's *Saint John the* 95 *Baptist*. In each type of figure a common quality pervades the whole structure. A short, thick-boned, sturdy man has arms, legs, head, torso, hands, feet, and even fingers and toes with certain characteristics in common which impart a unity of character to the whole figure.

The expressive qualities of the forms of each individual figure change considerably with changes of mood. If a person looks alert, tense, sad, relaxed, vigorous, or languorous this is because there have taken place subtle alterations in the quality

facing page
44 THE LITTLE DANCER AGED
FOURTEEN (1880) by Edgar
Degas; bronze with other
materials, 40 in. *Tate Gallery*

96

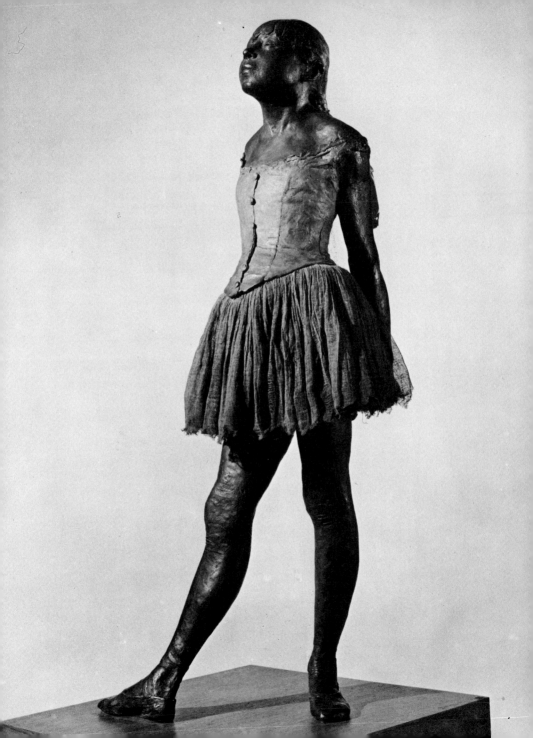

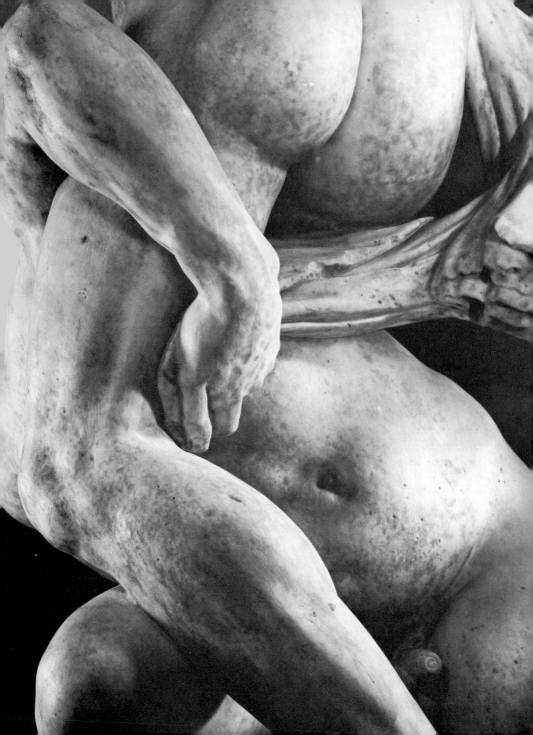

and relationships of the forms whose repercussions pervade a great deal of the structure of the figure. A particularly vivid example of this in sculpture is the tenseness of the figure holding the key in Rodin's *Burghers of Calais*. The tight mouth and jaw, the hands gripping the key and the stiff upright stance all share the same kind of tension. Compare them with the drooping resignation in the forms of the next figure.

From this enormous richness and variety of form sculptors have taken what they need and what interests them. Using the expressive forms of the figure as a point of departure, they have selected, simplified, stressed, and modified different aspects of them and created all the astonishing varieties of figure sculpture that have been and are being produced throughout the world.

SCHEMATA FOR THE HUMAN FIGURE

When we look at a number of Greek, Indian, Egyptian, or African tribal sculptures of the human figure we notice immediately that there is a strong family likeness among all the members of each group. They are not exactly alike but they all appear to have been made to a formula which has been passed on from one generation of sculptors to the next. This is in fact exactly what has happened. In their attempts to find a way of representing the varied, complex, subtle, and mobile flesh-and-bone structure of the human figure sculptors did arrive at formulas.

A formula for constructing representations of a type of object—in this case the human figure—is called a *schema*. There are schemata for both two- and three-dimensional representations. The Egyptian two-dimensional schema for the human figure is well known. It fuses in one presentation a profile view of the head, a front view of the shoulders and a profile view of the hips, legs, and feet. Byzantine painters used a schema for the human head which involved constructing it and relating its features within three circles. Perhaps even more familiar than these examples are the graphic schemata that children develop during what is sometimes called the schematic phase of child art, when they find a formula for representing their concepts of such things as houses, trees, boats, people, and so on. In these two-dimensional schemata the human figure is reduced to a more or less easily drawn configuration of planimetric elements. In schemata for fully three-dimensional sculpture the bewilderingly complex structure of the figure is resolved into a configuration of solid forms which, like those of a Cycladic

Fig. 49

[. 49
tail of a relief carving of sirê, Egyptian; wood

tail of SAMSON AND A ILISTINE (1567) by Giovanni Bologna. *Victoria and Albert seum. Crown Copyright*

Fig. 50
Cycladic Amulet; marble, 5 in.

'violin' figure, may be nothing more than a hardly recognizable *Fig.* sign for the female figure or, like those of a Classical Greek athlete or Aphrodite, may be an elaborate and anatomically accurate translation of the forms of the body into sculptural terms. But at whatever level an artist operates, and whether he inherits, borrows, or invents his own schemata, they are an essential part of his equipment. Without them he would be lost in face of the complexity and flux of appearances.

Whatever the contribution of individual genius may have been to the invention of traditional schemata in past civilizations, once invented they became the common property of all sculptors. In societies that placed little if any value of the self-expression of the individual artist, and in which there were no pressures on artists as there are today to develop a personal style and to invent their own images, a sculptor's conscious aim was to achieve correctness or excellence within the traditional schemata. Once a satisfactory formula for representing the human figure was arrived at, it was passed on from one generation of artists to the next and if it developed at all, it would do so by gradual modifications. The need for these modifications would arise when a sculptor was trying to express something for which the traditional schemata were inadequate.

The schemata for the human figure devised by sculptors living in different times and places vary enormously. This is due partly to the complexity and ambiguity of the forms of the human figure, which make it open to a variety of interpretations, and partly to the widely different purposes for which sculptural representations of the human figure have been made and the diversity of interests, levels of civilization, and expressive needs of the people who made them and of those for whom they were made. Nobody would expect, say, the wood-carvers of Buli living in African tribal society, fifth-century Greek sculptors living in the sophisticated society of Athens, and Buddhist sculptors living in Angkor to have been interested in the same aspects of the human figure or to have sought a similar expressive character in the images they made of it.

Egyptian schemata for the human figure hardly changed over about three thousand years. The Greek schema for the male figure, on the other hand, developed with amazing rapidity considering the ground that was covered. From the Archaic period to the fourth century, Greek sculpture bears witness to a steady increase in the understanding of the structure of the

figure and an ever augmented ability to represent its movements in space, to articulate its main volumes, and to overlay them with minor forms that accurately represent the musculature of the body. This growing naturalism can be traced in representations of the general movement and proportions of the figure as a whole and in the treatment of such features as the hair, the *Fig. 67* features of the face, and the muscles. An additional and in some ways contrasting motive, present particularly in the fifth century, was a tendency to idealization, an attempt to achieve in 30 sculpture an ideal image of man with forms more perfect than those of any actual man. The nature of the sculptural schemata employed by a society is intimately bound up with the whole of its outlook and with its fundamental attitudes and beliefs. It is not difficult to find aspects of Greek philosophy and literature which provide analogies both for the naturalism and for the idealism of Greek sculpture.

The Indian schema for the figure expresses an entirely different outlook and a different basic attitude to life. There is idealization in Indian sculpture as in Greek, but it consists in a perfecting of simplified equivalents for human forms rather 8, 61, 84 than in an attempt to achieve a perfect version of actual human forms. There is clarity, perfect articulation, and carefully controlled proportions in both traditions. In the Indian tradition these are at the service of a transcendental religion for which the sculptor created other-worldly images; in Greek sculpture they serve an almost scientific inquiring spirit and glorify the image of man.

It is perhaps not a coincidence that the most elaborate and highly perfected schemata for the male and female human figure in sculpture were developed by the two most intellectually and artistically influential civilizations that have ever existed— ancient India and ancient Greece. The Indian schemata spread with Buddhism throughout the Indian subcontinent and the Far East, dominating the sculpture of Indonesia and Indo-China and strongly influencing that of China and Japan. Those of the Greeks, spread throughout the Hellenistic world, were taken over by the Romans, forced underground but never quite extinguished during the Middle Ages, and revived during the Renaissance, since when they have dominated the sculpture of Europe almost to the present day and still survive, usually in a degraded form, in certain kinds of public statuary. These highly developed and flexible schemata have seldom been acknow-

ledged for the great achievements that they are. What great schemata like those of the Indians and Greeks can do is to provide a rich conceptual framework which the skill and sensibility of individual artists can invest with the beautiful and expressive forms of particular works of art.

THE IMPORTANCE OF DRAPERY Although Henry Moore has shown considerable interest in drapery and has produced a number of works in which it plays a prominent role, the very mention of this part of the art of sculpture is enough to make many people today—including most young sculptors—yawn with boredom. It seems far removed from anything that contemporary sculptors are interested in doing in their own work and has come to be associated in the minds of a great many people with the dullness of Victorian Revivalism, the trivial decorativeness of neo-Gothic church sculpture, and the fuddyduddyness of roomfuls of plaster casts of the antique. This is a pity, because anyone setting out to learn what to appreciate in sculpture and how will miss a great deal unless he develops some awareness of the qualities of drapery and some understanding of the role it has played in the great works of the past.

The first and most obvious reason why we must take drapery into account is the vast amount of draped sculpture which has been produced. This is not surprising if we bear in mind that the human figure has always been the main subject of sculpture and that in most civilizations people have ordinarily gone about in public clothed. In the north of Europe, in particular, as the great German art historian Wölfflin remarked, 'The real person is the *clothed* person and not the nude person'[1]—a fact which, together with the body-denying tendencies fostered by Christianity, has been of enormous consequence in medieval sculpture.

A second reason for the importance of drapery lies in the indisputable historical fact that almost all the interesting linear forms and patterns in sculpture have been derived from costume and drapery. For while the special character of sculpture is that of an art of three-dimensional solid form, it also makes use of line and pattern and often depends for much of its effect on the interplay of these three types of form. In draped sculpture, in particular, the interplay of volume, line, and area may be extremely complex, varied, and subtle, as we shall see.

[1] *The Sense of Form in Art* (New York, 1958 ed.), p. 60.

A third reason is that in some styles of sculpture, among which the most notable are Gothic and some kinds of Baroque, drapery has frequently been the main instrument of expression, while in other styles, including Greek, its expressive and formal qualities are, to say the least, a visually exciting addition to those of the nude figure and a comparably rich source of sculptural ideas.

Finally, while present-day sculptors may not be interested in actually producing draped sculpture of their own, they may well find in the work of the great masters of drapery a foretaste of some of the abstract expressive forms exploited by much twentieth-century sculpture. It is in the forms of drapery rather than in the forms of the figure itself that European sculptors have felt most free to experiment, and some of the results have been astonishing.

THE STRUCTURE OF DRAPERY We have already spent some time inquiring why it is that the forms of the human body have proved such an inexhaustible theme for sculptors. It is worth inquiring also why the garments with which people clothe the body have until the present century been of similar undying interest and capable of a similar variety of treatment. We may be sure that the forms of drapery would never have absorbed the attention of sculptors so long or been used in so many marvellous works if they had not been inherently fascinating, like the forms of the human figure itself, on account of their structural complexity and variety of expressiveness.

The behaviour of cloth as it stretches over or wraps loosely around the underlying volumes of the figure, is gathered up into tight folds or falls in long, loose drapes, adheres to the surface of the body or flies away from it, is not haphazard, chaotic, and unstructured. There are structural constants in drapery, as there are in the human figure, which may be understood by the sculptor as general principles underlying the variety of detail in particular instances. The construction of all folds is basically identical, and their arrangement follows a number of general laws.

It may be useful to anyone considering sculptural draperies for the first time if, without going into too much detail, we mention some of the general principles which govern the behaviour of draped materials. Without some general notions to guide our attempts to discern order in the complexities of

Fig. 51

Fig. 52

Fig. 53

sculptural draperies we may well find ourselves at a loss amidst their bewildering diversity of detail. Perhaps the best way to acquire most of the basic information that is needed about the behaviour and construction of folds is to perform a few simple experiments with a bath towel, blanket, or length of muslin. This will give some idea of the repertory of forms which is available to the sculptor, and it will do so far better than any attempt to describe them verbally.

The simplest folds are those which, like the folds of curtains, are gathered so that they hang vertically from a series of neigh- *Fig.* bouring points. In costume such folds occur most frequently in skirts or tunics which are belted or gathered at the waist. The folds descend in a series of alternating parallel hollows and 5, 4 rounded prominences which read as highlights and shadows and create a powerful linear effect. When used in sculpture they may be given considerable depth, and even undercut, or they may be treated as shallow fillets or incised lines; they may be 49 rounded like pipes or flat-topped like ribbons or ironed pleats.

Another kind of vertical fold is formed when cloth is suspended from a single point, as it is when lifted in the hand, *Fig.* fastened on a shoulder or hung from a hook. Such folds occur in groups or bunches with one fold superimposed on another, 46 sometimes producing a considerable bulk. They widen as they descend and the edges of the cloth may fall into a series of alternating diagonals which make a decorative zig-zag pattern. 71 Again, depending on the softness and weight of the material, these folds will be more or less flat and pleated or round and tubular in section. They are made use of in Archaic Greek and Romanesque sculpture, where they are linear, flat, and considerably simplified; and they are also used in Gothic and later Greek, where they are treated in a more complex organic manner and are given more volume. They also occur in Oriental sculpture.

When cloth is suspended between two points, its folds naturally tend to fall into catenary curves and to radiate from *Fig.* the points of suspension. A catenary is the curve assumed by 5, 46 anything like a chain (Latin, *catena*) hanging freely between two points of suspension. Owing to the progressive decrease of weight as the curve descends, the degree of curvature increases constantly towards the lowest part. Catenary folds are made up basically of two curved planes which meet at a rounded edge. Curved drapes of this kind, especially a series of them, are

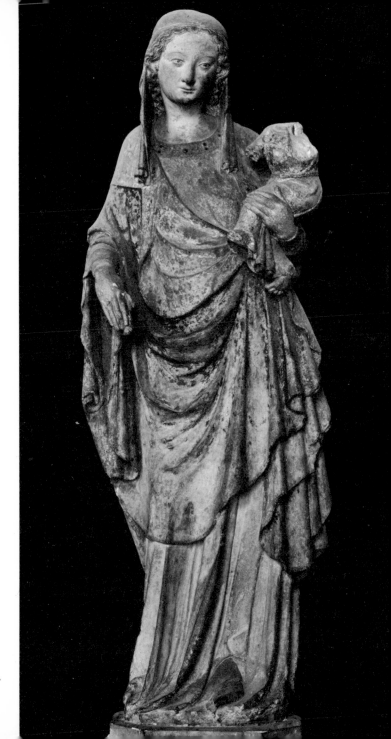

VIRGIN AND CHILD, from La
Celle, early 14th century; stone,
62 in. *Louvre*

among the most attractive of all the forms that drapery has to offer the sculptor and their effects have been widely exploited. The configuration of planes that is generated by a series of descending catenary folds may be extremely beautiful. Gothic sculptors used this effect again and again in their work, and in countless figures of the Virgin, especially in France, the organization of the drapery is based on a contrast between such a series of falling looped folds—sometimes called a Gothic 'cascade'— on one side of the figure and a steadying bunch of long vertical or sweeping folds on the other.

Draperies do not only hang from the figure; they are also sometimes wrapped around it or pulled tightly over it. Just as 48, the form of the skin-covered surface of the body is modified by the outward thrust of rounded muscle and hard bony prominences and is able to relax and wrinkle or stretch tight, so drapery, which can become almost a second skin, may be modified by the hard and soft forms of the body that press against it from inside and can blend them into new shapes. But because drapery is loose and does not fit the body like a skin, it adheres to it only in parts. The total form of a draped figure is therefore a combination of the forms of the human body with the forms of drapery obeying its own laws.

By relaxing and crumpling in hollows and stretching tautly over prominences, drapery can enhance the tension in parts of a sculpture. This effect is particularly noticeable when such outward thrusting parts as the knees, the breasts, the elbows and the shoulders push against the cloth that is over them. Where the cloth is drawn tautly over the prominent parts, there is usually a complete lack of folds and the area is smooth. The folds form at the edges of this prominent area, radiating from it, and focusing attention on it. Where cloth is tightly stretched 48 between two related forms, such as the knees of a seated figure, it tends to form taut lines connecting them; but when there is no tension on the cloth it will either hang in a series of catenary loops or crumple in the space between the forms. The contrasting qualities of the smooth, taut prominences and tense lines of stretched drapery on the one hand and the crumpled confusion or graceful curvature of relaxed drapery on the other were exploited for the first time by the Greeks and have fascinated sculptors down to the present day.

When folds crumple and change direction abruptly, forming an angle rather than a curve, they give rise to a characteristic

movement of surfaces which is focused on what is sometimes called an 'eye' of the fold. This may be roughly described as a dimple on the inside of the fold that raises and narrows the edge, giving the highline along the fold a slight kink. The movement of planes that spreads outwards from the 'eye' of the fold is always basically the same, whatever the nature of the fabric. These little 'eyes' tend to create small pools of shadow 50 and small highlights which punctuate and add sparkle to the abrupt changes of direction of the broken angular folds of a great deal of German Late Gothic drapery.

A working knowledge of such recurrent structural features of drapery was an essential part of the equipment of classical and post-classical Greek sculptors and of European sculptors from the beginning of Gothic to the first part of the present century. The study of this aspect of the art of sculpture is usually called the 'anatomy of drapery'.

These underlying regularities do not in any way make the forms of drapery monotonous. The laws which govern their behaviour are general laws which are manifested in an infinite variety of individual forms. The folds of different kinds of material—wool, cotton, silk, muslin—vary enormously in character if not in their fundamental structure. Moreover, as the folds contact the body and as the body moves, their conformation changes endlessly, modifying the total shapes of the draped figure and yielding an inexhaustible variety of pattern. Human inventiveness, too, has effectively prevented monotony by being more abundant and ingenious in the devising of costume than in almost anything else. The urge to keep the body warm and protected, to make it sexually attractive and socially acceptable, to symbolize status, and to express in some outward form the dignity of office or the gaiety or solemnity of an occasion are some of the powerful motives which have been responsible for the great variety of costumes and the care with which they have been designed. Clothes become an extension of our personalities as they express our attitudes, preoccupations, moods, and ways of life.

But the forms of costume and drapery are expressive not only in this last sense; they also have their own inherent expressive character. They may be soft and rounded or crisp, flat, and angular; they may be light and flutter restlessly or heavy and hang in deep, static folds; they may adhere to the body, revealing its shapes, or fly or fall away from its surface to create shapes

of their own. They may be shallow and delicately shaded or deep and full of dark recesses and highlighted ridges. They may move calmly in the unison of parallels or long curves radiating from a common source, or they may be agitated and broken or turbulent and swirling like flames or cascading water.

Sculptors do not simply copy the forms of drapery, any more than they copy the forms of the body; they translate them into expressive sculptural form and use them to enhance the total effect of their compositions. The uses they make of drapery vary considerably in different kinds of sculpture and even in any single work the drapery may serve a number of different purposes—as decoration, as a means of creating effects of chiaroscuro and movement, as a device for emphasizing or diminishing the impression of volume, and so on. All we can do here is to look at some of the more important qualities and functions of drapery in a few of the main styles of sculpture. Once the reader begins to see drapery in the way I am suggesting, he will no doubt begin to discover for himself other qualities in it and other ways in which it contributes to the effectiveness of the sculpture as a whole.

DRAPERY AND VOLUME Perhaps from the sculptor's point of view the most important thing about drapery is the opportunity it provides for bringing line into his work. One of the greatest contrasts in the realm of visual forms is that between the bulk, weight, and sheer space-filling solidity of fully three-dimensional volumes and the intangible weightlessness and space-traversing mobility of line; and, as one might expect, sculptors have taken full advantage of the expressive and formal possibilities of this contrast.

Line may be introduced into sculpture in a number of ways. We have discussed in another section the way in which solid forms present to vision an infinite series of contours and we have seen how other linear effects are introduced into the volumes themselves by means of edges and highlines. We have also considered the way in which lines come into being where solid forms meet and intersect. These contours, edges, highlines, and intersections are linear features which we see as intrinsic parts or aspects of the volumetric structure of the sculpture. In many works they are the only linear features present. There are other linear features, however, which we do not see as parts or aspects of the volumetric structure but as additions to it. Among these are lines that are painted or drawn on

its surface. Such non-sculptural features do not concern us here. But the linear forms of drapery and costume are additions of a more substantial kind, raised above and recessed into the body of the sculpture. They may be felt with the hand and are visible not because they are of a different colour from the rest of the sculpture but because they are three-dimensional and modulate the light that falls on them. Some of them are superficial and decorative, others are more intimately fused into the whole volumetric structure.

Let us examine first some of the ways in which the linear forms of drapery may be used to enhance or diminish the impression of the three-dimensionality of the volumes they overlie.

Volumes, as we have already noted, have three main sections which are not all equally intelligible to vision from any one point of view. If we view a solid form from the front, its contours give us a good idea of its vertical sections in the frontal plane, but the other two main sections—horizontal and profile —are extended not across our line of vision but in depth, parallel with it, and are thus not fully visible. They have to be assessed and gauged from other clues, the chief of which under normal circumstances derive from the distribution of light and shade on the surfaces of the form. As a surface turns away from a source of light it darkens slowly or quickly according to its degree of curvature. The positions of highlights, deepening and softening shadows, and reflected lights provide us with clues to its movement in depth. In a perfectly even light a volume with a smooth, plain surface will look flat; the contour of its frontal projection will define its extension in the frontal plane but there will be no visual clues to its extension in depth. This fact is illustrated by the impossibility of showing in a drawing by contour alone, without shading, the difference between a flat circle and a sphere.

Another clue to the depth of solid forms may be provided by lines which define their section in depth. The way in which horizontal section lines, in particular, make visible and emphasize volume is perfectly familiar to most women. No woman who is over-weight will wear a horizontally striped dress, because it stresses the fullness of the volumes of her body by drawing attention to their cross-sections. Linear methods of emphasizing and displaying volume are especially useful in the case of outdoor architectural sculpture, which may have to be viewed from a fixed frontal direction and may be flattened by a

strong, even light. The shadow-catching ridges and hollows of drapery are extremely effective for this purpose.

Perhaps the most straightforward use of this perceptual device occurs in Indian sculpture. The jewellery and costumes of Indian figures are stylized in such a way that they make the cross-sections of the figure easily visible from the front and 7, 4 enhance the fullness of its rich convex forms. Bracelets and armlets show up the rotundity of the arms; coronets, tiaras, and fillets encircle the head, extending its volume and stressing its roundness; rows of necklaces emphasize the plane across the top of the shoulders, throw up the circular-sectioned neck, and, like the banding on many pots, ease the transition from the vertical neck to the sloping shoulders; the girdles and sashes bring out the apple-like fullness of the abdomen and the round-ness of the hips and ease the transition from the pelvic volume to the thighs; the fullness of the legs is shown by the stylized horizontal banding of the cloth around them; and even the growth of the ankles from the plane of the instep may be punctuated by encircling anklets.

Lines that describe the horizontal and vertical depth sections of sculpture are not necessarily the ones which create the strongest visual impression of depth from the front view. In fact, viewed from directly in front, these lines would be subject to the same foreshortening as the surfaces they overlie and would appear as straight lines. They would show up the depth of the volumes only when they were to the left or right of, or above or below, the centre of vision; and their capacity to do this would diminish as the distance of the spectator from the sculpture increased. Far more effective are oblique sections and other curved lines which are not true section-lines at all.

The extent and direction of the foreshortened part of the surface which turns away from the spectator into the dimen-sion of depth are revealed more clearly by lines which run obliquely over the surface than by lines which are parallel to the spectator's line of vision. This may be difficult to grasp without illustration. Fig. 54 shows front and side views of a simple volume. The distance from *A* to *B* is as great as that Fig. 5

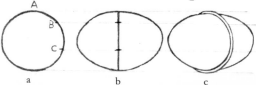

Fig. 54

a b c

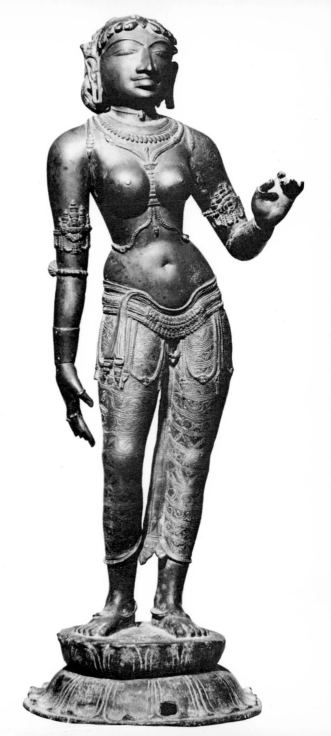

47 CHOLA QUEEN, Indian, 13th or
14th century; bronze, 53·5 cm.
Private Collection, Madras
(photo: *Royal Academy*)

from *B* to *C*, but in frontal projection it appears smaller on account of foreshortening. These foreshortened areas of surface are extremely important wherever we are forced to rely on a single point of view for our impressions of depth, in drawing and relief sculpture as well as in frontally presented sculpture-in-the-round. Their movement and extension in depth must somehow be made more visible from the front. This may be achieved by the use of lines which describe an oblique section and thus present, as it were, a compromise between the frontal and depth planes. As these lines disappear over the edge of the volume they are visible from the front and can be made to suggest the extent of the receding surface. This device is common in Greek sculpture, in which draperies are usually wrapped obliquely round the forms of the figure in such a way that they make the sections in depth visible from the front. Examples may be found in almost every piece of Greek draped sculpture produced after the Archaic period, but perhaps the finest of all occur among the flowing linear forms of the draperies which wrap round the legs of the group of three female figures, commonly known as *The Three Fates*, from the east pediment of the Parthenon. Much more elementary but extremely effective

Fig. 55
Detail of THE THREE FATES

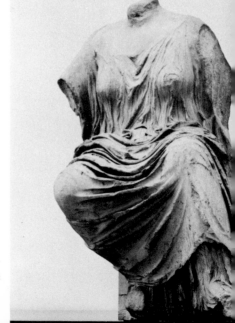

48 THE THREE FATES (*c.* 440 BC), from the east pediment of the Parthenon; marble, H. 1·34 m. *British Museum* (photo: *Hirmer Fotoarchiv München*)

examples may be found in Indian and other Oriental sculpture. The girdles of Khmer stone figures, for instance, are usually tilted forward out of the horizontal. The effect of this in the female figures is to stress the fullness of the hips and of the great bell-shaped skirts that start at the waist. The uncluttered purity of these lines marking the junction of body and skirt is in keeping with the large, uncomplicated but subtle shapes of the volumes. Much of the effectiveness of necklaces and hair-lines as a means of revealing the section of the neck and head also depends on the way in which they are tilted out of the horizontal to become visible from the front.

Lines which follow the sections of the forms are only one of the linear devices used in the drapery of Greek and allied styles of sculpture to make the movement of the surfaces in depth more visually intelligible in the frontal plane. What in principle all these lines achieve is this: their path in three dimensions is such that when they are seen in visual projection—that is, two-dimensionally—they serve a function similar to that of the interior lines used by draughtsmen to explain the movement and changes of direction of surfaces on the two-dimensional picture plane of a drawing. In other words, they 'model' the

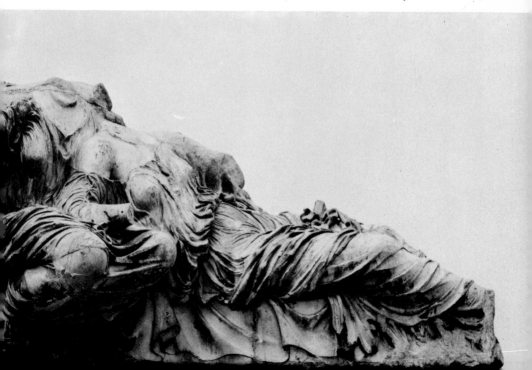

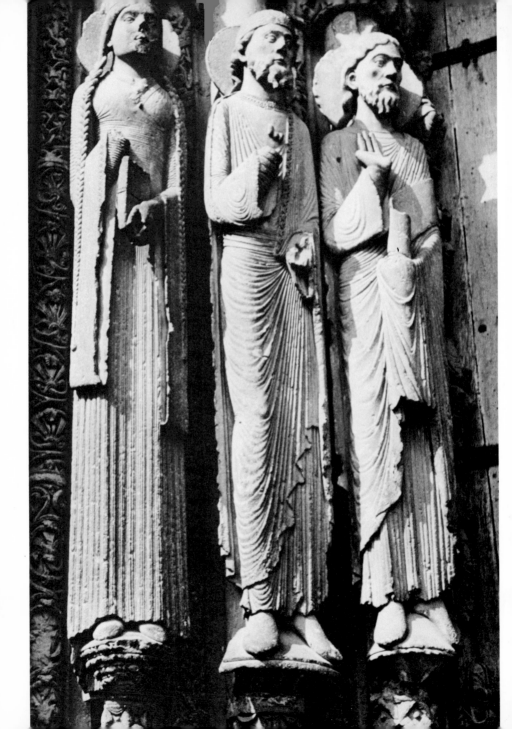

Fig. 56

surfaces, and for this reason they are sometimes called 'model-ling lines'. It may seem odd that the three-dimensionality of three-dimensional forms should need clarifying, but it must be borne in mind that vision does not apprehend frontally pre-sented three-dimensional form directly as such but depends on clues in the two-dimensional projection. If we are able to walk round a sculpture, such clues are not strictly necessary. The work of Greek sculptors, however, was usually intended to be viewed from the front and they use the linear forms of their draperies to provide clear visual clues to its three-dimensional-ity. Their understanding of this process was no doubt assisted by their knowledge of how to render three-dimensional form in line-drawing and relief.

It is typical of Greek civilization as we know it from its other achievements in literature, philosophy, and art that its sculp-tural forms should show a high degree of visual intelligibility. What is especially fascinating about this aspect of Greek sculp-ture is that visual methods of presenting form are used to make the tangibility of the form clearer and more easily apprehended. Our eyes tell us what our hands would like to know.

The role of linear forms in Indian and Greek sculpture is in direct contrast with that of the drapery of many medieval niche and wall sculptures. By reversing the methods of Indian sculp-ture these medieval works play down the features that act as clues to the depth and separate individual existence of the com-ponent volumes of the figure and emphasize those that contri-bute to the unity of the two-dimensional pattern of the front view. Anything that tends to bring out the individual volumes, such as a collar that underlines the section of the neck or a hair-style that sweeps back round the head or a belt that reveals the section of the trunk, tends to be minimized, while anything which stresses movement up and down or across the whole figure or which directs attention along its contours is empha-sized. It is surprising how often in medieval sculpture, if we except the great classical period of the thirteenth century, the suggestion of the continuity of the forms of the drapery round the back of the figure is suppressed and all the movements and counter-movements of line and plane are completely resolved in the front view. Our attention is held to the front view by the arrangement of the folds, which tend to run parallel with the contour or to turn into it and become continuous with it. The most common example of this is the draping of material over

48, 54

Figs. 56 57

49

46, 49

the head in such a way that it destroys all impression of the head as a separate volume and creates lines and planes that run up and down the sides of the face, framing it but never leading 49 our attention away from the frontal plane into depth. The hair 22 of Archaic Greek female figures acts in a similar way, guiding our attention down the side of the face, diverting it from the extension of the head in depth and bringing it back to the contour of the shoulders and the front surfaces of the chest. This characteristic of so many medieval architectural figures helps to integrate the sculpture into the façade of the building; to decorate without destroying the plane of the wall. The general vertical tendency of the folds of the drapery is also no doubt due to a desire to blend the sculpture into the general form of the building.

Generalizations about medieval draperies must not, however, be taken too seriously. What I have said applies to a great deal of medieval statuary, but there are numerous exceptions. Almost every possibility of drapery in sculpture was exploited at some time during the amazingly prolific centuries between the beginning of Romanesque and the end of Late Gothic. The range includes the ecstatic linear style of the Vézelay tympanum, 53 the vertical rigidity of the *Ancestors of Christ* at Chartres, the 49 almost Greek draperies of the great goldsmith Nicholas of Verdun and the Reims *Visitation*, the powerful simplicity of the aristocratic courtly robes of the Master of Naumburg's *Uta* and *Gerburg*, the voluminous richness of the madonnas of the so-called soft style, the heroic massiveness of Sluter's folds, the gentle angularity of Riemenschneider, and the extravagant 50 fantasies of the Master H.L.'s High Altar at Breisach.

In Indian sculpture the figure is usually almost completely nude; the volumes of the body provide the main forms and costumes and jewellery serve mainly to emphasize and decorate them. Medieval figures, on the other hand, are draped almost from head to foot and faces and hands, which are often highly expressive, are the only parts of the body that show. In many medieval carvings we cannot trace any relationship between the body and its garments. There is, of course, a vaguely defined body present in the sculpture, but the sculptors have been more interested in the forms of the drapery for their own sake than 10, 4 in their functional relationship with the body. Many High Romanesque and early Gothic figures give few hints of a body

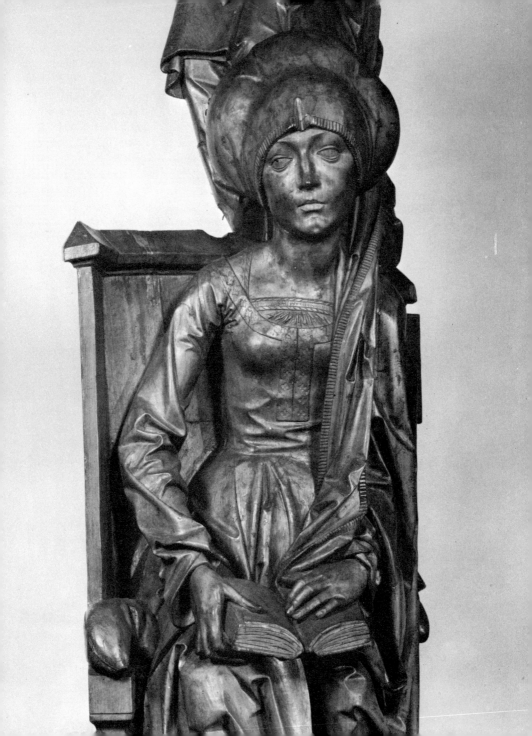

beneath the drapery. The tight columnar shapes and decorative linear draperies of some of the pillar figures at Chartres and the *Solomon* and *Queen of Sheba* from Corbeil owe as much to the architecture for the inspiration of their forms as they do to the human figure and its garments. In a rather different way the voluminous folds of Late Gothic drapery also disregard the underlying shapes of the body and proliferate according to their own laws. In extreme cases the parts of the figure are fused by the drapery into one large volume which, if there were no face and extremities, would be almost unrecognizable as a representation of the human figure.

In Greek sculpture after the Archaic period the relation between the body and the drapery is a balanced one in which neither dominates but each enhances the special qualities of the other. The lines of the drapery emphasize and clarify the solid shapes of the body while the body itself acts as a firm structure to which the draperies are anchored but around which and over which they can play, weaving patterns of their own. The bodies are seldom completely clothed; the folds and bunches of cloth cover them in some places and in others leave them naked. And even where the body is covered by drapery we can usually trace its forms and are constantly made aware of its functional relationship with the forms of the drapery.

This weaving of drapery over and around the forms of the nude figure is one of the most effective inventions of Greek sculpture. A very clear and simple example of this occurs in one of the best known and historically most influential of Greek sculptures, the *Apollo Belvedere*. The gathered folds of his cloak *Fig.* are pinned on the right shoulder, loop round the front of the neck and pass back over the left shoulder to return again to the front at the crook of the arm, where they are draped back once more over the forearm. This serpentine path carries the folds right across the width of the shoulders and along the length of the outstretched arm.

Rather more complex and subtle examples of the play of drapery around the nude forms of the body occur in the *Sepulchral Monument with Ktesileos and Theano*. In this we see *Fig.* clearly how the apparent movement of drapery around the forms of the figure can enhance the impression of three-dimensionality and volume which we derive from a relief. The artist who carved this work was obviously pleased with the effect of the movement of the folds over the shoulders and

Fig. 58
Detail of APOLLO BELVEDERE,
Greek, 2nd century BC; marble

g. 59
etail of SEPULCHRAL
ONUMENT WITH KTESILEOS
ND THEANO, Greek, 370 BC;
arble

round the upper arm, because he has used exactly the same treatment on both figures. The use he makes of the movements of the folds in depth is in direct contrast to the medieval practice of resolving their movements in the frontal plane.

Bernini developed the free movement of draperies around the figure much further than the Greeks, and for this incurred the censure of Sir Joshua Reynolds, who in his 'Tenth Discourse' delivered in 1780 to the students at the Royal Academy said:

The folly of attempting to make stone sport and flutter in the air is so apparent, that it carries with it its own reprehension; and yet to accomplish this seemed to be the great ambition of many modern sculptors, particularly Bernini; his art was so much set in overcoming this difficulty, that he was for ever attempting it, though by that attempt he risked everything that was valuable in the art.

Bernini's *Neptune and Triton* shows to what extent he was 51 prepared even in his early work to weave the drapery around the figure. And who would like to rob the sculpture of the drapery dolphin's head which sports and flutters in the air behind Neptune's left leg? Reynolds, critic as well as artist, is by no means the only one who has sought to impose restrictive legislation on artistic freedom on the authority of abstract principles, in this case even legislating against what had already been successfully achieved. He did not like the Baroque.

Another marvellous invention of the Greeks for making the most of the interplay between body and drapery is the transparency of the so-called 'wet' style. This occurs frequently, in such works as the *Victory of Samothrace* and the exquisite relief of *Victory Undoing Her Sandal*. The effect of transparency is 52 achieved by leaving raised ridges running along the surface of the figure with areas of the nude body showing between them. It is an extraordinarily effective device for getting the compositional advantages of the linear forms of drapery without losing the sensuous surfaces of the female nude.

DRAPERY AND THE Although Ruskin was wrong in believing that draperies 'so far
IMPRESSION OF as they are anything more than necessities' have only two func-
MOVEMENT tions, as 'exponents of motion and of gravitation', he was none the less right in attaching importance to these two functions. For, as he says, draperies 'are the most valuable means of expressing past as well as present motion in the figure, and they

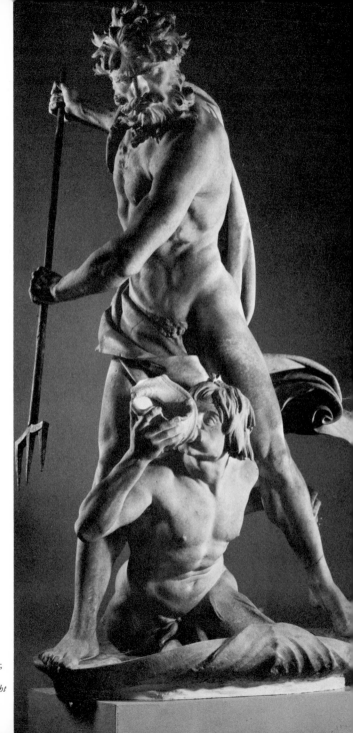

51 NEPTUNE AND A TRITON
(*c.* 1620) by Giovanni Bernini;
marble, 73 in. *Victoria and
Albert Museum. Crown Copyright*

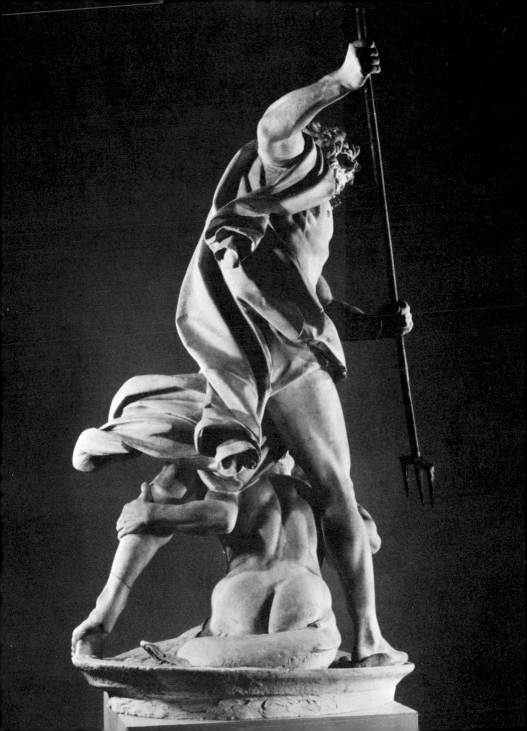

are almost the only means of indicating to the eye the force of gravity which resists such motion'.[1]

How best to represent motion in the visual arts is a problem that has concerned a great many artists, painters as well as sculptors. The most striking manifestations of this in the twentieth century have been the experiments of Duchamp and the Futurists. By 'motion' I mean here, of course, the movements of the figures or animals or other objects which are represented or even movements of a configuration of abstract forms, as these movements are expressed in the sculpture as a whole; I do not mean the internal tensions and 'movements' that exist among the parts of a sculpture. People who have given no special thought to the problem often suppose that a figure or animal will look as though it is in motion if it is so to speak 'frozen' and represented accurately as it is at one moment of time in a continuous process of movement such as running, leaping, or walking. In fact, as many photographic stills prove, it will very probably look paralysed rather than mobile. Obviously some one phase of a continuous action must be represented, but this does not automatically guarantee an impression of movement. In order to give such an impression it is necessary to determine the arrangement and character of the forms so that they *express* movement rather than merely imitate moving things.

Painters and draughtsmen can convey an impression of movement by means of indeterminate outlines and blurred images, but such methods are not open to the sculptor. The boundaries of solid forms may be complex and broken but they cannot be indeterminate or blurred. What the sculptor has to rely on are the axial movement of his forms, the directional qualities of their shapes, and the capacity of line to express motion. In figure sculpture the axial directions of the component volumes of the figure are variable and may be used to give an impression of movement; but, unless considerable distortion of form is permitted within the conventions of a style, the actual shapes of the volumes are much less susceptible of variation. Drapery, however, is extremely variable. Its shapes are modified much more by the forces that act on it, such as gravity or wind, and by the effects of motion than are the shapes of the figure itself. (We must include here that other marvellously variable feature of the human figure, the hair, which is not

facing page
52 VICTORY UNDOING HER SANDAL, from the Temple of Athene Nike on the Acropolis, early 5th century BC; marble, 42 in. *Acropolis Museum, Athens*

[1] *Seven Lamps of Architecture* (1849), Ch. IV, para. II.

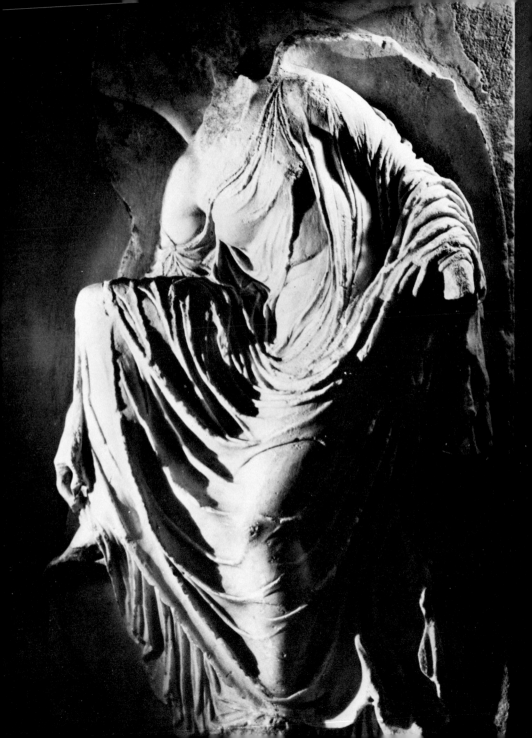

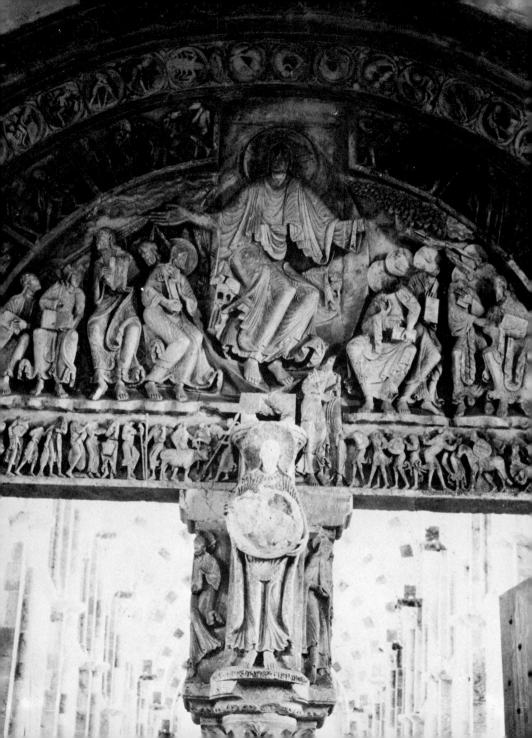

a

b

Fig. 60

unlike drapery in its general behaviour and which has been widely used to such good effect by sculptors.)

The linear forms of drapery are able to convey an impression of movement partly, no doubt, by direct association but also through their own expressive character. As is well known and may be clearly seen in many medieval figures, vertical and horizontal lines in general convey an impression of calm and stillness—so in fact do catenary curves—and they do so in a universal way, as what might be called expressive archetypes, independently of any particular association, even in abstract sculpture. Diagonals, especially converging diagonal lines, again generally speaking, convey an impression of movement. They strive towards a particular direction. But the kind of line which above all imparts the greatest degree of movement to a draped figure is the undulating ogival curve. Its flowing alter- *Fig. 60* nations of convex and concave curvature are the most universal means of expressing motion by line and it is found in all the great traditions of visual art. It was in fact the main device used for this purpose by Greek sculptors and subsequently by Renaissance and post-Renaissance European sculptors. It occurs in the billowing cloaks of Greek horsemen and the wind-whipped garments of the *Victory of Samothrace*, in the gentle undulations of the draperies of the *Victory* from the 54 balustrade of the temple of Athen Nike, in the long folds of the skirts, the trailing ribbons and fluttering hems of Ghiberti's angels, and it produces the effect of a gentle breeze through almost all the reliefs of Agostino.

EXPRESSIVE QUALITIES IN DRAPERY

The range of expressive qualities that may be achieved in drapery is enormous. Here we will consider a few outstanding examples of draped sculpture to illustrate the kinds of expressive qualities it is possible to achieve by this means.

In the well known Burgundian Romanesque tympanum of *The Miracle of Pentecost* at the cathedral of Vézelay the central 53 figure of Christ is covered with garments whose shallow folds *Fig. 61* bear little relation to the actual behaviour of cloth. Their violently conflicting abstract rhythms are entirely linear and made up mainly of whorls, zig-zags, and complex opposed systems of swirling lines. There is no rest for the eye among these

53 THE MIRACLE OF PENTECOST (1125–50), from the narthex of the Church of the Magdalen, Vézelay; stone, H. *c.* 35½ ft. Photo: *Roger Viollet*

lines and although almost every one of them is curved, there is nothing soft or graceful about them. The curves are for the most part short and tight and they focus sharply into points. Their repetition is harsh and mechanical and there is a lack of variation in the individual forms. In conjunction with the unrealistic scale, flatness, elongation, and awkwardly angular pose of the figure the vertiginous dynamism of the draperies creates a feeling of almost delirious visionary excitement. Like nearly every other feature of this great expressionistic work the linear patterns of the drapery contribute to its other-worldliness. Their abstraction is not merely decorative, nor does their interest lie merely in any fascinating but arbitrary play with linear forms for their own sake; their main function is to enhance the expressiveness of the sculptor's portrayal of the awe-inspiring majesty of Christ and the miraculous event of Pentecost; to remove the vision from the ordinary world into another plane of being.

There is a comparable complexity and restlessness in the folds of the drapery of the *Victory Leading a Bull* from the temple 54 of Athene Nike on the Acropolis, but how different it is in spirit and what an entirely different mood it expresses! Here the drapery behaves as we might expect it to. It is functionally related to the forms of the body and its folds are moved from the inside by the body's movement and from the outside by a gentle breeze. They are more irregular than the Vézelay folds and less mechanical, having both the variety and the organic coherence of something natural. Their curves are gentle undulations, they are loose and flowing, their edges flutter. They convey an impression of softness and delicacy and they cling to the body, defining its shapes and enhancing its gentle femininity. Yet for all their apparent fluidity how carefully they have been arranged to model the surfaces of the forms they overlie! The overhanging fold at the waist is tilted downwards so that it defines the section of the abdominal region above the navel; the hips and thighs are modelled by the great wave of folds that sweeps across them and by the curved folds that run down them; the profile of the breasts is defined by the lines that run over them; and the roundness of the arm is emphasized by the folds that pass obliquely round it. Where the Vézelay draperies inspire us with a feeling of the difference between this world and the transcendental mysteries of medieval Christianity, those of the Greek figure stress what is lovely

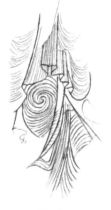

Fig. 61

facing page
54 VICTORY LEADING A BULL
from the Temple of Athene
Nike on the Acropolis, early
5th century BC; marble, 42 in.
Acropolis Museum, Athens
(photo: *Hirmer Fotoarchiv
München*)

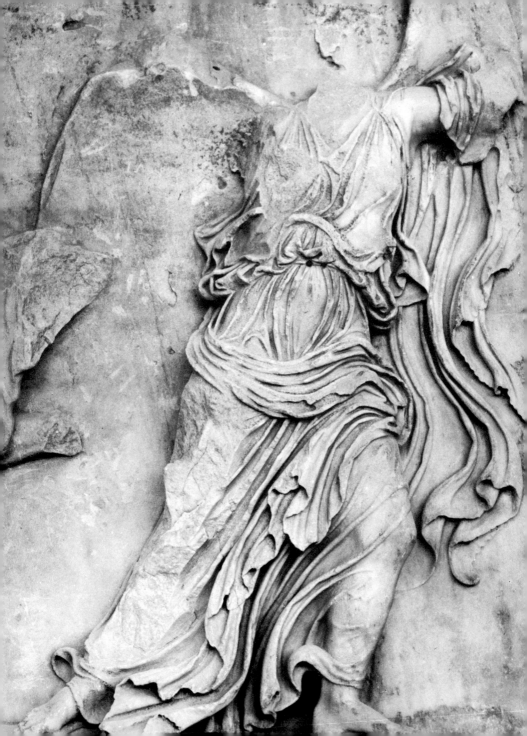

in the human body and envelop it in an atmosphere of lyrical softness.

The mood of harshness and conflict is in fact almost entirely absent from Greek sculpture. The prevailing character of Greek drapery, even in compositions depicting struggles, such as the *Battle of the Lapiths and Centaurs* from the pediment of Olympia or the *Battle of the Gods and Giants* in the Great Frieze of the Pergamum Altar, is one of harmony. Like the highly organized and rather bland musculature of the Greek male figure, the graceful, harmonious curves of Greek drapery are ill suited to the expression of conflict and struggle. They are never harsh, angular, or fragmented. Their folds fall into graceful catenary curves or flutter into lyrical ogival curves or are organized into harmonious parallel groups or groups that radiate from a common centre.

The small boxwood carving of the *Virgin and Child* by the 55 German sculptor Veit Stoss is less than nine inches high, but its draperies are treated with remarkable boldness and energy. The wild and broken forms of the cloak conflict strangely with the serene expression of the Virgin's face and the graceful curve of her pose. The contribution that the folds make is not primarily a linear one. The outer garment is separated from the body and shaped into curved sheet forms that contain deep, shadow-catching recesses and numerous broken planes. The turbulence of the right side of the cloak is countered by the long continuous curve of the left side—a curve that sweeps from the left shoulder down the full length of the figure and across the feet to the opposite corner of the base. This is in fact a variation on the favourite French Gothic method of treating the Virgin's draperies by opposing a long sweeping fold and a so-called 46 Gothic 'cascade'. The agitation of these draperies is different in quality from that of both previous examples. The serpentine path of the edge of the cloak and the rich twisting and buckling of the planes seem to be a product of sheer exuberant artistry, the cadenza of a virtuoso wood-carver.

While Veit Stoss appears to have enjoyed the play of draperies for its own sake, creating complex rhythms which in the case of the small *Virgin and Child* seem to have little to do with the subject of the carving, Bernini, in his amazing *Ecstasy of Saint Teresa*, 74 has used the expressive forms of the drapery to reflect and intensify the psychological content of the work. The heavy, fragmented shapes of Saint Teresa's garment completely dis-

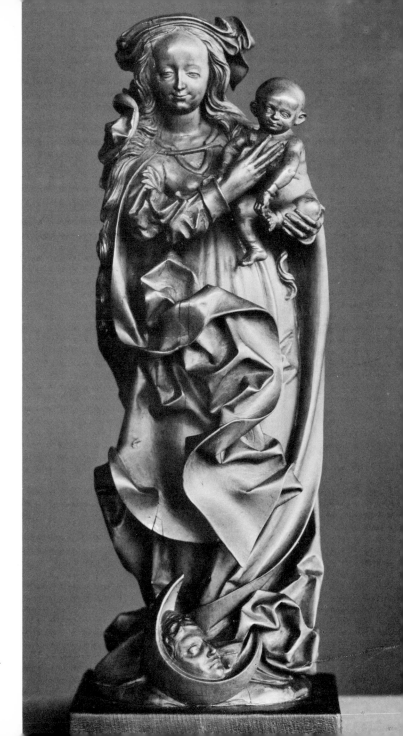

VIRGIN AND CHILD (c. 1505)
by Veit Stoss; boxwood, 8½ in.
Victoria and Albert Museum.
Crown Copyright

a

b

Fig. 62

solve the volumes of her body and their weight seems to bear down on her swooning figure. There is no coherent sequence of lines that we can follow in the folds. In fact line counts for little in them; they strike us mainly as a collection of irregular painterly patches of light and shade, whose extreme complexity defies our attempts to see and cling to any particular configuration. There is no rest in the work, but its surfaces are so incoherent and its outline so broken that we are more aware of a shifting over-all visual impression than of any clearly organized relationship of parts. A similar complexity and scale runs through the whole composition but the dynamic, flame-like folds of the angel's garment are quite different in character from those of the saint. They envelop and seem to lick around his body so that, in the words of Saint Teresa herself, he seemed 'to be all on fire'. The expressive qualities of the draperies of the two figures reflect their different roles in the drama and enhance the emotional intensity of the whole composition.

When we look at sculpture from the point of view of its composition, it soon becomes obvious that its component forms may be related to each other spatially in a variety of ways and that these arrangements have different expressive characters. Nobody can fail to receive some kind of an impression of the tightly packed immobility of Egyptian sculpture, the subtly 32 balanced movements of a Polyclitan athlete, the almost explosive compression of some of Michelangelo's compositions, the 78 tortuousness of Giovanni da Bologna's, and the openness and 63 spatial freedom of Henry Moore's. But there is a world of 27 difference between receiving a vague, generalized impression of a certain expressive quality in the composition of sculpture and fully apprehending the way in which the sculptor has disposed all the parts of his work in relation to each other. In the world's great sculpture these arrangements are not mere renderings in stone, wood, or bronze of poses of the human figure, frozen moments in the lives of actual moving bodies. They may be this to a certain extent, but they are primarily carefully considered compositions of solids, interpretations or paraphrases of the expressive forms of the human figure in the language of sculpture, and they are governed by rules and principles that belong to the art of sculpture, not to the science of anatomy.

Different ages and different sculptors have for various reasons organized the forms of their sculpture in different ways. The reasons for these differences offer a field of speculation for historians and critics who are interested in sociological and psychological explanations of works of art, but are not germane to our present purpose. A grasp of some of the principles that govern the main kinds of composition is, however, essential for the appreciation of sculpture as an art. My aim is not to provide a catalogue of different kinds of sculptural composition but to outline a few basic principles and to give some idea of what may be seen if we know how to look at sculpture from this point of view.

In a great work of sculpture, as in other great works of art, all the parts contribute to the total composition; even the direction of a finger and toe or the curve of an eyebrow is not arbitrary. The apprehension of such compositions is a process in

Lorenzo de Medici

Giuliano de Medici

Fig. 63
Details of the Medici tombs
(1524–34) in the Medici Chapel,
Florence, by Michelangelo;
marble

which an initially general and vague impression of the whole composition becomes progressively sharper and clearer as we become aware of more and more detail in the context of the whole.

The best approach to an understanding of this important aspect of the expressive form of sculpture is through consideration of some of the main kinds of composition that are to be found in figure sculpture. The main advantages of figure sculpture for this purpose are that we are all familiar to some extent with the three-dimensional structure of the figure and that all its parts have names by which we can conveniently refer to them. But most of what we see in figure sculpture and many of the principles we discover underlying its spatial organization may also be found in abstract and in animal sculpture.

There are two key concepts which are extremely helpful in enabling us to distinguish different kinds of composition and to grasp the principles of their organization. These are the concepts of an *axis* and a *plane of reference*. They help to make the complicated relations between the forms visually intelligible and are indispensable for the description and discussion of sculpture.

AXES

Any symmetrical or near-symmetrical volume has one or more axes. These may roughly be described as imaginary centre lines to which all parts of the volume may be related. All the main volumes of the human figure are sufficiently symmetrical to have easily envisaged axes.

Each volume of a sculptural composition enters into axial relations with the others and it is by reference to the direction of their axes that we are able to define the relative directions of the volumes. Consider, for example, some of the axial relations that may hold between the head and the neck, that is between a roughly egg-shaped and a roughly cylindrical volume. One of the most important decisions a portrait sculptor has to make concerns the relations between the axes of these two volumes. Nothing conveys so powerfully the mood of a figure as the set of the head upon the neck, and from all possible arrangements the sculptor has to choose the one that is most expressive of the character he wishes to represent. The mood of most of Michelangelo's figures depends considerably on the set of their heads. Compare, for example, the *Lorenzo* and *Giuliano* and the four Fig. reclining figures of the Medici Tombs, the Bruges Madonna 78, and the Madonna of the *Pietà* of 1501, and the *David* and *Moses*. 31,

132

a

b

Fig. 64

The concept of an axis applies not only to single volumes but also to symmetrical or near-symmetrical groups of volumes. The human figure, particularly when standing upright, is a fundamentally bisymmetrical system of volumes with an over-all vertical axis. Many of the most frequently recurring poses of the human figure in sculpture may be conveniently apprehended and described by reference to this axis.

The movements of the volumes of the figure that may be thought of and perceived in relation to the vertical axis are of two kinds. First they may *tilt* out of the vertical in any direction _Fig. 64a_ that is anatomically possible and secondly, again within the limits of anatomical possibility, they may *rotate* around the _Fig. 64b_ axis. These two kinds of movement, singly or in combination, may be organized by the sculptor in various ways to create different balanced arrangements of volumes. The spatial dispositions of the main volumes of the figure may be fused into an over-all rhythmic movement which is a continuous one running right through the figure, or they may be set off against each other to make a composition that depends for its effect on a balanced alternation of contrasting directions. Before we can discuss the composition of figure sculpture in any greater detail, however, we must explain the role of the plane of reference.

PLANES OF REFERENCE Planes of reference are imaginary planes to which the position, _Fig. 65_ direction, and movement of the axes and surfaces of the forms of sculpture (or any other three-dimensional object) may be related. The three principal planes of reference, the use of which is deeply rooted in our psycho-physiological habits of perception, are the *frontal*, *horizontal*, and *profile* planes. These mutually perpendicular planes provide a complete spatial frame of reference for the forms of sculpture. They assist the spectator in visually distinguishing different kinds of spatial composition and may be a great help to sculptors in the conceiving, planning, and execution of their work. Like the vertical and horizontal axes they provide fixed positions and directions from which other positions and directions are regarded as deviations and against which movement may be measured.

The use of these planes of reference by the sculptor produces two main kinds of effect on the finished work. It is important to distinguish these since failure to do so often results in a faulty appraisal of the qualities of the sculpture. One kind of effect is on the *shape* of the component solids themselves; the other is

Fig. 65

on their *arrangement* or composition, that is on the way in which they are organized in relation to each other in space. This distinction will become clearer as we discuss examples.

In some sculptures, such as those representing reclining figures or animals, the horizontal plane of reference plays an important role; but in most sculpture it is the vertical frontal and profile planes that control the composition. And of these vertical planes the two most important are the frontal and profile median planes which pass through the centre of the upright Fig figure and whose line of intersection forms its vertical axis.

FRONTALITY In numerous free-standing figure sculptures from Egypt, Sumer, Archaic Greece, Mexico, and the ancient Far East all the main volumes are grouped along a vertical axis and face in the same direction. It is doubtful whether the lack of movement in these figures can be entirely attributed to the sculptor's inability to surmount the technical difficulties of carving figures in movement. It is possible that these archaic civilizations had a special need for the qualities of immobility in their statuary. There is no doubt, however, that such axial rigidity and frontality arise as a natural solution to the difficulties of planning and carving large-scale stone statues, especially at an early stage of technological development. It is perhaps not easy for somebody who has not tried to carve a complex sculpture to realize how apt one is to become 'lost' in a block of stone. To keep all the proportions, directions, and shapes of a moving figure constantly in mind is extremely difficult.

We know that in the planning and execution of their sculpture the Egyptians—to choose the earliest and most extreme example—made use of a procedure which is closely related to what we now call orthographic projection,[1] and that they arranged the parts of the figure to conform readily to this procedure. The main reason why orthographic projection was used by the Egyptians and is now the accepted graphic language of all constructional trades is that it provides a 'true', that is an unforeshortened, representation of the dimensions and shapes of three-dimensional objects.

[1] 'Orthographic projection is the method of representing the exact shape of an object in two or more views on planes generally at right angles to each other, by extending perpendiculars from the object to the planes'. French & Vierck, *Graphic Science* (New York, 1958), p. 78. The term 'orthogonal' (right-angled) is sometimes used in place of 'orthographic'.

Fig. 66

The direction and number of the views of an object required for a complete graphic description of its shape and dimensions vary with the complexity of the object, but those most commonly used are the front, side, and plan views. In orthographic projection these views are projected on the frontal, profile, and horizontal planes of reference, which may be thought of as the faces of a box containing the object. It will be readily seen that the four cardinal views of the figure—left side, right side, back and front—may be projected onto the four vertical faces of a rectangular stone block thought of as containing the figure. It will also be readily seen that by cutting *Fig. 66* away the stone around these outlines right through the block the sculptor can 'block out' the main shapes of the figure. Such a procedure enables him to remain in constant and complete control of the measurements, proportions, and spatial arrangement of the main volumes of the figure. But in order to use this procedure and to keep this control he has to forgo a great deal of movement, as we shall now see.

All material objects may be measured and defined by three spatial dimensions: height, width, and depth. The true (that is, not foreshortened) measurements of the main parts of the figure in these three dimensions can be drawn in frontal and profile projection only if the axes and main surfaces of the forms are in planes parallel to the planes of projection, that is, to the faces of the block on which the outlines are drawn. In order to preserve this parallelism the movement of the volumes of the figure has to be severely restricted and any tilting of axes or inclination of surfaces has to take place in one of the two main planes. Similarly any rotation of the forms about their axes must be a 90° rotation. Almost without exception the main volumes of Egyptian statues are arranged so that their axes are either in the profile or in the frontal planes. (The 90° rotation occurs in 68 relief sculpture and in drawing.) *Fig. 49*

The human figure is far too complex for all its forms to be represented in their true shape and size by only four views. A full orthographic drawing of the figure in modern terms would require an enormous number of auxiliary drawings showing oblique views, plan views, and sections. The method used by the Egyptians leads only to a blocked-out cubic version of the main volumes of the figure. How the sculptor develops his work from this point and how he varies this basic procedure in order to introduce a limited amount of movement depends

largely on what he knows of the structure of the figure. Having approached his carving in the first instance by means of two-dimensional projective views, he may subsequently develop it into a composition of fully three-dimensional volumes conceived and executed in the round. The use of projective views, as I have pointed out in a previous chapter, does not necessarily imply that the sculptor cannot think of the figure as a structure of volumes in the round. It may be merely a technical device for arriving at the first stages of a carving. Egyptian sculptures are limited in their movement in space but some of them are among the most satisfying of all sculptures in the fully three-dimensional realization of the volumetric structure of the 56, human figure and in the subtle modelling of its surface forms.

It is sometimes said that Egyptian sculpture is fundamentally two-dimensional because it is controlled by the vertical axis and the frontal and profile planes. Nothing could be further from the truth. Such a mistaken view shows how necessary it is in appreciation to divorce a consideration of the spatial organization and movement of the forms of sculpture from a consideration of the qualities of the forms themselves and of their structural relations. Egyptian sculpture, like many other archaic frontal types of sculpture, offers little to be enjoyed in its spatial composition beyond a peculiarly fascinating and haunting stillness. But the forbidding rigidity and monotonous poses should not distract us from the almost contradictory warmth and subtlety of modelling and the delicate sensibility to the inner structure of the figure that it so often displays. (It is possible for the reverse situation to exist, where a great deal of interesting movement and sophisticated spatial organization has been devoted to sculpture whose volumetric structure is negligible and whose surface modelling is completely lacking in plastic subtlety.)

An interesting exercise in the appreciation of Egyptian sculpture is to look at a number of works with the attempt to see to what extent the shapes and spatial arrangement of their main component solids display characteristics derived from the technique of carving by means of projective views and how far the sculptor has been able to develop his work beyond this blocked-out preliminary stage towards a fully three-dimensional composition.

Some sculptures that lack axial movement and are blocked out by means of projective views do not transcend the limita-

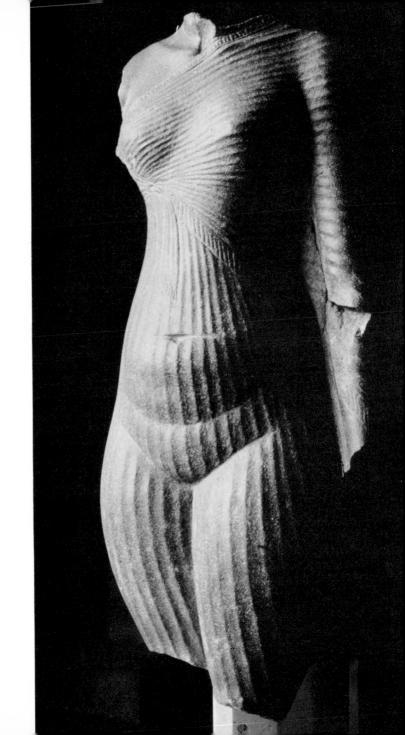

TORSO OF AN ARMANAN
PRINCESS (Nefertiti?),
Egyptian, 1375–50 BC; red
quartzite, 11·5 cm. *Louvre*

Fig. 67
KOUROS, Greek, *c.* 600 BC;
marble, 6 ft. 6 in.

tions of the method by developing into compositions of fully three-dimensional forms but remain fundamentally two-dimensional. This is true of some of the least appealing ancient sculptures and is very noticeable in Archaic Greek Kouroi (nude male figures). These are almost completely lacking in any *Fig.* volumetric structure and their surface forms, instead of being modelled, are merely drawn by incising the surface. There is little invitation in these works to pass beyond the surface. We are presented simply with an area of surface defined by a more or less attractive and vital outline and decorated with linear patterns. A comparison of the heads and torsos of these Archaic Greek male figures with those of Egyptian figures should show clearly what their limitations are. Rhys Carpenter's severe but justified comment is very pertinent:

the ready response which archaic sculpture evokes from the modern admirer may betoken a (more) serious defect in his powers of sculptural appreciation. For sculpture, in its true and proper right, is the visual art of *solid* form; it is precisely here that archaic representation is lacking. Its schematic devices are planimetric projections of the visual field; and the visual field is the *painter's* province. It may well be this pictorial aspect of archaism which makes it so easily intelligible; and the opinion may accordingly be hazarded that a marked preference for archaic over more mature sculptural production is not the best warrant of sculptural sensibility in the beholder.[1]

Yet although these serene Archaic Greek sculptures do not reach the highest peak of the art of sculpture, they have a quiet beauty of their own to which Rhys Carpenter is certainly not insensitive and which tends to disarm even the sternest critics.

The immobility of these early works did not satisfy Greek sculptors for long and the development of Greek sculpture took a different course from that of Egyptian, if Egyptian sculpture can be said to have developed at all. Instead of merely acquiring a more subtly articulated structure of volumes and minor forms within the framework of the rigid archaic poses, it simultaneously developed also a greater freedom of axial movement and escaped the domination of the vertical planes. The main drive of Greek sculpture was towards a greater understanding of the anatomical structure and movement of the actual human body and it became progressively more naturalistic.

facing page
57 Fragment of a colossal statue of
Rameses II (Ozymandias),
Egyptian, *c.* 1250 BC; granite.
British Museum (photo: *Edwin
Smith*)

[1] Rhys Carpenter, *Greek Sculpture* (Chicago, 1960), p. 57.

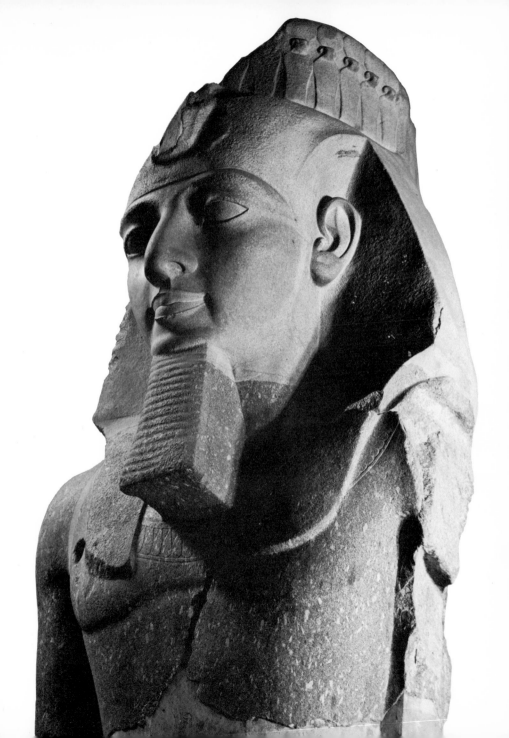

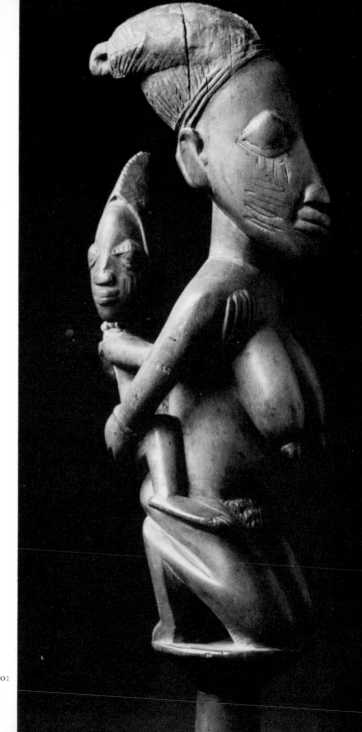

58 OSHE SHANGO, African
(Yoruba); wood, $16\frac{1}{2}$ in.
D'Harnoncourt Collection (photo:
Herbert List)

An example of a recent sculpture which shares the limitations of Archaic Greek figures is the large torso, *Mankind*, by Eric Gill. Its linear qualities and silhouettes are very carefully considered but it is almost completely lacking in any inner structure. Its form is almost entirely a result of the intersection of the front and profile views. Big and impressive and, in its limited way, lovely as it is, it offers little to be enjoyed through our specifically sculptural sensibilities.

There is no sculpture in the world conceived more fully in the round or that reveals more imaginative fertility in the invention of three-dimensional form than African wood-carving. Yet in the overwhelming majority of cases its composition is dominated by a vertical axis derived from the axis of the cylin- 59 drical trunk from which it was carved, and with a few notable exceptions it is completely frontal. Yet although its volumes do not turn on their axes or tilt laterally, the severity of their arrangement is often mitigated by a considerable tilting in 23, 58 depth—a feature which shows up most clearly in photographs taken from the side view, although it is plain enough from any view of the sculptures themselves.

The impression of intense vitality which we get from African figure carvings cannot be ascribed to any single feature or aspect, but it is partly due to the fact that the sculpture as a whole is designed in the round in such a way that its volumetric structure may be easily apprehended; we are constantly aware of its three-dimensionality and our attention is not arrested by the contours and silhouette of the frontal projection. I do not mean by this that we feel impelled to walk round the sculpture, but that we are aware even from the front view of the full three-dimensional existence of its component volumes. This effect is achieved in several ways: by inclining the volumes in depth, giving rise to backward sloping planes across the thighs, the top of the skull, the shoulders, the underside of the abdomen, and the breasts; by creating clear, sharp lines in the horizontal or near-horizontal plane where one volume meets another— round the top and base of the neck where it meets the plane of the underneath of the head and the top surface of the shoulders, round the hips where the legs join the body, or round the knee and ankle joints; by making the thickness of the volumes equal to or greater than their width; by the use of linear decoration derived from neck-rings, armlets, scarification marks, head-dresses, and so on, which make the spectator aware of the

sections of the volumes; and by opening up the sculpture and freeing the arms and legs so that they can be seen in their 'air-surrounded entirety'. In Archaic Greek sculpture on the contrary there is usually nothing to lead the spectator's attention away from the linear and areal shapes of the projective view towards an awareness of the figure's extension in depth. The front view is complete in itself and our attention is drawn *along* 22 the contour and *across* the surface but not *around* the volumes.

African sculpture is the clearest example of the way in which the control of the four principal planes of reference over the spatial arrangement of the component volumes of a sculpture may be accompanied by a lack of control over their shapes. The shapes of the volumes are related to their own axes and inner structure and hardly at all to the planes of reference. This is largely due, no doubt, to the fact that a cylindrical branch or tree trunk does not present four sides which coincide with the four main planes of reference as do the faces of a stone block. A cylinder has a vertical axis but no faces.

AXIAL MOVEMENT Movement of the sculptured figure away from a rigid verticality may be achieved without disturbing its frontal composition by tilting its volumes laterally without rotating them about their axes. This kind of movement gives rise to one of the most common of all sculptural poses. It is most clearly exploited in Indian sculpture and in the sculptures based on the highly influential work of the great fifth-century Greek sculptor, Polyclitus. In this pose the weight of the figure is placed on one leg, thus tilting the pelvis sideways and causing one hip to be thrust out. This calls for a counter-balancing movement in the upper part of the figure, in which the thorax and shoulders tilt in the opposite direction to the hips. From the front and the back the contours of a figure in such a position give a set of contrasting rhythmic curves, one side long and relaxed, the other broken and more forceful. This gentle and subtle axial movement, in which the controlling influence of the vertical axis is still present but loosened, has been a great favourite with classicizing sculptors, who have returned to it again and again. Maillol, whose 60 main interest was in the volumetric aspects of sculpture, found the opportunities it presents for creating a delicate counter-balance of perfectly proportioned volumes and rhythmically related contours still worth pursuing in the twentieth century and still capable of new interpretations. To work on such a set

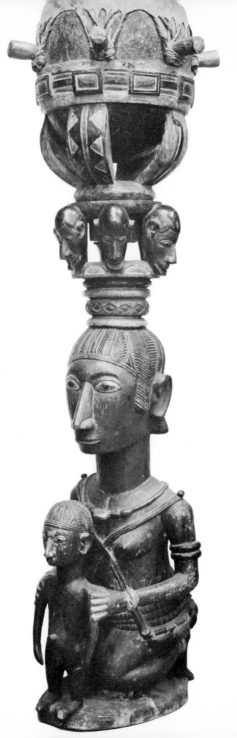

59 Drum, African (Baga); wood,
44½ in. *British Museum*

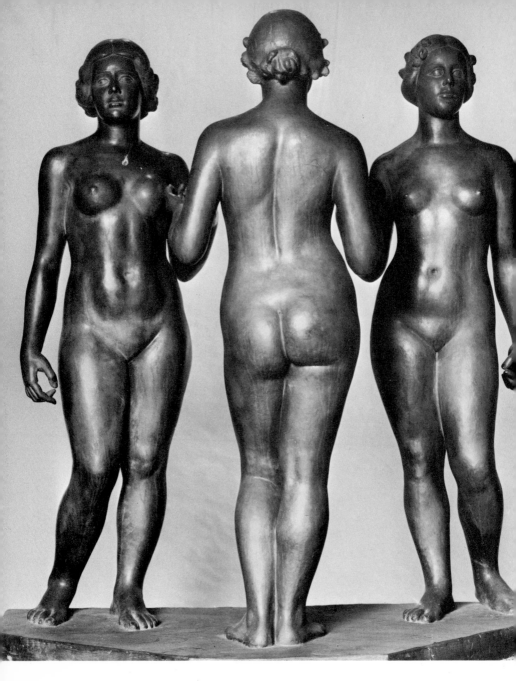

60 THE THREE NYMPHS (1936–8) by Aristide Maillol; lead, 63 in. *Tate Gallery*

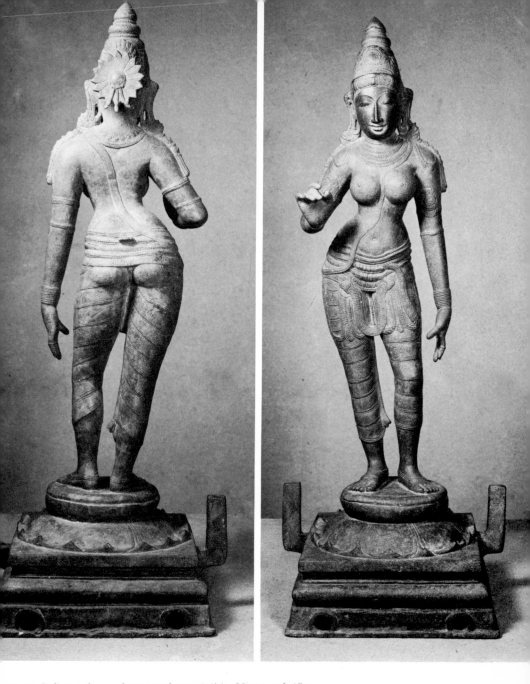

PARVATI, Indian, 12th or 13th century; bronze, 26½ in. *Victoria and Albert Museum. Royal Collection*

problem is like writing a poem in a tightly controlled form such as a sonnet or a sestina.

Sculptures which are variations on a similar compositional theme can teach us a great deal about the art of sculpture. To compare half a dozen Indian bronzes which are identical in pose and to see how even within the severe limitations of Indian iconography and iconometry it is possible for one sculptor to achieve such different visual effects from another, or to compare two entirely different variations on the same theme such as *The Three Nymphs* of Maillol and the Indian bronze *Parvati*, makes one more keenly aware of the subtlety of the range of formal and expressive qualities that are at the sculptor's disposal.

Another entirely different range of formal and expressive qualities is made possible by rotating the volumes of the sculptured figure around the vertical axis. Starting at the feet and moving up through the knees, the hips, the thorax, the shoulders, and the head, it is possible to turn the figure in a continuous, gentle, screw-like movement. Alternatively the lower and upper halves of the figure may be turned in opposing directions, a movement which was favoured by High Renaissance sculptors, particularly Michelangelo, and is generally known by the Italian term *contrapposto*. The tension between the 62 opposing directions of forms in *contrapposto* creates a feeling of strain, a restlessness or lack of repose. It was one of the main expressive instruments in the style of Michelangelo and is partly responsible for the feeling of interior conflict that is present in so much of his work.

When the torsion or rotation of the forms of the figure and their horizontal displacement, or tilting, are combined, it is possible to construct figures with volumes, surfaces, and contours whose directions vary from all points of view. The notion of a plane of reference then becomes completely inapplicable. Such freedom of movement was characteristic of many late Greek works which developed the experiments in axial rotation of the third-century school of Lysippus, but it is most highly developed in the Mannerist sculpture of sixteenth-century Italy. The Mannerist sculptors, reacting against the Renaissance preference for works which were intended to have one principal aspect and a limited number of secondary aspects, used bodily movement to create sculptures which were intended to be viewed from all directions. While Renaissance sculptors, as has been said, usually avoided compositional devices that

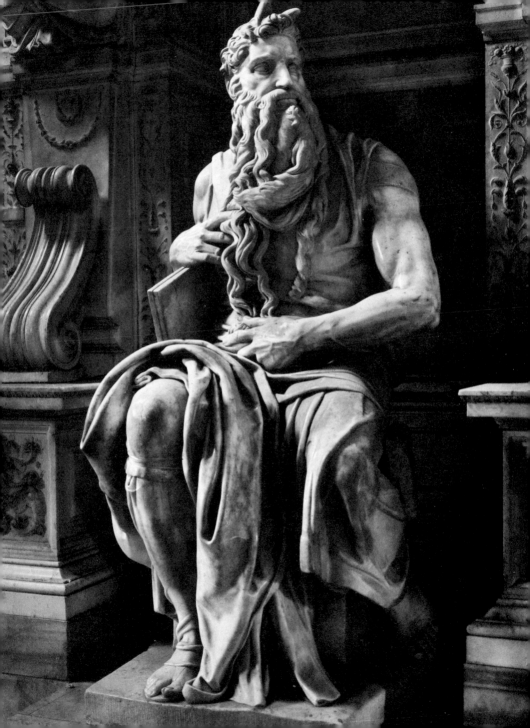

impelled the spectator to move round the sculpture and aimed to make their work intelligible and satisfactory from one principal viewpoint and a limited number of secondary ones, Mannerist sculptors arranged their forms in such a way that they do not present a completely intelligible 'pictorial' view from any one position and can only be fully grasped by viewing them all round. The term *figura serpentinata* has frequently been used to characterize the twisted, convoluted figure of Mannerist sculpture which, as Panofsky has said, 'seems to consist of a soft substance which can be stretched to any length and twisted in any direction'.[1]

The most renowned of Mannerist sculptures are the group compositions of the great revolutionary and leading exponent of Mannerism, Giovanni da Bologna. In *The Rape of the Sabines* 17 and *Samson and a Philistine* the forms are arranged spatially in all 63 directions around a vertical axis, creating a continuous spiral evolution in space which is extraordinarily dynamic. In the sketch for *The Rape of the Sabines* there is no suggestion whatever of a plane of reference, although the forms are compactly organized to fit into a block, and in the whole complex design there is hardly a single unit that has a vertical or horizontal axis. How far removed in spirit are these sculptures from the vertical, frontal, four-sided, static compositions of the Egyptians!

PROPORTION The proportional relations that exist among the parts and dimensions of a piece of sculpture are of three main kinds: linear, areal, and volumetric.

Linear proportions include: (a) the relations that exist inter- Fig. nally among the dimensions of a single form: for example, between the length and width of a single volume like a head, or among the dimensions of simple blocks, or between the length and breadth of such secondary forms as a nose or an eye; and (b) the relations that exist between the linear dimensions of one Fig. form and another—for example between the lengths of different component volumes like the neck and the head or the legs and the arms, or the lengths of different secondary forms like the nose and the eyes.

Areal proportions exist between any areas of a sculpture which Fig. are differentiated by colour or texture or are separated by dividing lines. An extremely simple example of this is the relation between two areas of a simple volume, say a cylinder,

AB : CD AB : BX

a b

Fig. 68

[1] *Studies in Iconology* (London and New York, 1962), p. 176.

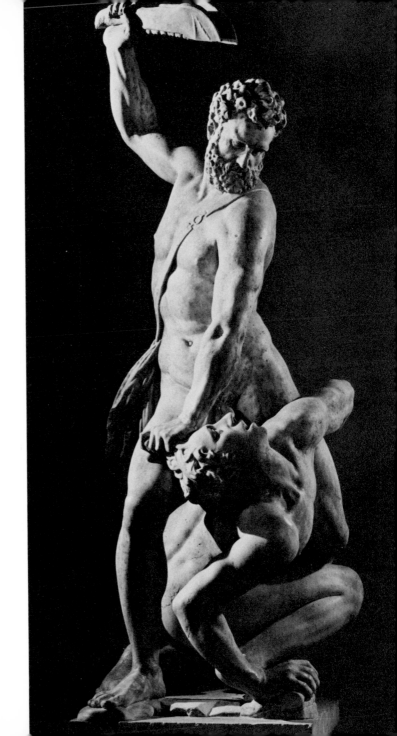

SAMSON AND A PHILISTINE
(1567) by Giovanni da
Bologna; marble, 6 ft. 10½ in.
Victoria and Albert Museum.
Crown Copyright

Fig. 69

which are divided by an engraved line or by a difference of texture. Such divisions are common in draped sculpture, especially in Gothic, Romanesque, and early Greek, where the drapery is conventionalized into a pattern on the surface of the volumes. Areal proportion also exists among the planes of a sculpture which are separated by an edge or a highline. The proportions among the areas of the various muscles—pectoral, abdominal, etc.—contained within the pattern of conventionalized surface anatomy of a Polyclitan torso are another example. 49 Fig.

Volumetric proportions, unlike the other two kinds, are found only in such fully three-dimensional arts as pottery and sculpture. They depend for their appreciation on the spectator's ability to apprehend volumes as volumes and to sense their relative 'weights' or masses. Thus while every type of proportion is important in sculpture, the proportional relations of its volumes are the most specifically sculptural.

As far as I am aware, no satisfactory explanation has been put forward of why human beings find some proportions more satisfying than others. Attempts have been made to establish connections between certain kinds of mathematical ratios and what is generally regarded as good proportion, and a number of artists have based their work on these. Architects rather more than sculptors have been interested in this sort of thing. But even if such a procedure works, which is open to doubt, a knowledge of mathematical theories of proportion is completely unnecessary for the appreciation of sculpture. For however useful such calculations may be to the artist when he is creating sculpture, and however intellectually intriguing an awareness of complex mathematical relations in a work of art may be, it is through the senses, by virtue of their sensory properties, that works of sculpture must be appreciated. If the proportions do not satisfy us perceptually, it is no use trying to justify them by a theory of proportion; and if they do satisfy us perceptually then there is no point in trying to do so. Similarly irrelevant from the point of view of appreciation—interesting though it may be from other points of view—is a knowledge of the canons of proportion employed, for example, by Egyptian, Indian, and Greek sculptors. These canons are standardized ratios between the dimensions of the sculpture, the main purpose of which is to guarantee, as it were, good results.

It is a fact, whether we can explain it or not, that we do rejoice

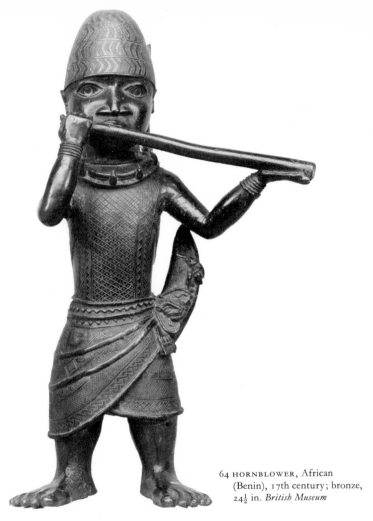

64 HORNBLOWER, African (Benin), 17th century; bronze, 24½ in. *British Museum*

in something that we call good proportion and that we are affected in different ways by different kinds of proportional relations. Although we cannot say once for all what constitutes good proportion in sculpture, we can train ourselves to become aware of different kinds of proportions, and as we do so we should begin to see what contribution they make to the expressive form of the sculpture as a whole. It is by *experiencing* sculptural form that we develop a sense of proportion, not by applying rules of our own or by recognizing any canons of proportion to which particular works may conform.

The concept of proportion is a familiar one. We develop a sense of proportion about everyday things that is capable of making sharp and subtle distinctions. This is especially true of the proportions of the human figure. We assess human proportion by reference to an implied norm or ideal, saying that somebody's legs are too short, hips too broad, or nose too long. But good proportion in figure sculpture is not simply a matter of transferring to sculpture the proportions of what would ordinarily be regarded as a well-built person, although this view has been held. The proportions of primitive sculpture are often extremely satisfying, yet they bear little relation to actual or ideal human proportions. The proportions of some of the 58, most beautiful African sculptures would in real life constitute the most appalling deformity. The head is usually enormous, the legs are often dwarfed, and the trunk is sometimes reduced to a minimum. The elongation of the figures on the west portal of Chartres Cathedral or of the Epstein's *Christ in Majesty* at 49 Llandaf or of Etruscan bronze figurines is expressive and *Fig.* beautiful, but they are not at all like even the slimmest of real people. The long, slender forms and heavy, rooted feet of Giacometti's modelled figures combine with their agitated surfaces, rigid frontality, and tightly withdrawn poses to create a powerful feeling of nervous tension and neurotic withdrawal. The expressiveness of these figures depends considerably on their exaggerated slimness. Such elongations and contractions of the forms of the human body give rise to proportions that are satisfying not as human proportions but as expressive sculptural ones.

Maillol, taking his point of departure from classical Greek 60 sculpture, attempted to create a perfectly balanced and proportioned group of sculptural volumes based on a fairly close approximation to the proportions of actual female figures. He took care, however, to select for a model a type of woman whose proportions were right for the kind of sculpture he wanted to create and he simplified and modified her forms in subtle ways to conform to his proportional ideal. 'I look for architecture and volumes', he said; 'sculpture is architecture, balance between masses, tasteful composition. . . . My aim is to rejoin Polyclitus.'[1] Few sculptors in modern times have approached Maillol's wonderful sensitivity to volumetric proportion. We have to revert to Indian and Greek sculpture, both of which *Fig.*

[1] Quoted in Marchiori, *Modern French Sculpture* (New York, 1964), p. 10.

Fig. 70
Standing Woman, Etruscan,
3rd century BC; bronze, 28 cm.

Fig. 71
Greek and Indian female torsos

had a strong influence on him, to find work that is in the same spirit and shows a similar concern for proportion.

The great fifth-century Greek sculptor Polyclitus, who believed that 'a well-made work is the result of numerous calculations, carried to within a hair's breadth', exemplifies in an extreme form the deep concern of Greek sculptors with proportion. Unfortunately the treatise he wrote on proportion in sculpture has not survived, and no originals of his work have come down to us. There do exist, however, a number of marble copies of his work, which was chiefly in bronze, and some bronze statuettes which are in his style. These give us some idea *Fig. 37* of the nature of his work.

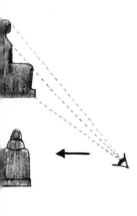

The creation of a system of perfectly balanced volumes somewhat less closely imitative of actual human anatomy was also undertaken by Indian sculptors. The proportional rela- 61 tions of the major components and details of their figures is controlled by an iconometric code so elaborate and detailed that it includes rules for the diameter of the irises and the nipples and for the length, breadth, and projection from the head of the ears.

The proportions of a piece of sculpture as it is actually seen by a spectator are what count and not those between its actual measurements. For this reason it is usually necessary to modify the proportions of a sculpture if it is to be placed in a high position or if it is of a considerable height. A seated figure, such as a *Fig. 72* medieval madonna, which is sited high on the façade of a building would not be clearly visible unless some adjustments were made to its proportions. If its dimensions were those of a normal human being, it would when seen from below appear dwarfed in its upper part and its knees may well obscure most of its body, leaving only its head peeping over them. To counteract this foreshortening, figures in such positions are lengthened in their upper parts and the head and shoulders are made large in relation to the rest of the figure. The length of the thighs is also usually shortened and the plane across the top of them slanted upwards. In addition to these adjustments to its proportions the figure may be made to lean out from the building at an angle. It is important to bear all this in mind when we are looking at such sculptures displayed at eye level in museums.

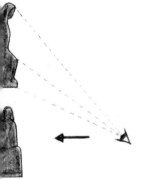

Fig. 72

In sculpture as in pottery there may be an interplay, or counterpoint, between areal and volumetric proportions. The volumes of a sculpture may be divided into areas of colour or

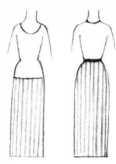

Fig. 73

texture the boundaries of which do not correspond to the divisions between one volume and another. The result of this can be a lively tension between one set of proportions and the other. A simple example of this occurs in the well-known Benin *Mother Goddess*. More complex examples are to be found among Gothic and Indian figures. In Indian bronzes there is often a particu- 61 larly subtle interplay between the proportions of the volumes and the intervals between the decorated and undecorated areas of the figure. The possibilities of such interplay have been exploited also by dress designers. The position of a belt or a Fig neckline can drastically affect the whole look of a person. In a similar way the decoration of pots can modify their over-all Fig proportions without actually changing the shape of the pot at all.

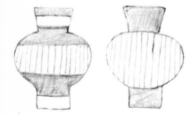

Fig. 74

CHAPTER 5　Relief and Free-standing Sculpture

Relief sculpture is a complex and subtle art form combining many of the qualities of the two-dimensional and three-dimensional arts. It is not very popular with sculptors of the present day but in most cultures of the past it has been a major art form. Many of the greatest works of art of all time are relief sculptures.

There are some influential writers on art whose eagerness to promote the twentieth-century conception of sculpture as a fully three-dimensional and spatially free art has misled them into thinking it necessary to be either derogatory or condescending towards relief sculpture. The implication of such an attitude tends to be either that relief sculpture is an impoverished mode of true sculpture, struggling to free itself from architectural dependence and to emerge as an autonomous art of fully three-dimensional space or else that it is a bastard art form resulting from the improper union of sculpture and drawing.

The ultimate absurdity of this point of view is reached when the whole classical and Renaissance tradition is denigrated for its adherence to principles of composition which are related to the principles of relief sculpture. This is a matter which we shall take up in the second part of this chapter. For the moment the main thing upon which to insist is that relief sculpture is an art form in its own right and should never be regarded as an over-developed kind of painting or an under-developed kind of sculpture.

The modes of existence of sculptural form in three-dimensional space are too varied and complex to fit neatly into the two broad categories of relief and free-standing sculpture. There are, for example, a number of block-like Mexican stone figures which stand freely in space but are really only four-sided reliefs. On the other hand there are numerous Indian and medieval carvings which are attached to a wall but whose forms have their natural depth and are so deeply undercut that from the spectator's point of view they might as well be free-standing sculptures backed against the wall. There are even sculptures in which some of the forms are attached to the wall and others are completely free from it. Nevertheless, although there are

many hybrids, some such distinction as that between relief and free-standing sculpture is indispensable.

Generally speaking, a relief sculpture is one that projects from a ground such as a wall, tombstone, or column and has its depth dimension diminished or condensed. Reliefs combine some of the qualities of paintings and drawings with some of those of fully three-dimensional sculpture. The 'three-dimensional' forms in paintings and drawings exist in an illusory, or notional, space and have no actual three-dimensional properties. Their depth is represented pictorially on a plane surface by means of a variety of projective systems ranging from the unsophisticated mixed methods of primitive and child art to the complex and precise methods of perspective projection. Reliefs inhabit a world that lies somewhere between this illusory pictorial space and the real everyday space inhabited by fully three-dimensional sculpture.

Some of the pictorial methods (that is, methods which operate in the picture plane) used in relief sculpture are: careful selection of the view represented so that it conveys a clear idea of the subject; careful selection of interior lines and contours so that they convey an impression of three-dimensional form and make a good linear composition; perspective, including diminution of size with distance and the construction of a convincing pictorial depth-space; and the overlapping of forms which suggests that one form lies behind another. The main sculptural methods (that is, methods that actually make use of the depth dimension of the relief) are the movement of surfaces and forms in depth, surface modelling and variations in the degree of projection of different parts of the relief from the background. All the spatial effects of relief sculpture are achieved by combinations of these two methods.

Relief sculpture has a wider range of subject matter open to it than free-standing sculpture. One reason for this is that it is not so limited by the qualities of the material. The objects represented in a relief have no actual weight and no centre of gravity. Problems of actual physical balance, material strength and physical support do not therefore arise as they do in free-standing sculpture. Figures can be made to fly or hover, massive forms can be made to stand on the thinnest of supports and draperies can fly away from the figure in ways which even Bernini would not try in a free-standing composition. Another reason is that the 'illusory' aspect of relief space makes it

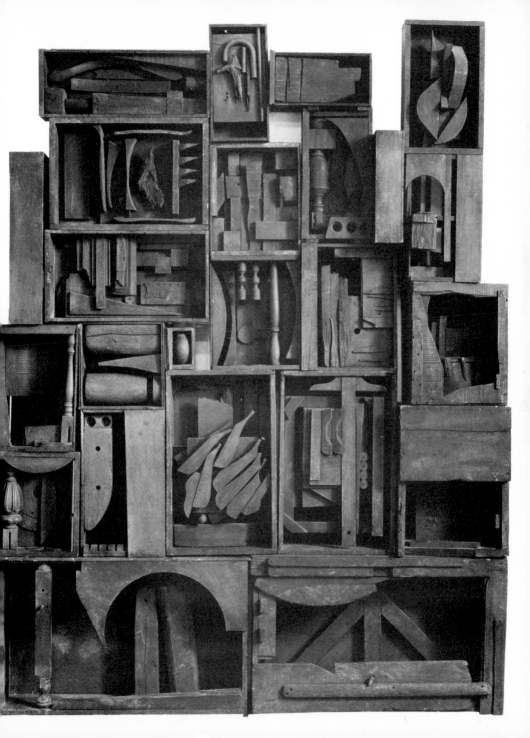

Fig. 75
Detail of wall, from Chichen
Itza, Mexico

Fig. 76

possible to represent the kind of things that may be represented in paintings and drawings but which would be unthinkable in free-standing sculpture; for example, crowd scenes, landscapes, skies, and interiors of buildings.

Reliefs are usually classified according to the degree of their projection from the background into low, medium, and high relief. Each degree of projection does not, however, have its specific set of attendant properties and as a method of classifying reliefs it is not very helpful. Account also has to be taken of the manner in which the relief is related to its background and the way in which the sculptor uses the depth that is available to him.

Some reliefs are not so much sculptures on a wall as sculptured walls. They do not stand out against the wall as figures on a ground but turn the whole surface of the wall itself into a pattern of projections and recessions. The most extreme examples of this are to be found on Mexican buildings. Whole areas of the walls of the Nunnery at Chichen Itza, for example, Fig. are made up of a repeating pattern of stylized masks. Many sculptors of the present day treat relief in this way. It is an 65 approach that is particularly suitable for non-figurative sculpture.

Other reliefs seem to be embedded in the wall or to be raised from it as though they were eruptions of its surface rather than something attached to it as to a background plane. For the majority of reliefs, however, the wall serves as a background from which they are in varying degrees visually, if not actually, separate.

The way in which we perceive the relation between a relief and its background plane depends a great deal on the way in which the edges of its forms meet the background. If the Fig. transition is a gradual one so that the forms slope gently to meet the ground or glide smoothly into it, the relief will appear to be strongly attached to its background or even embedded in it. A steeper edge or more abrupt transition will tend to detach the 5, 69 forms from their background, but the most effective device for this purpose is *undercutting*. This important technical device is used widely not only in reliefs but also in sculpture in-the-round. It serves as a means of separating minor forms from the underlying masses and is perhaps most commonly used in sculpture in-the-round for giving volume and projection to the forms of drapery. An undercut is simply a cut behind the forms

158

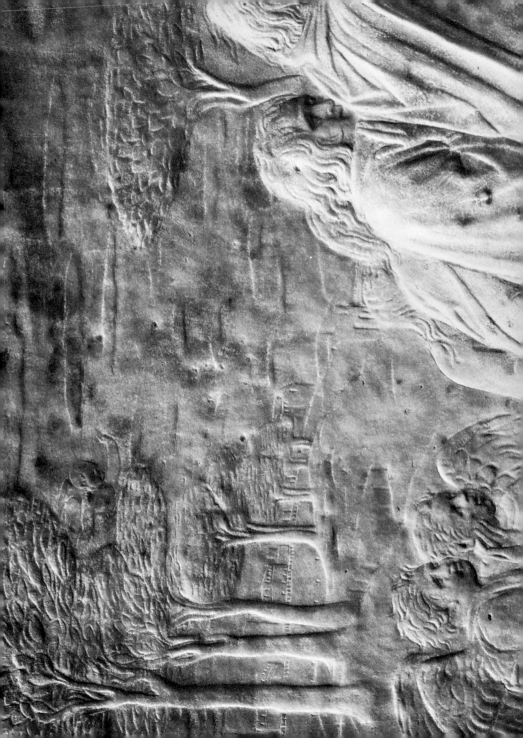

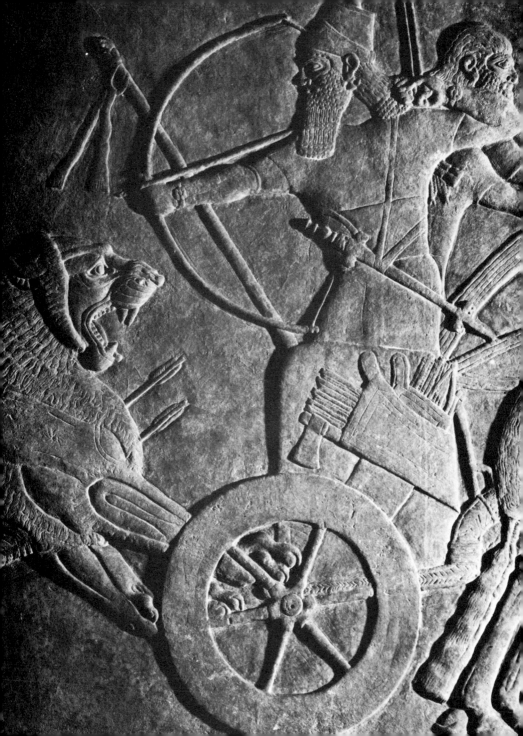

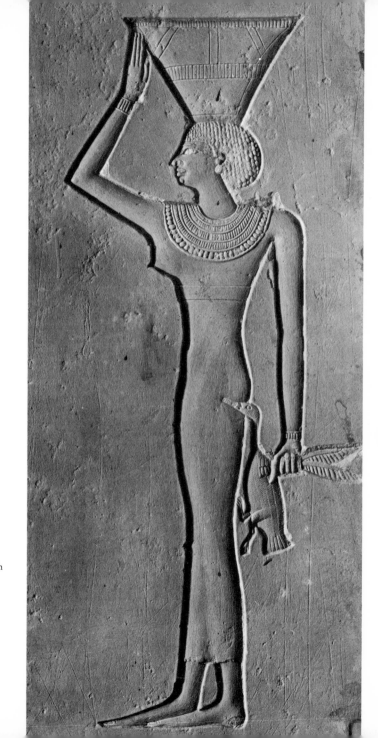

ail of ASSURNASIPAL
N-HUNTING, Assyrian, 9th
tury BC; stone, 34 in.
ish Museum (photo: *Edwin
th*)

t
ail of Egyptian sunken
ef, c. 2100 BC; limestone,
n. *British Museum* (photo:
in Smith)

and may be regarded as the first step towards actually releasing them from the background. It provides the sculptor with an opportunity to make his surfaces and lines look as though they continue round the back of the forms. It also traps shadows between the relief and the background. These shadows help to throw the relief out from the ground and in some kinds of relief contribute to an effect of chiaroscuro. High reliefs may be very 2, deeply undercut so that they have no apparent attachment to the wall and in many cases portions of the sculpture such as the head, legs, and arms may be carved all round so that they are in fact detached.

The degree of emphasis placed on pictorial or sculptural methods respectively in the spatial design of reliefs differs considerably in various styles. Egyptian low reliefs rely for much of their effectiveness on clearly defined outlines. The carving is spread out on the plane of the wall and conforms to the same planimetric conventions as Egyptian drawing. Anything that suggests depth, such as foreshortening, perspective, and overlapping of forms is absent or kept to a minimum. There is, too, a minimum of surface modelling, although what little there is can occasionally be extremely subtle. The strange form of Egyptian relief known as *coelanaglyphic*, or sunken relief, is the 68 most planimetric of all. It does not in fact project from the wall at all but is carved within a shallow recess formed by cutting a groove into the wall around the outline of each object. The usual firmness and clarity of Egyptian line is reinforced by the way in which the sharp outside edges of the surrounding grooves catch the light. The low mural reliefs of ancient civilizations often display an astonishing brilliance in their linear design. The strong, sometimes hard lines of Assyrian low 67 relief and the lyrical quality of the curvilinear reliefs at Angkor Vat are two examples that express entirely different moods.

Pictorial methods of an entirely different kind are used in the form known as *stiacciato*, or flat relief. This most shallow of all forms of relief was invented by Donatello and was used also very effectively by Desiderio da Settignano. In Donatello's *Christ Giving the Keys to Saint Peter* almost every device open to 66 the draughtsman for creating the 'illusion' of spatial depth is used to its utmost. The whole surface of the panel is part of the composition and there is no distinction between the relief and the ground plane. The background is, in fact, completely non-planar and is made to suggest an infinity of space. In the detail

shown, the use of perspective is most apparent. The diminishing clouds, the receding, overlapping undulations of the ground, the perspective of the line of trees and the delicately incised city in the background all suggest an unlimited pictorial space in which the action of the figures is taking place. This *stiacciato* technique is perhaps the most painterly of all methods of relief sculpture—it can even be made to suggest qualities of light and atmosphere. It depends for all its effects on the use of very fine incised lines and an extreme delicacy and and subtlety in its surface modelling.

In the reliefs of classical antiquity the ground plane of the wall or slab is treated as inviolable and acts as a reference against which the actual projection of the sculpture may be assessed. Overlapping is frequently used to suggest depth but an 'illusory' pictorial space is completely lacking. Because Greek relief aims at complete clarity of presentation in the two-dimensional visual projection and arranges its forms in order to achieve this, it is sometimes accused of being too dependent on vision alone and lacking in tactual qualities. This, it is suggested, detracts from its sculptural qualities since the specific appeal of sculpture as an art is to our sense of touch. Such a conclusion seems to me to arise from a theoretical mistake rather than a sensory appraisal of the sculptures themselves. We have already referred to this in connection with frontality and we shall discuss it at greater length in the next section. Classical reliefs, in fact, achieve their effects almost entirely by means of sculptural methods. They make use of varying degrees of projection from the background and are usually at least in part undercut. Moreover, within the limits of the degree of projection they achieve an extraordinary subtlety and plasticity of surface modelling. They never give the impression that they are merely protrusions from or bosses on a wall, but have a self-sufficient statuesque quality. In such mature masterpieces of Greek relief as the Parthenon friezes, the *Hegeso* and *Ktesileos and Theano* gravestones, the column base from the Temple of Artemis at Ephesus, and the Winged Victories from the parapet 52, 54 of the Nike temple, the sculpture is completely plastic. Even the linear design springs from and contributes to the three-dimensional qualities of the relief. The contours, for example, are a result of the modelling of the interior forms and are frequently broken and at different depths. They do not form a continuous outline to which the interior forms are made to

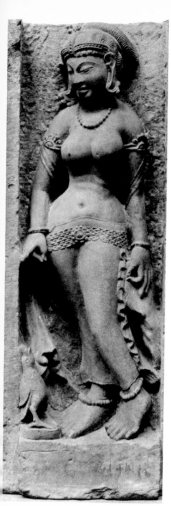

69 Female Figure With a Bird, Indian, early 9th century; sandstone, 81·5 cm. *Patna Museum* (photo: *Royal Academy*)

conform. And the main functions of the interior lines, as we saw in the chapter on drapery, are to clarify the movement of surfaces and enhance the impression of volume. They are not mere decoration.

Indian relief sculpture, even more than Greek, places its emphasis on sculptural methods. The figures are almost always undercut and detached visually, if not actually, from their background and almost everything is subordinated to the impression of volume. Although the background plane is often concealed under a profusion of detail, it is always implied and is never carved into an illusion of spatial recession. Partly because the volumes of Indian figures are divested of all the surface anatomy that is present in Greek sculpture and partly because their drapery and ornament are laid tightly over the volumes so that they do not break the continuity of their surfaces, the outlines of Indian reliefs tend to be simpler and more continuous than those of Greek reliefs. In the example shown there is a 69 marvellous combination of fluid contours and full rounded volumes which gives a gentle feminine softness to the whole composition.

Indian relief sculpture aims like Greek at clear visual presentation from one viewpoint; but even more than the Greek this desire for visibility is pursued by Indian relief without loss of tactual qualities. In fact, if the idea of a sculpture strong in tactual qualities has any meaning at all, it is perhaps more clearly exemplified in Indian sculpture than in any other style. The volumes have the fullness and all-round, self-enclosed completeness and palpability of a fruit.

Although a greater projection naturally allows more scope for the movement of surfaces in depth, it does not necessarily lead to a fuller or more effective use of the third dimension or to a higher degree of expressiveness. Some sculptors work with such sensitivity and precision within a very limited depth space that they impart to their work an extraordinary plastic subtlety and richness. The delicacy of surface modelling, complex overlapping of forms and variety of line that are possible in very low relief are brilliantly displayed in the *Virgin and Child* by the 70 fifteenth-century Italian sculptor, Agostino di Duccio. The twelfth-century English whalebone *Adoration of the Magi* shows 71 an equally amazing but extremely different use of the formal and expressive possibilities of small-scale low relief. Although both these carvings are low reliefs dealing with a similar

Christian subject, and although both are stylized and make equal use of line, their moods could hardly be more different. The Agostino has a quality of gentle, refined lyricism. It is full of softly curved surfaces and delicate flowing, rippling, and curling lines. Its rhythms are those of things which are relaxed and lacking in tension, which are moved gently by external forces. *The Adoration of the Magi*, in spite of its small size, is powerful and severe. Its forms are boldly carved and its lines are assertive—they either sweep over the forms in strong curves or cut across them in sharp zig-zags. Its rhythms belong to a less gentle order than those of the Agostino.

In some Baroque reliefs all the possible modes of spatial existence in relief are exploited in one composition. Figures in the most forward plane are detached wholly or partly from the background; others, somewhat further back, are carved in lower relief; while in the distance others hardly project at all and are diminished by perspective. Violent foreshortening is common and the whole scene may be enacted against a background receding in perspective with a sky and clouds overhead.

Probably nothing in sculpture is more alien to sensibilities attuned to modern sculpture than the Baroque relief. Its particular fusion of the two arts of painting and sculpture is not in keeping with current trends. The creation of an 'illusion' of depth is something that not many painters today are concerned with. They are more inclined to emphasize the reality of the picture plane—the surface of the canvas itself. And modern sculptors are more interested in free-standing sculpture than in the sort of illusory space to which relief carving lends itself. The agitated complexity of these Baroque reliefs, with their flying draperies, gesticulating arms, and welter of small, broken shapes, seems to modern taste to be a misuse of stone. Psychologically, too, many people are apt to find them repellent. To a post-Freudian generation their expression of religious feeling often seems to be exhibitionist and unsavoury. For these reasons Baroque reliefs may well serve to test the adaptability of our responses and our ability to overcome the limitations of our period tastes. It requires some effort of imagination to approach these sculptures without prejudice and to see what has been achieved in them.

SCULPTURE RELATED TO A WALL Sculptures which are made for standing in a niche or in front of or against a wall are obviously intended to be seen from only a

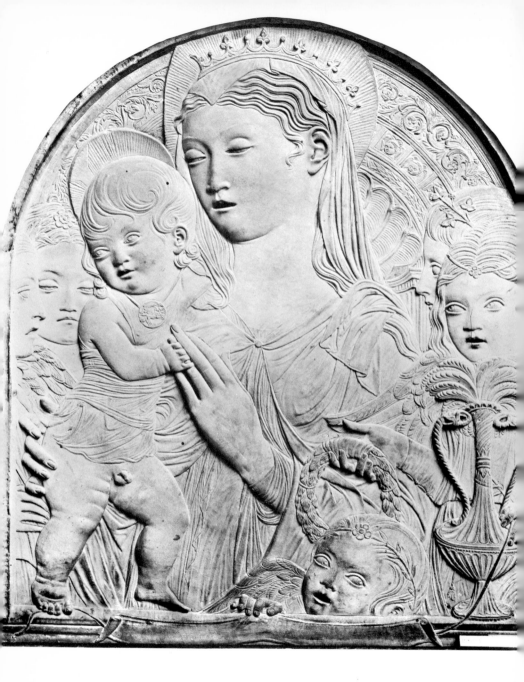

70 VIRGIN AND CHILD (*c.* 1454) by Agostino di Duccio; grey marble, 22 in. × 18¾ in. *Victoria and Albert Museum. Crown Copyright*

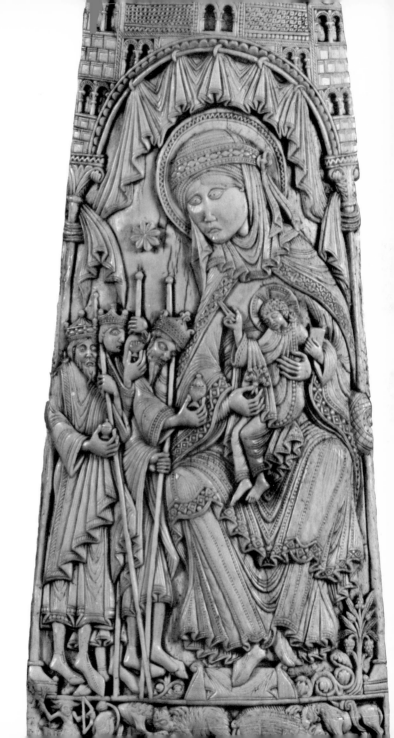

71 THE ADORATION OF THE
MAGI, English, early 12th
century; whalebone, 14½ in.
*Victoria and Albert Museum.
Crown Copyright*

limited range of frontal positions. Their design must, therefore, be completely intelligible from the front, and if they aim to communicate any feeling of the weight and depth of their volumes, they must do so from their frontal aspect. For the appreciation of such works it is important to understand this. Many people today over-emphasize the value of walking round sculpture and believe that it is the only way to get a grasp of its three-dimensional structure. And they frequently draw the conclusion that, because wall and niche sculptures cannot be walked round, they must somehow be lacking in three-dimensional form. But such a view is mistaken for two reasons. First, it is not always necessary to see all round a sculpture in order to grasp its structure as a composition of solids in three dimensions or the character and shape of its volumes. These may be completely apparent from a limited view so that the only reason for walking round the sculpture would be to confirm what we have already understood from the front or to see some details of the hidden surfaces. Second, there need be no diminution of the volumes of a sculpture simply because it has its back to the wall. In fact, many Egyptian, classical Greek, and Indian sculptures of this kind impress us most powerfully with the fullness, clarity, and depth of their volumetric structure. It cannot be emphasized too strongly that because a sculpture is intended to be viewed from the front it is not necessarily 'pictorial' and unsculptural. A sculpture may be free-standing and yet thoroughly two-dimensional in conception or it may be attached to a wall or a column and be completely three-dimensional in conception.

Where these wall and niche sculptures tend to be limited is not in the three-dimensional qualities of their volumes but in their spatial arrangement. The disposition in space and the interrelations of their volumes are controlled by frontal planes of reference which are parallel with their background, and are governed by the need to make the sculpture intelligible and satisfactory as a design from the front. Their aim is to satisfy the spectator with a front view so that he does not feel that he needs to walk round the sculpture in order to apprehend it as a design in three dimensions. Thus they tend to avoid any severe tilting of the volumes towards or away from the spectator such as might result in a visually confusing foreshortening and to keep the overlapping of forms to a minimum, spreading them out in the frontal plane at right angles to the spectator's line of vision

rather than in depth. Axial rotation, too, tends to be restrained and limited to gentle movements that do not upset the general frontal composition.

Since these compositional methods are typical of relief sculpture, this method of conceiving sculpture-in-the-round is sometimes called the *relief conception of sculpture*. Almost all classical and Italian Renaissance sculpture has been conceived in this way. The nineteenth-century German sculptor, Adolf Hildebrand, has given the fullest description of the method. He asks us to

think of two panes of glass standing parallel, and between them a figure whose position is such that its outer points touch them. The figure then occupies a space of uniform depth measurement and its members are all arranged within this depth. When the figure is seen now from the front through the glass, it becomes unified into a unitary pictorial surface, and, furthermore, the perception of its volume, of itself quite a complicated perception, is now made uncommonly easy through the conception of so simple a volume as the total space here presented. The figure lives, we may say, in one layer of uniform depth. Each form tends to make of itself a flat picture within the visible two dimensions of this layer, and to be understood as such a flat picture.[1]

Wölfflin, however, seems to have answered better than Hildebrand the objections that this idea would give rise to. He warns us that we must not suppose that depth is lacking in sculpture that is conceived in this way; it is only 'restrained, thus giving a plane-like impression'.

The relief conception [he says] may well have its deepest roots in visibility, which it guarantees, since the arrangement in the plane is the most easily comprehensible of all possible arrangements. . . . Applied to sculpture in the round, the principle means that the spectator does not have to walk around the figure in order to grasp its content; instead the figure makes all its essential elements known in the view from one side, in one pronounced main view.[2]

Few sculptors today would accept this relief principle. Modern sculptors do not attach much importance to the visual projection of their work either in the frontal or in any other plane and they are more likely to emphasize the differences between their art and the art of painting than to draw attention to the similarities. Moore, for example, demands, as we have

[1] *The Problem of Form* (1907 ed.), p. 80.
[2] *The Sense of Form in Art*, pp. 190–1.

seen, that his work should be apprehended as a structure of three-dimensional forms existing in a completely unrestricted space.

What is often not realized is that there is no necessary conflict between the principle that sculpture should be intelligible from one view and the principle that it should be apprehended as a structure of fully three-dimensional volumes. A great deal of Italian Renaissance sculpture, like Indian wall and niche sculpture, is both completely satisfying as a frontal projection and completely satisfying as a structure of fully three-dimensional forms. It is only the *arrangement* of the volumes in space that is restricted by the demand for intelligibility from the front.

Most large-scale Italian Renaissance sculpture in the round was conceived in relation to architecture and designed to occupy a niche or stand in front of a wall. These Renaissance sculptures and many Gothic sculptures in the round, including some column figures which preserve only the most tenuous connection with their background, combine a feeling for gentle movement in depth with a respect for intelligible frontal presentation. The movement of Donatello's *Saint George*, for 72 example, is not just movement related to an architectural background as to a picture plane. It springs from inside, from an organic axis. But the slight changes of direction do not break the general control of the frontal plane. What they do is to introduce variations which give a balanced asymmetry and make the front view more pleasing.

The pediment sculptures from Olympia, Aegina, and the Parthenon show very clearly how Greek sculptors adapted 30 quite complex groups of figures in all manner of poses—sitting, lying, squatting, struggling, crouching—for clear presentation in the frontal plane. They also illustrate the extraordinary resourcefulness of Greek sculptors in devising compositions to fit awkward shapes. What a marvellous invention for filling the narrow corner of a triangular pediment is the *Dying Warrior* 73 from the east pediment of the Temple of Aphaia on Aegina, and how brilliantly it is arranged in the frontal plane! The movement which begins at the lower legs and progresses along the thighs, the abdomen and the chest and culminates in the head turns the figure through almost 180°, yet in spite of this torsion the composition is perfectly satisfactory from the front. This continuous movement from the feet to the head is accompanied by a progressive expansion of the areal shape occupied by the

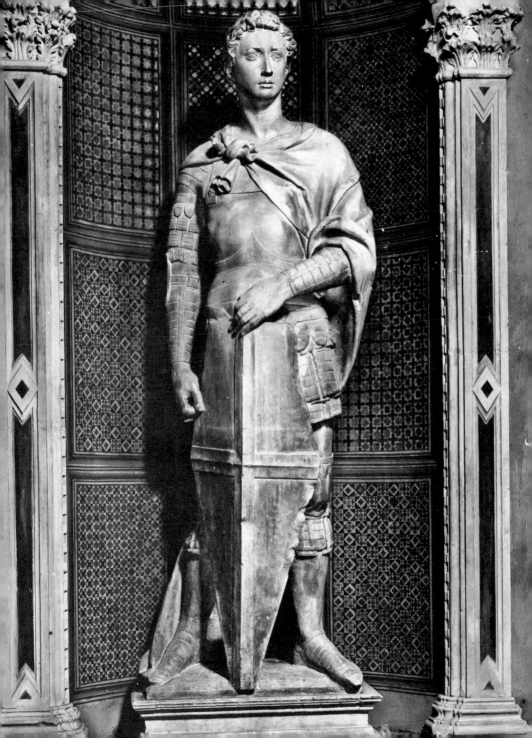

silhouette of the figure and the shield as the composition grows to fill the increasing width of the triangle.

Michelangelo was an individualist and an innovator in the composition of his sculpture as in almost everything else. In common with almost all Renaissance sculpture, his carvings were designed to stand in a niche or against a wall and to be viewed from one principal aspect; but, unlike the majority of classical and earlier Renaissance work, most of them are as fully extended in depth as they are in the frontal plane. They are not primarily related to the background plane or built up around a main axis of the figure. The spatial disposition of their parts is related to the block of stone from which they were carved and within which they are, as it were, still tightly packed. The result of compressing so much movement of volumes within the confines of a cubic space is to frustrate the energy of the powerful, muscular figures so that the spectator is arrested, as Panofsky very aptly puts it, 'in front of volumes that seem to be chained to a wall, or half imprisoned in a shallow niche, and whose forms express a mute and deadly struggle of forces for ever interlocked with each other'.[1]

The astonishing genius and originality of Bernini are nowhere more apparent than in the development of his conception

[1] *Studies in Iconology*, p. 176.

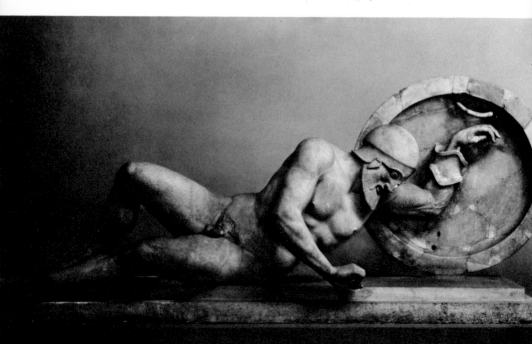

of sculptural composition, which moves from an acceptance of the notion of a self-contained statue to that of a completely new synthesis of architecture, painting, and sculptured figures, as in the famous Cornaro Chapel with its *Ecstasy of Saint Teresa*. In 74 this chapel the spectator is not simply confronted with a piece of sculpture but is contained within an environment completely designed by the artist with the main group as the focal point.

In his mature compositions Bernini returned, after the innovations of the Mannerists, to the Renaissance conception of sculpture with one principal aspect, placing most of his works in a niche or against a wall and taking great care to see that they were viewed correctly. He did not, however, adopt the Renaissance method of extending the sculpture mainly in a plane at right angles to the spectator's line of vision. For while he rejected the multi-view principle of Mannerist sculpture, he accepted its freedom of axial movement in all directions and extended his compositions in depth. In this respect his work has certain affinities with Michelangelo's. There are, however, important differences in the compositions of these two sculptors. Michelangelo's poses are more restrained. The spatial organization of the volumes of the figure is disciplined within the confines of the block and their directions are on the whole related to the directions of the faces of the block. Bernini's

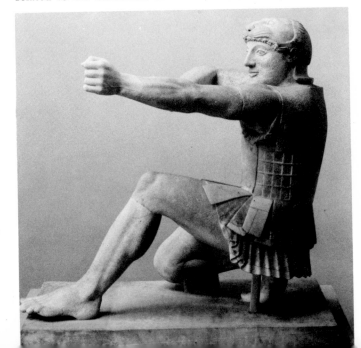

igures (*c.* 490 BC), representing, *ft*, a DYING WARRIOR and, *ight*, HERACLES, from the east ediment of the Temple of Aphaia on Aegina; marble, *ft*: 50 in., *right*: 30 in. Glyptothek, Munich

sculptures, on the other hand, are frequently made up of several blocks and their movement is unrestrained. Michelangelo is reported to have believed that stone carvings should be compact enough to be rolled down a mountain-side without breaking. Certainly he tied in the extremities of his figures so thoroughly by connecting them to the main masses that his work might survive such a trial in one piece. Bernini's, however, with their projecting extremities and flying draperies, would smash to pieces.

Most of Bernini's groups represent figures in violent action at the climax of some dramatic situation and his main efforts in composition are directed towards making this action intelligible from the principal view. This is true of *Pluto and Persephone, Neptune and A Triton, Habakkuk and the Angel*, and, most obviously, of *The Ecstasy of Saint Teresa*, which is framed by the architecture as though it were a picture. We may say that in this respect Bernini's sculpture is pictorial, for in representing action in the 'illusory' picture-space of painting, where of necessity only one optimum angle of view is possible, the arrangement of the figures must be such that the nature of the action is quite clear from that point of view. Bernini's space and volumes, however, are real, not 'illusory'. It is as though he has realized in actual space the groups that a painter might have presented in his notional or 'illusory' picture-space.

The composition of many of Bernini's sculptures is not resolved within the sculpture itself. In the *Neptune*, for example, the action is directed towards the pond below. With the *David* the spectator is involved in what one might call the 'dramatic' space of the sculpture, which includes the space behind the spectator, where Goliath, the object of David's concentrated gaze and action, must be imagined to be standing.

Complete freedom of axial movement, composition in depth, foreshortening (which implies a main viewing position from which the forms appear foreshortened), broken contours, projecting extremities and flying draperies, the use of the architectural setting as though it were a stage and the involvement of the spectator in the action are all characteristic of the most spatially free of all historical styles of sculpture, the Baroque, the development of which is largely attributable to Bernini. The general effect of all this in Bernini's sculpture is to join with his use of colour, light and shade, flame-like draperies, extravagant gestures, realistic anatomy and facial expressions, to produce

facing page
4 THE ECSTASY OF SAINT TERESA (1645–52) by Giovanni Bernini; marble, life-size. *Santa Maria della Vittoria, Rome* (photo: *Mansell/Anderson*)

51

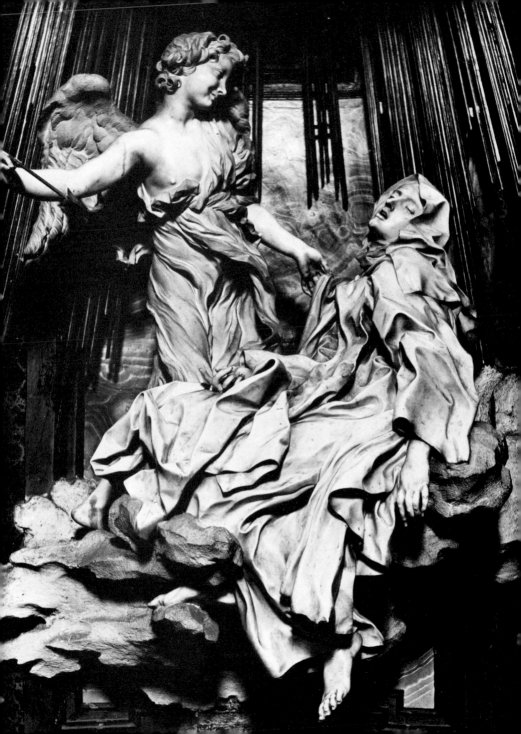

a highly emotional, rhetorical, and theatrical style in which the traditional boundaries between painting, sculpture, and architecture are broken down and the solid, substantial quality of sculpture sometimes dissolves into a weightless ghostliness.

SCULPTURE RELATED TO THE GROUND A sculpture attached to a wall is supported from behind and needs no support from underneath; like many Baroque sculptures and Epstein's *Saint Michael* at the new Coventry Cathedral it may appear to hover in front of the wall. A free-standing sculpture, however, is a material thing which like any other unattached object is subject to the laws of gravity and must stand or rest on something. This physical fact gives rise to two closely related problems which have to be considered in the designing of sculpture: physical stability and the visual relations between the masses of the sculpture and the ground on which it stands. Architects, furniture designers, and potters are faced with similar problems and many of their solutions are related to those of the sculptor.

Actual physical stability is a fairly straightforward matter. If a sculpture is not fixed to the ground, its stability depends on such things as the distribution of weight, the shape and size of the area over which contact is made with the ground, and the position of the centre of gravity in relation to this area. Such a sculpture will usually look stable if it is stable. If, however, the sculpture is fixed to the ground, it may lean violently to one side or balance on a small area so that, considered simply as an inert mass of material, it will appear unstable without actually being so. Actual stability in this case depends on the strength of the materials and the manner of fixing. It is therefore necessary to distinguish between the *actual* stability and the *visual* stability of sculpture. A sculpture must normally be stable, whether it looks stable or not, in order to prevent damage or accidents.

Many sculptures, including those which approximate in shape to cubes, cones and pyramids, most seated, kneeling, and reclining figures, and animals standing on four legs, are inherently stable and will rest safely on the ground. In fact, their general composition may have been determined to a considerable extent by the need for stability. The same need may also influence the proportions of a sculpture. The feet of African wood-carved figures, for example, are often made very large, no doubt partly in order to give the sculpture stability. Other

sculptures are not inherently stable and special measures have to be taken in order to make them safe. The most common way of doing this is to furnish them with a base.

There are various kinds of bases, contributing in different ways to the total effect of the sculpture. Some function simply as plinths or pedestals, setting the sculpture off from its surroundings, isolating it and perhaps placing it on a different level from nearby objects that are resting on the ground. Their function is rather like that of a picture frame. They are not an essential part of the composition and should not obtrude or need to be taken into account when we are looking at the sculpture. They may be supplied by the museum or gallery in which [20, 51] the sculpture is exhibited or, if it is placed in a permanent setting, they may be designed by an architect. Even when the sculptor himself supplies or designs a base it may still serve only as a part of the setting of his work. Bases of this kind should be distinguished from those which are part of the sculpture itself. Of course, when the sculptor is responsible for the design of bases for his own works, it may be difficult to assign them to either category and to say whether they should be looked upon as part of the sculpture itself or part of its setting. This does not, however, affect the general validity of the distinction. We can usually see whether the sculpture is a composition *on* a base or one that *includes* a base.

Many bases are an integral part of the sculpture, made from the same material and carved or cast with the rest of it. A sculptor may leave a mass of stone, clay, or wood at the foot of his composition, the main purpose of which is to provide stability through its weight and the large area over which it contacts the ground. This mass of material is often shaped into a neat slab or block, but sometimes it is left in a rough state. Rodin, attracted by the romantic overtones of Michelangelo's unfinished carvings, especially those that are embedded in a roughly pointed mass of stone, left many of his bases in this state and deliberately exploited the contrast between their [4, 75] rough, jagged surfaces and the smooth, finished surfaces of the figure. In some of his works the effect of this contrast is to suggest the emergence of form from chaos; but in others, such as the *Danaïdes*, the harshness of the base emphasizes the astonishing sensuality of the modelling of the figures.

But quite often a base which is an integral part of the composition may be elaborately carved or modelled, and then what

owes its origin to a purely physical need for stability may be turned by the creative imagination of the sculptor into a delightful and necessary part of the sculpture. The fertility of 101 Bernini's imagination shows abundantly in the elaboration of the bases of some of his sculpture. The bases of Donatello's bronze *David* and *Judith and Holofernes* are also richly and elaborately modelled. Sculptures which are designed for an architectural setting are often given bases that include architectural motifs such as columns and mouldings. These relate the sculpture to its architectural surroundings and provide a visual link or transition between them.

The elaboration of the bases of many stone carvings of standing figures is due to the need for support at the ankles. Stone has very different physical properties from flesh and bone; it is brittle, and extremely heavy, and to attempt to support a stone figure on normally proportioned ankles is to invite disaster. The tree-trunks, rocks, and other paraphernalia which abound at the feet of classicizing nude carvings are usually

75 DANAÏDES (1885) by Auguste Rodin; marble, 35 cm. × 73 cm. × 57 cm. *Musée Rodin, Paris* (photo: *Mansell/Alinari*)

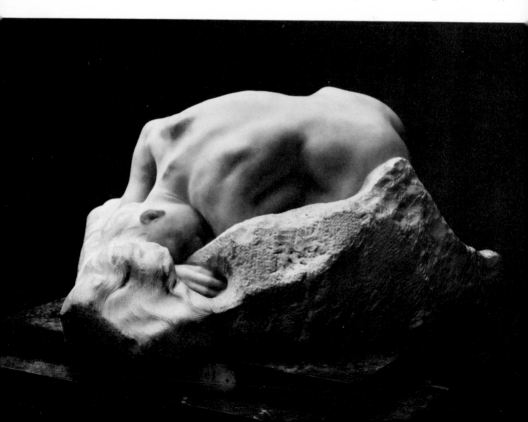

there in order to overcome this structural weakness. They are, of course, unnecessary in bronzes because metal has considerable tensile strength and, being hollow, is not as heavy as stone.

Sculptors working in bronze often take advantage of its tensile strength and design sculptures that are light and delicately poised. Most surviving Greek bronze figures have this character. The *Marathon Boy* and the *Poseidon* from Cape Artemision are two of the most beautiful examples. Having only a small area of contact with the ground, such figures must be fixed to a base in order to give them stability. A real human being stays upright when balanced on a small area like the soles of the feet by making constant adjustments in the distribution of the weight of the body which keep its centre of gravity over the area of contact with the ground, but a normally proportioned standing figure in a rigid material like bronze would be extremely unstable and liable to fall over with the slightest shock or breath of wind. Bases for figures of this kind are frequently made of a material whose qualities contrast with those of the bronze, the aim being not to blend the base and the figure but to separate them, so that the figure seems to spring from or to be lightly resting on the base rather than joined to it.

The ways in which the main masses of a sculpture may be related to the horizontal plane of the ground fall into three main groups. Anyone who is acquainted with styles of furniture, architecture, and pottery will recognize in them a close parallel to the features we shall be discussing in relation to sculpture. First, there are compositions in which the masses seem to be *rooted into the ground*, to be pressing down into it or to be emerging from it (Fig. 77a). Mountains, outcrops of rock, and hills have this character, including those man-made mountains, the Egyptian Pyramids. Egyptian seated and kneeling figures and sphinxes also have a rooted, earthbound quality. This is largely 32 a result of the way in which they meet the ground with sheer flat vertical or near-vertical faces and are heavier at their base. The second group of compositions are those in which the main masses seem to be *resting on the ground*—or on the base if that is part of the ground rather than part of the sculpture (Fig. 77b). They have the quality of a boulder lying on the ground and give the impression of being complete in themselves. Most of Arp's sculptures and many of Hepworth's have this character, as do 35 many of the reclining, kneeling and crouching figures from the

a

b

c

Fig. 77

pediments of Greek temples. The third group consists of
statues in which the masses are *raised above the ground* (Fig. 77c).
Of course, there must be some fixture to the ground, but this is
arranged in such a way that the masses appear to exert little
pressure on the ground. Sculptures of this kind often give the
impression that they are gently touching down on the ground
or taking off from it. When the masses are not merely raised
above the ground but expand progressively upwards, the im-
pression may be primarily one of growth. A great many modern
works have this character. Those of Brancusi which are based
on the forms of birds—*Maiastra, The Cock, Flight*—are examples
in which this upward-moving character is achieved without
sacrificing three-dimensionality and volume.

Of course, the relations between sculpture and the ground
plane are only one aspect of sculptural composition. The ex-
pressive character of particular works is only partly due to
them; their effect may be lessened or enhanced or changed in
other ways by the presence of other qualities.

The relations of vertical sculptures to the ground plane are
not as important as those of horizontal sculptures. The kind of
horizontal sculpture which has most engaged the interest and
exercised the talents of sculptors is the reclining figure. Some
reclining figures are related to their bases as though to a wall
and may be regarded as reliefs on a horizontal slab. It is true we
can walk round them, while we cannot walk round a relief, but
this is due to the fact that they are in the horizontal rather than
the vertical plane and we are creatures who walk in the hori-
zontal plane. There is in fact very little difference between the
qualities of medieval recumbent tomb figures and medieval
niche and relief figures. The reclining figure really becomes
interesting as a theme for sculpture only when the imagination
of the sculptor begins to use it to achieve compositional quali-
ties that could not otherwise be achieved.

Sculptors who are mainly interested in the volumetric aspects
of their work and who design it so that it appeals to the tactual
aspect of our sense of form usually make their horizontal sculp-
tures independent of a base, or at least make them appear to rest
on their bases rather than emerge from them or be embedded in
them. Too strong a visual attachment to a base, as to a wall,
may set up a resistance to our attempts to apprehend the sculp-
ture as a structure of volumes; it suggests that it is not a com-
position existing fully in the round and our sense of form is

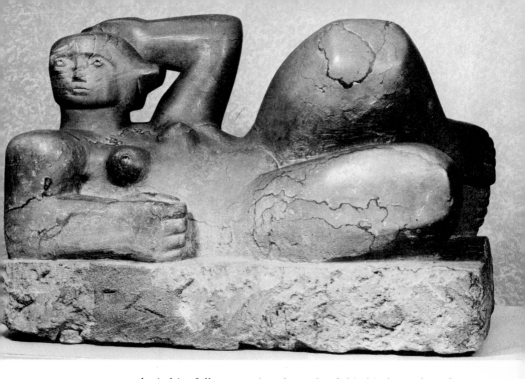

_INING FIGURE (1929) by
ry Moore; brown Hornton
e, 32 in. _Leeds City Art_
ry

78
CMOOL, Mexican (Toltec-
a), AD 900–1000; stone,

denied its fullest exercise. A work of this kind may be a free-standing sculpture but it lacks complete spatial freedom.

The reclining figure has been one of Moore's favourite themes and a great deal of his most inventive and original work has been devoted to it. The variety of ways in which he has related the figure to the ground plane or base in his numerous reclining figures makes a fascinating study. The Leeds figure of 76 1929 rises massively from its base like a great outcrop of rock and is rooted to the ground in the same way as the Mexican _Chac Mool_ figures which inspired it. The _Reclining Woman_ of 1930 and the much later Dartington Hall figure are similar. Unlike the rigidly horizontal medieval reclining effigies or the frontal, reclining Greek pedimental figures, they are composed of forms whose axes move freely in all directions; but their composition as a whole is still rooted in the base. The stone _Recumbent Figure_ of 1938, which is in the Tate Gallery, and the 28 large elm-wood and small metal reclining figures executed be- 33 tween 1938 and 1945 are, however, completely freed from their bases. Space penetrates between them and the ground plane and their forms are carved or modelled all round so that they are

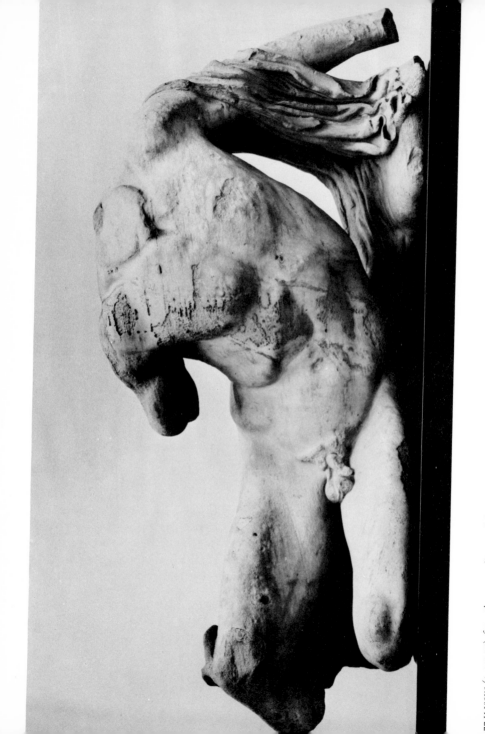

77 ILISSUS (c. 440 BC), from the east pediment of the Parthenon; marble, L. 1.56 m.
British Museum (photo: *Hirmer Fotoarchiv München*).

seen as wholly self-contained compositions resting on the ground rather than emerging from it. We feel as though we could pass our hands underneath them and scoop them up.

Perhaps the best known of all reclining figure sculptures are the incomparable *Dionysus* and *Ilissus* from the Parthenon and the four figures from Michelangelo's Medici Tombs: *Night, Day, Evening,* and *Dawn*. A point of special interest about all these figures is the way in which they are related both to the ground plane—in the case of the Michelangelos, to the curve of the lid of the sarcophagus—and to the frontal plane. The compositional problem has been largely one of creating interesting movements of form around a mainly horizontal axis while at the same time making the sculptures well designed from the front. This is, of course, apart from the problem of integrating them into the total composition of the pediment and tombs.

Michelangelo's four statues illustrate the variety of expressive qualities that can be achieved in the composition of reclining figures even within the limited range of one man's work. The *Night* and *Day*, with their uncomfortable poses and tightly-packed interlocking forms, are entirely different in mood from *Dawn* and *Evening*, which are open and relaxed. Perhaps the most marked contrast is that between the languorously sensual passivity of *Dawn* and the pent-up vigour of *Day*. The massive main forms of *Day* are crossed in depth by limbs which interlock and fill the space above and behind them, giving the whole composition a compressed, block-bound quality. There are numerous straightnesses among its block-like volumes and their surfaces are knotted and bulging with almost explosive energy. The forms of *Dawn*, by contrast, are relaxed and sinuous. The volumes of the figure turn in a long, subtly varied curve from the plane across the knees to the plane across the upper chest. The space above the figure is open and uncrossed by the limbs. There is a heaviness and lack of energy in its curves and a passive receptivity about its whole pose. These figures have been somewhat mutilated in order to fit them to the volutes of the sarcophagi and this accounts for a certain lack of coherence at their base. It does not, however, materially affect their general composition and mood.

ge 184
AY (1524–34) by ichelangelo; marble, 201 cm. *edici Chapel, Florence* (photo: *lansell/Anderson*)

ge 185
AWN (1524–34) by ichelangelo; marble, 200 cm. *edici Chapel, Florence* (photo: *lansell/Anderson*)

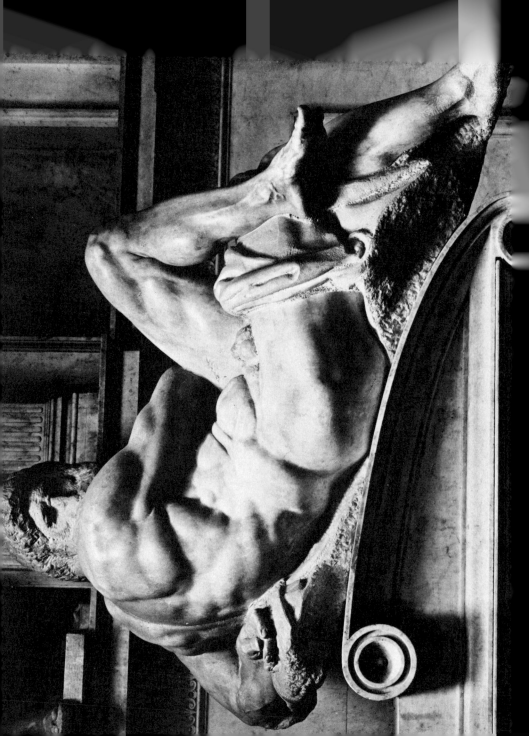

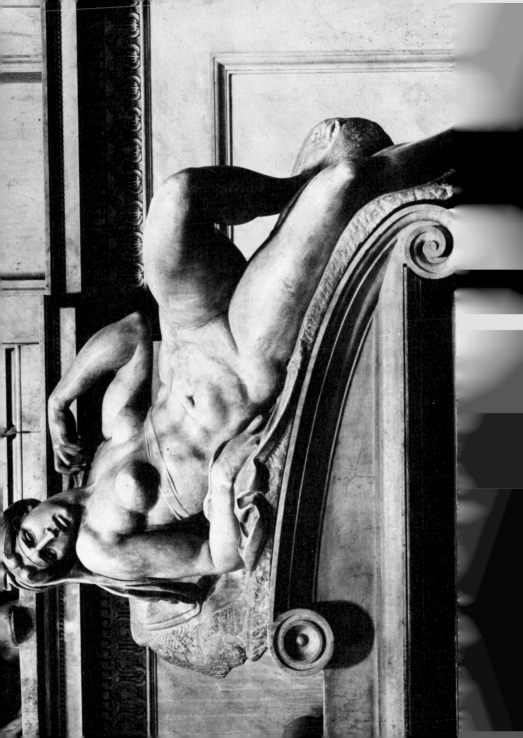

The art of sculpture is served by many crafts. It involves physi-
cal work and manual skills, for as Leonardo correctly, if some-
what derisively, points out,

> the sculptor in producing his work does so by the force of his arm,
> striking the marble or other stone to remove the covering beyond the
> figure enclosed within it. This is a most mechanical exercise accom-
> panied many times with a great deal of sweat, which combines with
> dust and turns into mud. The sculptor's face is covered with paste and
> all powdered with marble dust, so that he looks like a baker, and he is
> covered with minute chips, so that he looks as though he had been
> out in the snow.[1]

These remarks of Leonardo apply not only to stone-carving but
also to most of the other processes by which sculpture is pro-
duced. Clay-modelling, metalwork, plaster-work, and wood-
carving are just as arduous and messy as stone-carving.
Nevertheless few sculptors nowadays would look upon this
aspect of their art as a merely unfortunate servitude to physical
labour and material things. On the contrary, as the involvement
with materials is an intimate part of the process of creating
sculpture, most sculptors love their materials and do not resent
but enjoy the hard physical work of producing sculpture. There
is something about overcoming the resistance of obstinate
materials that is deeply satisfying, especially when the aim is to
convert mere mass into intelligible form.

It cannot be repeated too often, obvious though it is, that a
sculpture is produced by a sculptor *working a material* in order to
give it a form and that a finished sculpture is a *form embodied in a
material*. No matter how much some modern sculptors may
yearn for immateriality, turning from a sculpture of solids to a
sculpture of space and trying to define that space with such
minimal and ghost-like substances as transparent sheets of
perspex and gossamer thin nylon threads, the brute reality of
sculpture, which makes it part of the general furniture of the
world, is inescapable. Sculptures are enduring objects existing
in the same kind of three-dimensional space and in the same

[1] *Leonardo da Vinci: The Literary Works*, ed. and trans. J. P. Richter and
Irma A. Richter (2nd ed., Oxford, 1939), I. 91.

way as other material objects, and in this respect they differ from pictures, music, and literature. This does not make sculpture in any way superior or inferior to the other arts, but it does involve it with materials in a special and deeply intimate way.

From the point of view of the appreciation of sculpture the most important questions about materials are: In what ways and to what extent do they contribute to the total expressive form of the finished work? How much is it necessary to know about them? No all-embracing answers can be given to these questions because the attitudes of sculptors towards their materials have not been always and everywhere the same. They have in fact ranged between two extremes. On the one hand there have been sculptors who have used materials merely to embody their ideas without showing any special concern for the particular qualities of the materials themselves. They may even go so far as to produce versions or casts of their work in a variety of materials. On the other hand there have been sculptors who have sought their ideas in the material itself, allowing it to dominate their will to form and becoming almost subservient to it. Such extremists are rare, however, even today, and the most common attitude has always been one of some degree of cooperation or collaboration with the material, a partnership in which the sculptor has conceived his idea with the nature of the material in mind and has allowed the material to contribute its own qualities to the work, influencing the form as it develops and imparting a special flavour to it without dominating it.

The approach of the person looking at sculpture should therefore be flexible. He must be prepared to consider sculpture in which the qualities of the material make a more or less significant or more or less insignificant contribution to the whole work. The main danger which attends our approach to this aspect of sculpture is that of entertaining preconceptions about the role materials *should* play. In this connection, the controversy about 'truth to materials' is instructive.

TRUTH TO MATERIALS Because they felt that their predecessors and many of their contemporaries had lost all feeling for the intimate connection between form and materials, some of the sculptors of the early 'heroic' days of modern sculpture adopted an attitude which is summed up in the phrase 'truth to materials'. This became the battle-cry of artists like Modigliani, Gaudier Brzeska, Brancusi,

Eric Gill, Epstein, and later of Henry Moore, who were trying to re-establish what is known as 'direct carving'. They were reacting against the process common in the late nineteenth and early twentieth century of producing a carving by first modelling the work in clay and then using a pointing machine (a sort of three-dimensional tracing machine) for reproducing it in stone. This 'pointing up', as it was called, was usually carried out not by the sculptor himself but by assistant craftsmen. By this process a sculpture that may have been conceived in clay could be petrified, so to speak, in marble or some other stone. The qualities that come from directly carving the stone tended to be lost, but pointing up by no means always led to the production of bad work; it just sometimes led to the production of work that was not particularly suitable for stone. Rodin's carvings were produced in this way.

The kinds of sculpture that were most admired by the direct carvers were Early Greek, Sumerian, Mexican, and medieval, especially Romanesque, carving, in all of which the qualities of stone are exploited to great advantage. Like most reactions, 'truth to materials' went too far and some sculptors became almost afraid to impose their will on the material at all. Crouching figures were tortured into cubic blocks, and pieces of wood split from the trunk along their natural grain were sandpapered, wax polished and presented as works of art. It also became fashionable to disparage the work of many sculptors of the past—even sculptors as great as Bernini, who used stone with incredible freedom and skill—because they forced their material to take on forms that were considered not to be 'stone-like'. Of course, anyone who merely in order to demonstrate his skill tries to imitate the forms of crumpled fabric in a hard stone like marble must be at a loss how to occupy a great deal of spare time. But Bernini used his drapery as part of the dynamic forms of his compositions and in order to get the complex effects of chiaroscuro that he wanted in his work. He delighted in complexity and treated the qualities of stone as a challenge rather than as something that must be accepted. The Late Gothic cathedral builders did something rather similar when they achieved their light-weight, soaring structures and the complex laciness of their tracery in spite of the heaviness, brittleness, and general intractability of stone.

What kinds of form are 'right' for a particular material is to a certain extent a matter of opinion. Compare, for example, the

statements of these two sculptors: 'He who perforates the stone destroys the plastic impression that dwells in it. A hole in the block of a piece of sculpture is in most cases nothing but the expression of impotence and weakness' (Fritz Wotruba).[1] 'A piece of sculpture can have a hole through it and not be weakened—if the hole is of a studied size, shape, and direction. The first hole made through a piece of stone is a revelation' (Henry Moore).[2] Moore's 'if' and Wotruba's 'in most cases' probably render these two statements not entirely irreconcilable; but they serve as a warning against being too dogmatic about what may or may not be done in a material.

THE SENSORY AND STRUCTURAL PROPERTIES OF MATERIALS

There are two main ways in which the materials of sculpture may contribute to the finished work. In the first place they bring to it their own sensory properties. Like all materials, the materials of sculpture have visual and tactual properties of their own. Most sculptors bear these in mind as they work, exploiting them so that they become part of the total organization of qualities that is presented to our senses by the work.

The beauty of its materials is one of the most easily appreciated aspects of sculpture. The well-known translucency of marble, that seems to reflect light from below its surface, giving it a marvellous glow; the soft pinks of Indian sandstone; the rich colours and gleaming quartz flecks of polished granite; the hard blackness of old oak; the deep, figured brown of mahogany; the broad, open-textured grain of elm; the dry, warm earthiness of terracotta; the wonderful green patina of ancient bronzes and the soft sheen of polished lead—all these properties of materials are immediate and pretty well universal in their appeal. But they can also be seductive in themselves and divert attention from the formal qualities of the work. We may find ourselves admiring a beautiful piece of material instead of looking at the sculpture. I have even heard it seriously suggested that in order to avoid this danger all sculpture should be painted white. While there is no need for such extremes of aesthetic austerity, it is as well to remember that there are many bad sculptures and *objets d'art* made from beautiful materials and that the materials from which great masterpieces of sculpture are made are not always the most attractive in themselves.

[1] Quoted in *Fritz Wotruba* (from his private notebooks; Neuchâtel, 1961), p. 9.

[2] 'Notes on Sculpture.'

We should remember, too, that in most of the sculpture of the past the natural visual qualities of wood, stone, terracotta, etc., which our modern sensibilities find enjoyable, were concealed under layers of applied gesso and pigment. Nearly all the sculpture produced before the Renaissance was coloured artificially. In many cases the final perfecting of the form of the sculpture was carried out in a layer of gesso laid over the wood or stone as a surface for the paint to adhere to. Greek, Indian, and medieval carvings were elaborately painted and a great deal of care was devoted to this part of the work. It is known, for example, that such great painters as Van de Weyden, Jan Van Eyck, and the Master of Flémalle undertook the colouring of carvings as part of their normal work. What a tragedy it is that none of this survives and that we can only guess what a carving coloured by Van der Weyden would look like!

The properties of materials may be exploited by sculptors in different ways to achieve a variety of qualities in the finished work. For example, a sculptor intending to use the smooth, polished surfaces that are possible with bronze may follow a long and complicated procedure, bearing in mind all the time the kind of finished result he wants. First he will bring his clay model to a high degree of surface finish and then, having taken a plaster mould from the clay, will work on the inside of this. Then he will take a plaster cast from the mould and perfect the surface of this. At this point he will usually hand the plaster cast over to a foundry to be cast in bronze, perhaps going along to the foundry to do some work on the wax model that the foundry makes from his plaster cast. When this is done he will work on the surface of the bronze, filing, chasing, and polishing it until it is as finished as he wants it to be. Another sculptor using the same materials may aim to exploit other possibilities and achieve quite different qualities. For example he may hack and scratch the surface of a clay portrait in order to create a texture which, when cast in bronze and polished, will gleam on its raised edges and stay dull and oxidized in its recesses, thus producing a surface which is a metallic equivalent for the skin of an old person furrowed and ravaged by time or which is intended to introduce some other special, expressive quality into the work.

In addition to their visual and tactual properties the materials of sculpture have important physical, structural properties which present the sculptor with different opportunities and

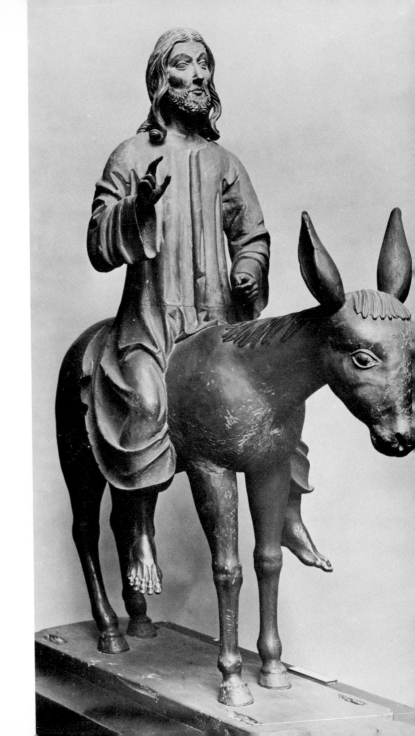

CHRIST ON THE ASS,
German, 16th century;
wood, H. 4 ft. 10 in.
*Victoria and Albert
Museum. Crown Copyright*

problems. They may suggest certain ways of forming the materials and discourage others by making some kinds of form easy to achieve and others difficult or impossible. A soft, crumbly stone like Bath stone demands a broad approach, whereas a hard compact stone like marble will lend itself readily to the carving of fine detail. The fibrous strength of wood, which enables the branches of trees to reach far out into space and ride the wind, also enables the sculptor to create slender, open forms or forms with narrow waists. Again, as we have 80 previously noted, the use of sheet metal tends to confine the sculptor to plane and single-curved surfaces.

The structural properties of materials may affect the forms of both figurative and abstract sculpture. In abstract sculpture the possibilities latent in his materials are the only limitation on the complete freedom which the sculptor would otherwise have; yet paradoxically they may also stimulate his inventiveness. Being free from the necessity of representing any natural form, he may engage his whole attention in exploring and exploiting the properties of his materials and may make it his concern to evolve forms that are particularly suitable to them.

TECHNICAL PROCESSES Intimately connected with the structural and sensory properties of materials are the technical processes used in working them. From the point of view of appreciation it would seem to be reasonable to argue that it does not matter much how the sculpture was arrived at; it is the finished product that counts. There are, however, many features present in the finished work which can only be understood and appreciated as the outcome of a technical process. We can enjoy the sculpture without knowing how it was produced, just as we can enjoy an etching or piece of Chinese calligraphy without knowing how they were produced; but our appreciation would be impaired. Consider, for example, the loosely modelled surfaces of Degas's small bronzes and Epstein's portraits. In these we can sense the 81, 83 smearing and kneading of the wax and clay as the artist builds up the forms or draws detail on the surface, like the brushwork of Rembrandt or the heavy impasto of Van Gogh. The surfaces of Michelangelo's carvings which are left with the marks of the 78 claw chisel and point on them are other examples. Even the completely smooth, tight surfaces of the Mexican mask of *Xipe Totec* (Flayed One) in the British Museum has a quality that 82

facing page
1 DANCER LOOKING AT THE SOLE OF HER RIGHT FOOT (*c.* 1911) by Edgar Degas; bronze, 18½ in. *Tate Gallery*

192

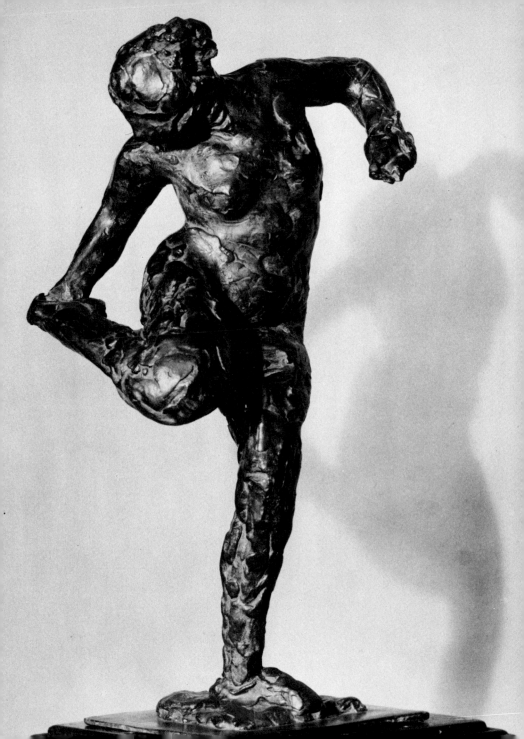

can be attributed to the sculptor's dependence on abrasion rather than carving, for the Mexicans had no metal tools.

Far more important than these surface qualities, however, are the deeper influences that technical processes may have on the structure and composition of the work.

The three main processes by which sculpture is made are modelling, carving, and construction. Each of these, in the normal course of events, produces sculpture with different aesthetic qualities and requires a somewhat different approach from the spectator. We shall consider each of them in turn.

Modelling Modelling is essentially a process by which the forms of sculpture are built up piece by piece out of plastic materials like clay, wax, and plaster, perhaps round an internal metal or wooden support (the armature) if the design demands it. The process results in characteristic effects on both the formal structure of the sculpture and its composition, or arrangement in space.

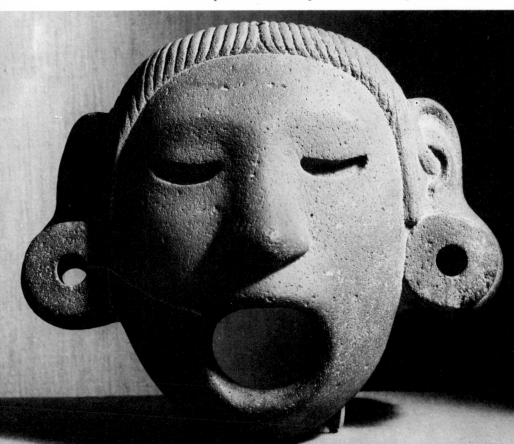

The most important thing about modelling as a means of creating a structure of solid forms is that it provides opportunities for actually constructing the underlying forms; the finished work is arrived at as the culmination of a process of growth from the inside and the internal structure may actually be modelled. The exterior of the sculpture may then be thought of not as the surface of a solid homogeneous lump, shaped from the outside by pressing or cutting like baker's dough or a piece of cheese, but as the external manifestation of a more or less complex internal structure of impacted and articulated three-dimensional solid forms.

The surface of a modelled figure may become extremely complex but the complexity will be an ordered one in which the main principle of order lies beneath the surface, in the arrangement and shape of the underlying main volumes around which all the minor forms are clustered.

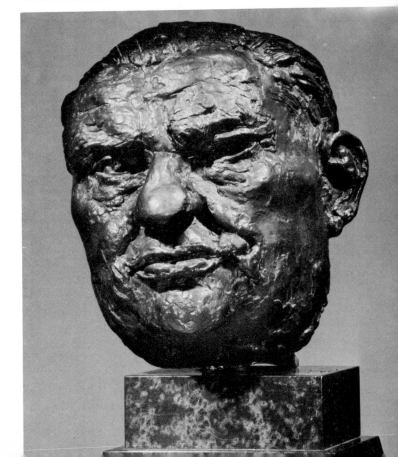

ft
*M*ask of Xipe Totec, Mexican, *1*4th century; andesite, 9 in. *B*ritish Museum (photo: *Edwin* *Smith*)

ight
*T*HE RT HON. ERNEST BEVIN *(*1943) by Jacob Epstein; *b*ronze, life-size. *Tate Gallery*

The most important *spatial* characteristic of modelling is its freedom. There is no frame of reference provided by the limits of a block of stone or piece of wood and, given adequate internal support, there is nothing to prevent its expansion in any direction. Modelled figure sculpture, therefore, may exhibit a degree of spatial freedom which is impossible in stone or only possible if enormous efforts are made to overcome the natural structural limitations of stone. When the casting of clay models is done in metals such as bronze or aluminium, which have great tensile strength, the spatial freedom becomes almost unlimited. It is then easy to stand a figure on one leg or to throw its arms wide of the body and to represent it in the most energetic poses. 84

Of course, a great deal of modelled sculpture does not have the structural and compositional qualities we have just described. It may be arrived at by carving and pressing into a lump of clay or by pinching and pulling it about. There is nothing wrong with such methods except that the results they produce are not usually of great plastic interest.

It is not surprising that the main advances in the spatial freedom and the movement of free-standing statuary have resulted from the modelling technique. Almost all the stone-carved sculptures of India are in relief. The best free-standing works are the bronzes which were intended to be carried in processions. And although the magnificent sculpture of the Khmer includes some free-standing figures in stone, which are very beautiful,

we know from inscriptions that the chief idols at Angkor were made of metal, usually some precious metal, and that stone was only good enough for secondary works. We are, therefore forced, as in the case of classical Greek sculpture, to judge Khmer statuary by the least important examples. The Vishnu from Mebon and the Siva from Por Loboeuk make us fully aware of the differences which existed between these two techniques. Free from the limitations imposed on the stone carver and with no need for a frontal pose, this great bronze [the Vishnu] sails through space with incomparable authority.[1]

The main steps in the achievement of movement and spatial freedom in Greek sculpture were also taken in modelling. Unfortunately most of the originals, like most of their Khmer counterparts, have been lost in the melting pot; but in the case of the Greek bronzes a number of copies in stone of some of the

[1] B. P. Groslier, *Indochina* (trans. Lawrence, London, 1962), p. 132.

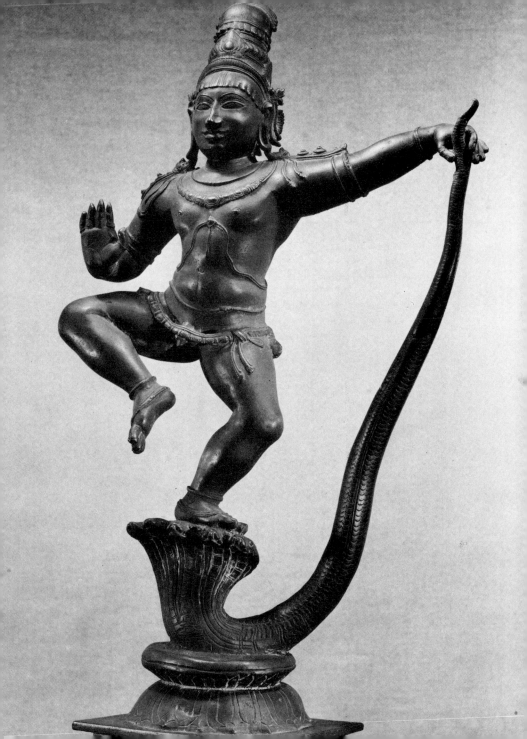

most renowned examples have come down to us. The frontal stone figures of youths and maidens from the Archaic period contain no suggestion of an internal structure except the incised outline of anatomical parts such as the thoracic arch or the ridge at the top of the shoulder blades. But by the classical period the sculptures had acquired both internal structure and a complex and extraordinarily subtle plastic surface. All the delicate ambiguities of flesh and bone are translated into a completely intelligible configuration of sculptural forms. We know that Myron and Polyclitus worked in bronze and it seems impossible to doubt that the earlier steps in this development were taken in the same medium before they were transferred to stone. The classical Greek schema for the figure seems clearly to have developed largely as a result of modelling.

The primacy of modelling in the development of free-standing sculpture in classical Greece was of immense importance to the development of Renaissance and post-Renaissance sculpture in Europe. The classical model has been the one to which European sculptors have returned again and again. The great Italian stylistic innovators—Donatello, Michelangelo, Bologna, and Bernini—and hosts of lesser sculptors have found in the Greek schema something that they needed. Unfortunately, genuine examples of Greek sculpture are few and many of these have been discovered only recently. What these sculptors turned to were for the most part Roman copies in stone of Greek bronze sculptures or late Greek and Hellenistic works which exploited in stone the styles that had developed much earlier in bronze. This has resulted in the domination of European stone sculpture by conceptions which derive ultimately from modelling.

Another way in which modelling has affected European stone-carving is through the use of preliminary clay models. They began to be used by Greek carvers at the time when they were breaking away from the spatial strait-jacket of the four faces of the block and attempting to vary the movement of the figure. Deprived of the easily grasped relationship between a block and a four-square sculpture, they needed to refer to a clay model in order to find their way about in the stone. It is extremely difficult to visualize in a block of stone the whereabouts of the parts of a figure in a complicated pose.

During the Renaissance small sketch models in wax or clay and full-size clay models were frequently used. Michelangelo,

Bernini, and Bologna made use of full-scale models for some of their work, and Michelangelo sometimes, and the other two often, left the execution of a great part of their work in stone to their assistants. In the hands of anyone not really sympathetic to stone as a material such a procedure can, and in the eighteenth and nineteenth centuries frequently did, lead to the mere translation into marble of what were basically modelled conceptions. The pointing-up in marble of clay models in a mechanical fashion by craftsmen assistants represented the final phase of the domination of European carving by modelling. It is no wonder that twentieth-century sculptors came to regard carving as a lost art in Europe and turned for inspiration to Sumerian, Assyrian, Egyptian, and Mexican stone-carving—traditions in which there was no trace of the influence of either modelling or Greek sculpture.

One unfortunate result of the ending of the long love affair between European sculptors and what used to be called 'the antique' is an unbalanced emotional antipathy to the whole tradition that stems from or is related to it—an antipathy which often does not discriminate between the brilliant originals and the innumerable second-rate works that have been derived from them. Rightly suspicious of anything which suggests a mindless reproduction of the forms of the figure, many devotees of modern sculpture cannot find a way of coming to terms with the naturalism of an art that uses a structure of formal units derived from and closely resembling the actual forms of the human figure, and in which no particular respect was paid to the qualities which modern taste regards as the special qualities of stone. They fail to see that in the hands of the great Greek sculptors these methods resulted in the production of works which are as 'pure' an achievement of human sensibility and intelligence as anything by Brancusi or any other twentieth-century master.

Carving Although many sculptors practise both carving and modelling, the two processes and the materials they involve are so fundamentally different that they naturally tend to appeal to different kinds of creative temperament. Rodin's passionate naturalism and feeling for movement find their best expression through the more fluent and immediate process of modelling and in the soft plasticity of clay. It is easier to imprint one's feelings on a material which can be manipulated quickly, which records

every gesture and offers no resistance, than on a hard and re-sistant substance which can be shaped only by prolonged and laborious processes of patient manipulation. While neither technique is easy, and certain kinds of modelling can be as exacting in their own way as carving, modelling does lend itself more readily to the expression of romantic states of mind. The expression of feeling by carving demands considerable control and restraint. Carving is a slow, deliberate business demanding a high degree of what Eric Newton called 'artistic stamina'—that is the ability to sustain the emotional charge and excitement of an idea through weeks, months, and possibly even years of arduous work. Certainly, to attack a block of stone in the frenzied, eyeball-rolling state which some people associ-ate with artistic creativity would be to invite disaster.

In these and other ways carving is at the opposite pole from modelling. Whereas the modeller starts with nothing and builds his sculpture from the inside outwards, the carver starts with a lump of material and works from the outside by removing sur-plus material until he arrives at the final form. As in modelling, the process of carving imposes a characteristic pattern on the sculptor's thinking and manner of working. But while the modeller searches for simplified forms which underlie all the minor forms and other details and exclude them, the carver searches for simplified forms which are defined by planes that lie over the minor forms and other details and contain them. Having roughed out these general over-all forms the carver will cut into their surfaces, leaving the most projecting parts and working down to successive layers of detail. The first roughing out of a head, for example, may show no trace of the eyes. They will remain hidden, so to speak, under general planes that connect the ridge of the nose and the superciliary ridges and curve round to the ears. At the next stage the eye may be defined by a simple curved plane or boss. This may then be cut into in order to separate the upper and lower lids and to carve the eyeball itself, which may then be drilled or incised to represent the colour of the iris and pupil.

From this grossly oversimplified account of the process of carving we can see that the forms of carved sculpture tend naturally to be ordered from the outside inwards. Each group of smaller forms is contained within a larger, more general shape. The first of these large containing shapes is, of course, the shape of the block itself, within which the finished forms of

sculpture are, as it were, still confined. We can usually sense in finished carvings the large simple shapes of the block from which they were carved. They are implied in the space im- 62, 76 mediately surrounding the sculpture. There will appear to be connections across this space where the highpoints of the surfaces are lying in the same plane and where the most projecting parts of the composition reach the limits of the block. Thus carvings often seem to be contained within their own restricted envelope or capsule of space, which is roughly the shape of the piece of material from which they were carved, 59 while modelled sculptures enter much more freely into relations with surrounding space because the sculptor is not restricted by the boundaries of his material. This has, I think, a great deal to do with the special kinds of expressive qualities that we perceive in direct carvings. Many of them have about them a quality of timelessness and quiet repose; they are introverted, enclosed within their own private space, cut off from us by an invisible barrier that separates their space from ours. When this self-contained quality is combined with a static frontality, as it is in many African, medieval, and Egyptian carvings, the impression of an otherworldly remoteness can be extremely powerful. In many of Michelangelo's works the effect of this confinement to a private space is to enhance the feeling that the figure is imprisoned or restrained—a feeling which, as we have already noticed, is also expressed through other means in both the composition of the sculpture and the qualities of its component forms.

Construction We have discussed constructed sculpture under the heading of spatial sculpture, since it is the process by which most of this kind of work is made. As a method of producing sculpture it is a recent innovation. Its essential feature is that it is a technique of producing sculpture by assembling it mostly from preformed pieces of material. It is thus very different from the plastic and glyptic processes of building or carving forms in a homogeneous mass of material.

The formal qualities of constructed, or assembled, sculpture depend very much on the techniques and materials that are used, and since these include almost any of the techniques and materials of modern engineering, the sculptures are extremely diverse in their sensory and their constructional characteristics.

Sculpture can be produced in any material that can be worked into a form. The most common traditional materials are stone, wood, clay, metal—especially bronze—bone, and ivory. These are in fact the world's oldest and most important basic raw materials. In recent times this range of materials has been considerably extended, and concrete, new metal alloys, fibreglass, and compounds made with synthetic resins are tending to replace the traditional substances. Present-day sculptors are engaged in a great deal of experimentation with materials and techniques. We could go on at great length to describe all the materials that have been and are being used but we shall have to limit ourselves to a brief discussion of some of the qualities of the most common modelling material, clay, and its uses for making terracottas and bronzes, and of the most common carving material, stone. For the rest, if the reader wants to pursue this aspect of sculpture further, there is a number of good technical handbooks which are reasonably exhaustive in the information they provide.

Clay The most widely used modelling material is clay. It is cheap and almost universally available. Some beds of clay are better for modelling than others but clay of some kind can be obtained simply by digging in almost any country in the world. The different clays used by sculptors vary from the highly refined porcelains used for making delicate ceramic figures like those from Meissen to the coarse sandy fireclays used for making large terracottas. The natural colour of clay ranges from pure white through various yellows and buffs to warm pinks and more typical terracotta reds and browns.

Clay has two properties that make it exceedingly valuable as a material for sculpture. First, it is extremely malleable. Its plasticity varies with the amount of moisture it contains. When it is very wet it can be poured into moulds as a creamy fluid (slip), and when it is dry it can be scraped and scratched away as a fine powder. Between these two extremes it varies from a sticky mud (slurry) to what potters call a leather-hard stage, when it can be carved like cheese. With just the right amount of moisture it can become a marvellous non-sticky and highly plastic material which will record accurately the impression of even a fingerprint. Nobody can fully appreciate an Epstein portrait or a bronze by Rodin unless he acquires something of the sculptor's and potter's feeling for the delightful plasticity of clay.

facing page
85 Ivory Mask, African (Benin), 16th century; 9 in. *British Museum*

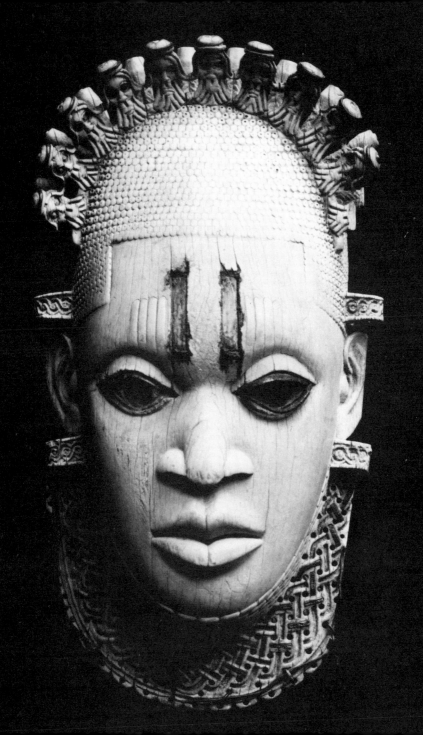

The other important thing about clay is the change that takes place in it when it is fired. When thoroughly dried and submitted to temperatures of between about 700°C. and 1400°C. under controlled conditions, its structure changes: it loses its chemically combined water and becomes hard and durable, almost, in fact, imperishable. This process of firing, which bricks and pottery also undergo, makes it possible for the sculptor to work in plastic clay and then turn his model, more or less as it stands, into something hard and permanent.

The two main sculptural uses of clay are for making ceramic sculptures, or terracottas, and for making models which are subsequently reproduced by casting in such materials as plaster, bronze, aluminium, lead, and concrete.

Terracotta Terracotta (baked earth) is one of the oldest and most widespread of sculptor's materials. In neolithic times small decorated animals and figures were made by pinching and squeezing clay into shape, rather as children still do today if left to their own devices. More sophisticated ceramic sculptures were produced by the Greeks, the best known being the charming statuettes from Tanagra. The ancient Chinese, as one might expect considering their superb tradition of pottery, produced magnificent ceramic sculptures of which the most widely 87 admired are the glazed and coloured animals and figures of the Tang dynasty. Many Pre-Columbian cultures also produced 86, 8 excellent terracottas. The Mayan people, in particular, used *Figs.* the plastic qualities of clay in a remarkably direct manner. The *80* forms of their figures are large and simple, and the costumes, jewellery, and fantastic headgear they wear are translated into sheets and coils of clay which are applied with astonishing freshness and impressed and engraved with the same vigour and feeling for the material that one finds in the best medieval earthenware.

Terracotta makes possible intricate and detailed modelling and highly textured surfaces which would be difficult, if not impossible, to cast. What it can do to perfection is exploit the plasticity of clay and provide an immediate record of the sculptor's handling of it. This quality is brilliantly exploited by Giovanni da Bologna in his model for a sculpture representing a *River God*. The wet-looking, smeared, and rippling surface 90 resulting from his fresh handling of the clay suggests the watery essence of the being it represents.

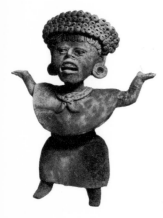

86 Terracotta Figurine of a Young Girl, Mexican (Totonac), AD 300–600; 12 in. (detail on facing page) *Museum of the American Indian, New York*

204

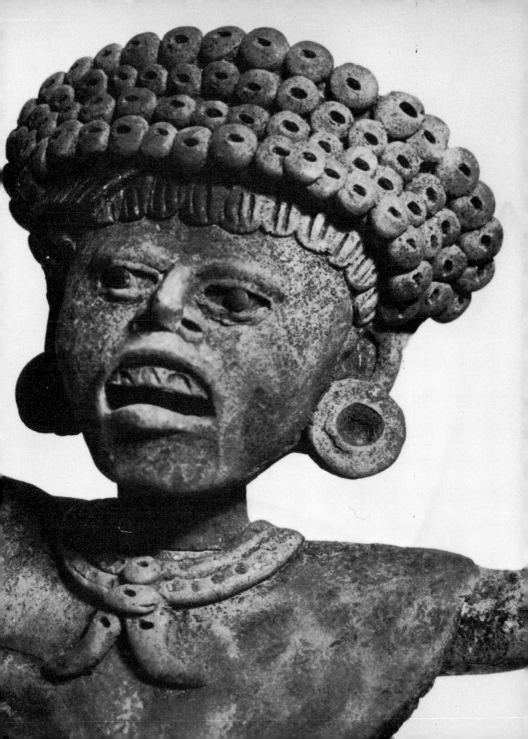

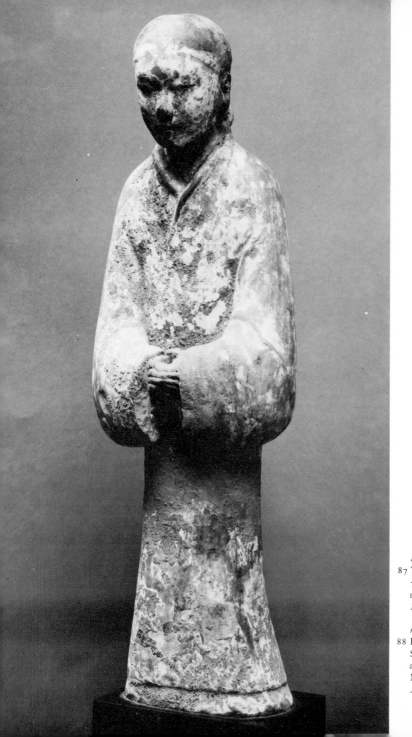

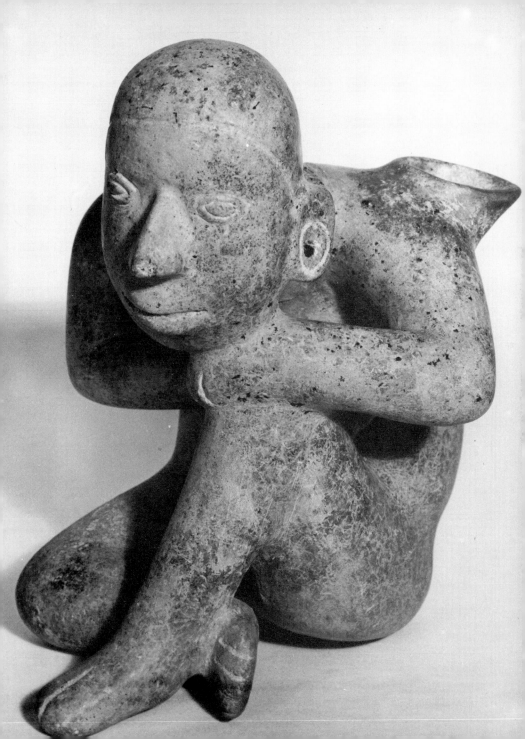

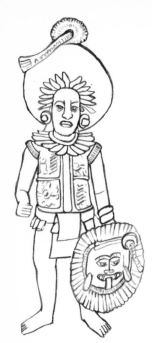

Fig. 79
Standing Warrior Figurine,
Mayan; terracotta, 12½ in.

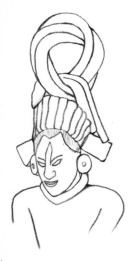

Fig. 80
Detail of Male Figurine,
Mayan; terracotta, 19·5 cm.

Another attractive feature of ceramic sculpture derives from the sophisticated techniques of colouring and glazing clay surfaces which potters have developed. The Chinese have done this superbly, as also have the della Robbias—a family of sculptors working in Italy during the fifteenth century. And if we include as sculpture all the small pottery figures of Meissen, Derby, Stafford, and other centres of commercial ceramics, the field, both of the sculpturally exciting and of the trivial and banal, is enormously extended.

Owing to the physical strains to which clay is subjected during the process of firing, terracottas are normally fired hollow with walls of an even thickness. When clay is fired it contracts by about one tenth owing to loss of moisture. A solid model made of ordinary clay would burst under the pressure of the expanding steam and one with walls of uneven thickness would be liable to warp and crack. There are two main methods of arriving at a model that will withstand the stresses of firing. One is actually to build it hollow in the first place and the other is to model it in solid clay and then scoop it out afterwards.

The first method is that most often used by sculptors who have been trained in the techniques of pottery. The main volumes are constructed by building up clay walls like the walls of a pot, by coiling, pinching, or throwing on the potter's wheel, and the details are added by attaching coils, slabs, or other preformed pieces of clay, rather as a potter attaches handles and spouts to the main body of a pot. In this method the nature of the materials and processes has to be taken into account at every stage. It encourages the imaginative use of materials and a great deal of formal inventiveness because the subject has to be translated into forms that are technically satisfactory rather than closely imitative. The kind of vitality these sculptures achieve is likely to be a vitality of clay forms—an equivalent for or translation of the vitality of real life into clay, not an attempt to reproduce it directly. This kind of vitality is very marked in the confident and vigorous inventiveness of the Mayan and some other Pre-Columbian terracottas.

Solid modelling has been practised on the whole by artists who have been trained as sculptors rather than as potters. It allows the sculptor to model more slowly and meticulously, piece by piece, and is more easily altered and corrected than hollow modelling. Because it allows the painstaking building up of forms, it has been favoured as a method by those sculptors

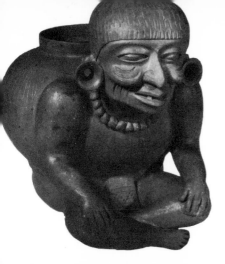

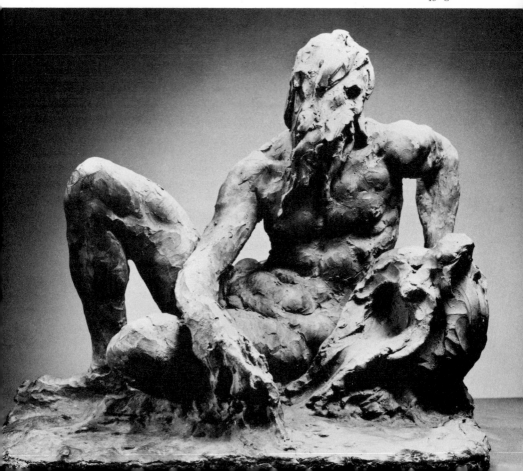

who aim to achieve a fair degree of naturalism in their work. It has, in fact, been the most common method of producing terracottas in post-medieval Europe.

A third way of dealing with the technical problems of terracotta modelling has been adopted by a number of twentieth-century sculptors. Instead of hollowing out the forms or building them hollow, they design them with sufficient voids and cavities to meet the technical requirements. Lipchitz, Zadkine, and Moore have done this. It is a method that is in keeping with the general tendency of twentieth-century sculpture to make more use of space. It also shows how the imagination of sculptors can be stimulated by the physical limitations of a material.

Bronze- and other metal-casting

Metal-casting is a technically involved and highly skilled process. Nowadays it is usually undertaken by professional founders, but there has not always been this division of labour in the production of metal sculpture. Ghiberti, for example, was his own bronze-founder, and Benvenuto Cellini, the Renaissance goldsmith and sculptor, has written in his *Autobiography* a wonderfully vivid and dramatic description of the casting in his own workshop of his large bronze sculpture, *Perseus*. Nothing conveys more vividly than this account of Cellini's deep involvement of sculptors with the technical, material aspects of their work.

Bronze is the most widely used metal for casting sculpture. It is an excellent material for outdoor use because it is structurally strong and highly resistant to corrosion. Clean bronze is a shiny golden colour and this is how it was used in ancient Greece and other civilizations of the past. The black, green and brown patinas which we nowadays admire so much in old bronzes are a result of the corrosive effects of the atmosphere or of immersion for centuries in sea-water or of burial in the ground. Most sculptors today prefer a patina to a clean bronze surface and use acids in order to patinate their work. It is important to remember that the colours of modern bronzes are chosen by the sculptor.

It is possible to cast almost any kind of modelled effect in bronze and the methods of building up the original model are very varied. In the past the most common materials for these preliminary models were wax and clay but it is becoming an accepted practice to work directly in plaster.

A sculptor who is working in plastic materials like wax or

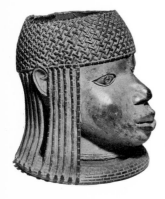

91 Bronze Head, African (Benin), 16th century. *Royal Scottish Museum, Edinburgh*

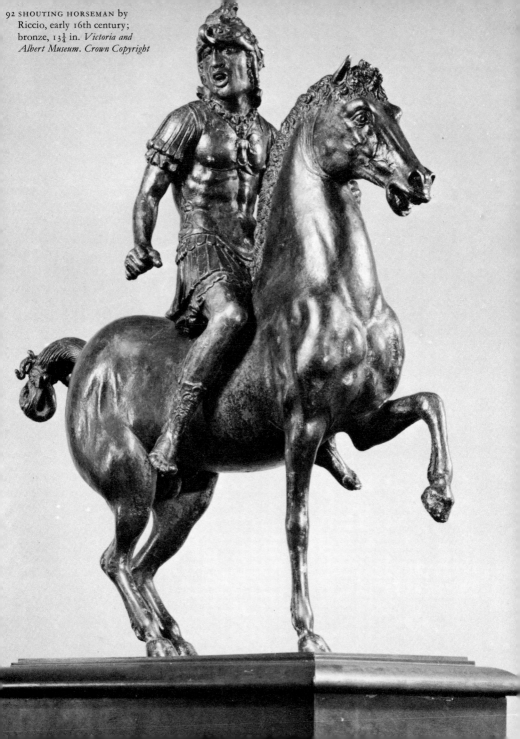

92 SHOUTING HORSEMAN by Riccio, early 16th century; bronze, 13¼ in. *Victoria and Albert Museum. Crown Copyright*

clay may use bronze simply as a means of making permanent a model whose qualities are primarily ones that derive from the modelling material. Bronze brings out to perfection the qualities of modelled surfaces. The light will catch the edges of the merest flick of clay or dribble of wax and will show up the smallest bumps, changes of plane, and indentations of the surface. When we look at a typical bronze by Epstein or Medardo Rosso 8 or at one of the casts made from Degas's little wax models of 8 dancers, what strikes us most forcibly about the material is the brilliant handling of the clay or wax, not the use of the metal.

In the Benin bronze heads and Indian bronze figures, on the 26 other hand, it is the use of the metal rather than the plastic 47 modelling material that we admire. All traces of personal handling have been removed by polishing and chasing the surface and it is obvious that the sculptor was continually thinking of and working towards the final product in metal. Bronze is an excellent material for highlighting and stressing the full roundedness of the volumes of these sculptures and for bringing out the intricate and delicate decorative features that are added to their surfaces.

Somewhere between the smooth impersonal rotundities of Indian bronzes and the rugged, 'handwritten' quality of Epstein's lie the intricate and plastically varied surfaces of such sculptures as the superb little bronzes of Riccio—a sculptor who worked at Padua during the first half of the sixteenth century and may claim to be the greatest master of the small bronze who has ever lived. The knotted complexity of surface of his *Shouting* 92 *Horseman* is not merely textural but is a result of Riccio's complete understanding of the inner structure of the figures of man and horse and reveals an ability to model forms that are expressive of great energy and inner tension. The delightfully fresh and fluid surfaces of his *Satyr and Satyress* express an 93 entirely different mood.

In many of his works Rodin makes marvellous use of the metallic reflections of dark, polished bronze, creating out of the muscular structure of the figure a rippling, light-breaking movement of surfaces which many critics have likened to qualities in the paintings of his contemporaries, the Impressionists.

93 SATYR AND SATYRESS by Riccio, early 16th century; bronze, 9½ in. (detail on facing page) *Victoria and Albert Museum. Crown Copyright*

Stone Stone is the most common of all sculptural materials and is the one that everybody associates most readily with sculpture.

There are many reasons for this, but perhaps the main one is that most of the important buildings of the past have been made of stone and their architects have used stone sculpture as decoration or in close association with the fabric of the building. Sometimes the component structural parts of the building have been carved into sculpture; or again the sculpture may be a separate object added to the building. In medieval churches such structural parts as the capitals of columns, corbels, tympana, roof bosses, door jambs, and water spouts were turned into sculpture, and the interior screens and exterior west walls of larger churches were inhabited from top to bottom by rows of carved stone figures. Greek temples had stone carved figure groups on their pediments and along their sides. In India and elsewhere in South-East Asia temples were elaborately decor- 94 ated with stone carvings inside and outside, while in some cases the temple itself was carved from the solid rock as though it were a huge piece of sculpture. Egyptian and Mexican stone carvings are also mostly associated with stone temples.

Another important use of stone has been for commemorative monuments and tomb sculptures. Being man's attempt to transcend time and decay, they have been made as permanent as possible. The ideal material for this purpose is stone.

The beauty of stone is known to everyone. It has a wide range of colours varying from the scintillating whiteness of some marbles through subtle variations of the whole spectrum to the deep black of diorite. It may be streaked with veins of mineral deposit, broken up into little patches of varying colour by its different constituents, or irregularly patterned by fossilized shells. Some stones will take a mirror-like polish, others are loose conglomerations of particles that will always remain crumbly.

All stones are lacking in tensile strength and some will fracture very easily when given a sharp blow. For this reason stone sculptures tend to be made compact and thick, and easily fractured projections are avoided. The vulnerability of projecting limbs and thin necks and ankles can be gauged from the present fragmentary state of most Greek carvings.

The hardness of stone is extremely variable. Alabaster is soft and easily worked; it can be cut with a knife. Granite is very hard and has usually been pounded away as a powder by hammer blows and rubbed away by abrasives. The methods and tools used for stone carving in any particular time and place

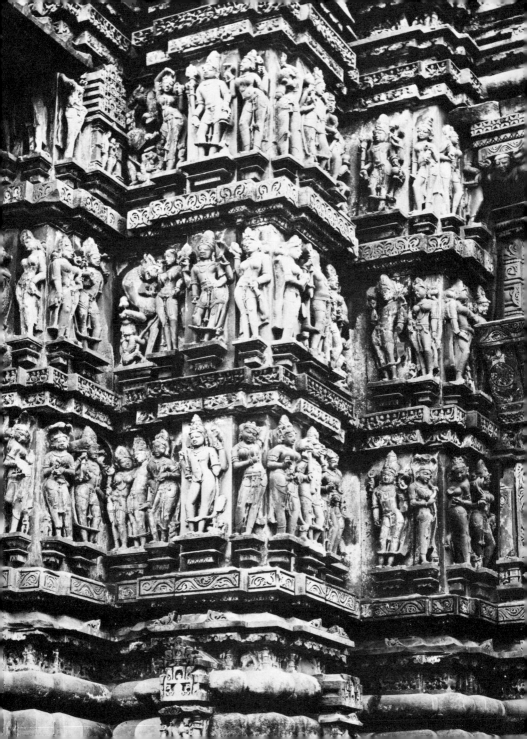

depend partly on the nature of the stone and partly on the level of technological development. The Mexicans had no metal tools; the Egyptians had only copper and bronze; we have specially tipped steel tools that will carve almost anything.

The two main ways of carving stone are by cutting and abrading. Each process yields different qualities in the finished work. Gothic sculpture is cut, mostly out of medium-hard stones, with metal chisels. The effect of this is to produce a general crispness and boldness in the forms. Edges tend to be sharp; lines are clear cut and are often engraved; the stone may be cut to a considerable depth and even undercut; the minor forms—folds of drapery, hair, eyes, etc.—may be boldly carved and deeply cut away from the main body of the sculpture; violent changes of plane and sharp angles are common.

Abraded sculpture is produced by rubbing the stone and wearing it away with sharp abrasive materials such as emery. Edges, therefore, tend to be softer; one form blends into another; the surface is not so deeply penetrated; the minor forms 82 do not project so much; changes of angle are less violent and less frequent. Wavy or curly hair, deeply fluted drapery, and boldly projecting muscle forms tend to be avoided. The overall effect is usually one of smoothness, gradual transitions, large planes, and shallow surface forms. The representation of drapery by long shallow flutings and the general blending of forms that are apparent in Egyptian sculpture in hard stone are 56 typical effects of the use of abrasion.

THE RANGE OF STYLES Sooner or later in any discussion about the visual arts the question of their relation to nature is bound to arise. It is the one aspect of the visual arts which many people find more bewildering than any other, and for some reason it arouses more passionate and heated arguments than any other. From the point of view of the appreciation of sculpture it is a particularly important question, since the attitude we adopt towards it can have far-reaching effects on our capacity to appreciate whole sectors of the sculpture of the past and present. Many people today, for example, find themselves unable to come to terms with the naturalism of Greek and Renaissance sculpture; others can find no way of approaching abstract sculpture or styles of sculpture in which natural objects undergo radical transformations. Such failures in appreciation are due for the most part to an unwillingness or inability to see that a great many different kinds of relation between sculpture and nature are possible and that most of them have resulted in the production of masterpieces of different kinds. Tolerance, receptiveness, and an attempt to see what has actually been achieved in the works themselves should enable us to appreciate what is good in any style.

In this chapter we shall look briefly at the variety of relations that have existed between sculpture and natural forms from complete realism to completely non-figurative sculpture. The outer limits of this range may be defined by two extreme attitudes that it is possible for a sculptor to adopt. On the one hand he may attempt to make a completely accurate reproduction of the forms of natural objects; on the other hand he may try to eliminate all resemblance to natural objects, even going to the extent of trying to suppress anything that may give rise in the spectator's mind to associations with them. For the former, sculpture is essentially an imitation of nature; for the second, it is an autonomous creative activity. Between these two outer limits lies the bulk of the world's sculpture. Some of it tends towards one extreme, some towards the other. We could, in fact, make some loose kind of arrangement of all the sculpture in the world, putting works which very closely resemble natural objects at one end and completely non-figurative works at the

other. Such an arrangement would not sort itself out neatly into large groups corresponding to different civilizations and periods. We should find works from all over the world and from widely separated periods grouped together at all points on a scale running from realistic to abstract.

<div style="display: flex;">

THE IMITATION OF NATURE

Because its space is our own familiar space and its third dimension is real and not 'illusory' or conventional as in painting, sculpture can imitate natural objects very convincingly, especially if it is coloured. But the human figure and animals are made of flesh, bone, skin, and hair and they move and are alive, while sculptural imitations are made of bronze, stone, and so on, and are static lumps of non-living matter. Even the closest imitation of men and animals in sculpture can only reproduce their superficially visible shapes in one position at one moment of time and in a dead material. Perhaps plaster casts and waxworks are the closest imitations we have of the human figure. But nobody is likely to claim that these are works of art. Yet there have been many artists who have recommended their pupils to imitate nature faithfully or have asserted that this is what they themselves are trying to do. Rodin, for example, claimed that 'there is no need to create . . . genius only comes to those who know how to use their eyes and their intelligence'.

</div>

What then are the differences between the imitation of nature in a plaster cast or waxwork and in, say, Rodin's *Saint John the Baptist*? First, and most important, the form of Rodin's *Saint John* is a product of human intelligence and not a mechanical copy like the plaster cast. And, unlike the waxwork, its aim is not to give us the illusion of real life by providing the kind of visual clues that are likely to deceive us into thinking that it is real. It is, rather, a modelled reconstruction of the expressive forms of the human figure as they were observed by one of the most extraordinarily acute and sensitive visual intelligences the world has known. Human vision and skill are not impartial, objective, and unfeeling like photography and plaster-casting. It is not our visual apparatus—retinas, etc.—that observes the world or our hands alone which make works of art. We do so as complete persons, and our observations and records of what we have observed are coloured by our personalities and interests, which in turn are affected by such complex factors as our social background, training, and nationality. Rodin's sculpture is imbued throughout with an expressiveness which we recognize

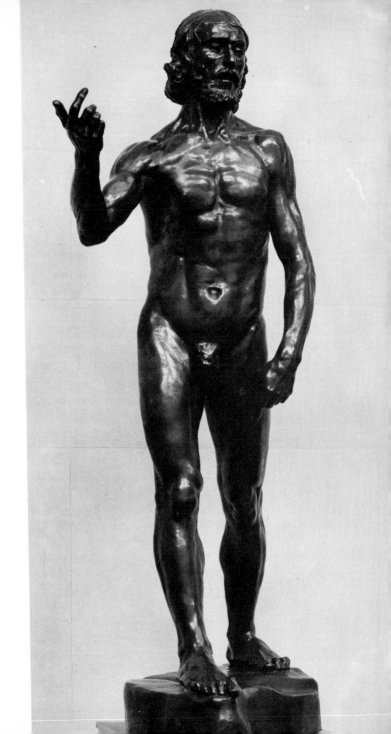

SAINT JOHN THE BAPTIST
(1878) by Auguste Rodin;
bronze, 200 cm. *Tate Gallery*

at once as a special quality of the work of Rodin and of nobody else, and it also has qualities which are typical of its period and place of origin. Perhaps in the *Saint John* he did model exactly what he saw. He certainly believed that 'there is no chaos in the human body. It is the model for everything, the beginning and end of everything.' But we see only what we have the capacity to see, and who but Rodin had the sensitivity, perceptiveness, knowledge, passion, and skill to see and model as he did the expressive form of this hard, ascetic body? Who else could have given it such virile energy, such a powerful over-all rhythm and tenseness, and such unity of character in all its forms, or seen its anatomy in terms of these rippling bronze surfaces?

Much of the confusion over the validity of naturalism in art has arisen from the use of such misleading phrases as 'copy from nature', 'faithful imitation of nature', and 'photographic verisimilitude'—phrases which may define what some painters and sculptors may have considered to be their aims but which cannot possibly describe their achievements. The subtlety, complexity, and variety of the forms of the main subject matter of sculpture—the nude and draped human figure and the figures of animals—are so great that in attempting to see them clearly each artist sees only certain configurations, certain kinds of relationships and expression in them, and the work he produces as a record of his observations is inevitably personal. It is not the degree of 'likeness' that we see in his work which determines its value as a work of art but the order and expressiveness he has perceived in the forms of his model and recorded in his work. One of the main reasons why it has even been possible to make an important art form out of the attempt to imitate men and animals in sculptural materials is the fact that as subject matter they are sufficiently subtle, complex, and varied to stretch human powers of perception to the utmost and to provide opportunities for varied interpretation. This is nowhere more apparent than in portraiture.

Portrait sculpture is of necessity closely bound up with the observation of natural form. The portrait sculptor works from a model, selecting and stressing what the model possesses as a unique individual. If the portrait is to be successful there must be something in the model which makes the sculptor want to work on that particular head or which captures his interest after he has started working. It may be a fleeting individual quality of expression that can only be caught or suggested in a loose and

sketchy treatment, or it may be some quality in the structure of the head which has to be patiently analysed and painstakingly modelled or carved. If the sculpture is to be a portrait and not just a study of a head or a sculptural exercise based on the forms of the head, the sculptor will be concerned with what he sees as most representative of the character of his sitter and will therefore stress those features and qualities that seem to him to be peculiarly the sitter's own. Epstein has had this to say about his own method:

In my portraits it is assumed that I start out with a definite conception of my sitter's character. On the contrary, I have no such conception whatever in the beginning. The sitter arrives in the studio, mounts the stand, and I begin my study. My aim, to start with, is entirely constructive. With scientific precision I make a quite coldly thought out construction of the form, giving the bony formations around the eyes, the ridge of the nose, mouth, and cheek-bones, and defining the relations of the different parts of the skull to each other. As the work proceeds, I note the expression and change of expression, and the character of the model begins to impress itself on me. In the end by a natural process of observation, the mental and physiological characteristics of the sitter impose themselves upon the clay. This process is natural and not preconceived.[1]

The portrait sculptor may be caught on the horns of a dilemma, between the need on the one hand to do justice to the sitter's character and on the other to produce a well-designed sculptural composition. Part of the art of portraiture lies in finding a satisfactory solution to this dilemma. Some sculptors produce extremely fine heads with beautiful and well-composed forms but lacking in character and individuality; others concentrate less on the design of the head and aim primarily at the expression of character. It is remarkable what varied solutions to the problems of portrait sculpture there have been. Compare, for example, the numerous excellent portraits in Egyptian sculp- 57 ture with those of the Romans, for whom portraiture was the main kind of sculpture, or the Ife portraits with those of 3, 83 Epstein and Marini, or to take the most extreme of all possible contrasts, Bernini's *Louis XIV* with Brancusi's *Mlle Pogany*. 96, 97

There are many different degrees of naturalism. We say, for example, that Rodin's work is more naturalistic than classical Greek sculpture, that Greek sculpture became increasingly naturalistic between the sixth and third centuries B.C., that

page 222
LOUIS XIV (1665) by Giovanni *Bernini*; marble, 38¾ in. *Palace of Versailles* (photo: *Mansell/ Alinari*)

page 223
MLLE POGANY (1931) by *Constantin Brancusi*; marble, 27½ in. *The Louise and Walter Arensberg Collection, Philadelphia Museum of Art*

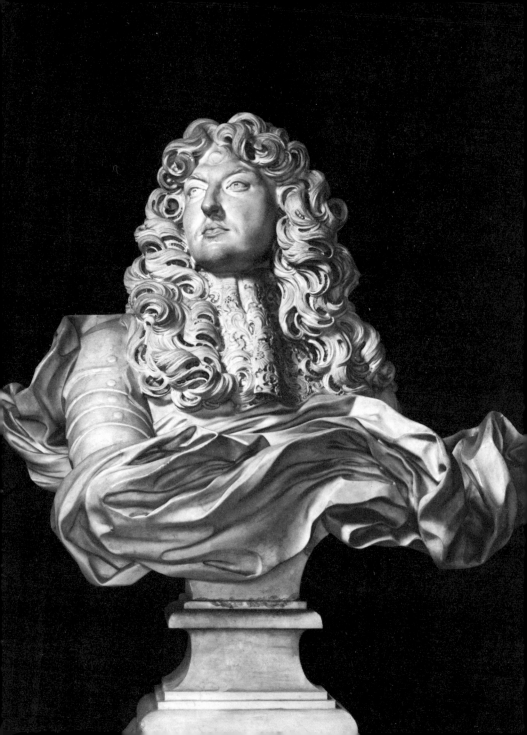

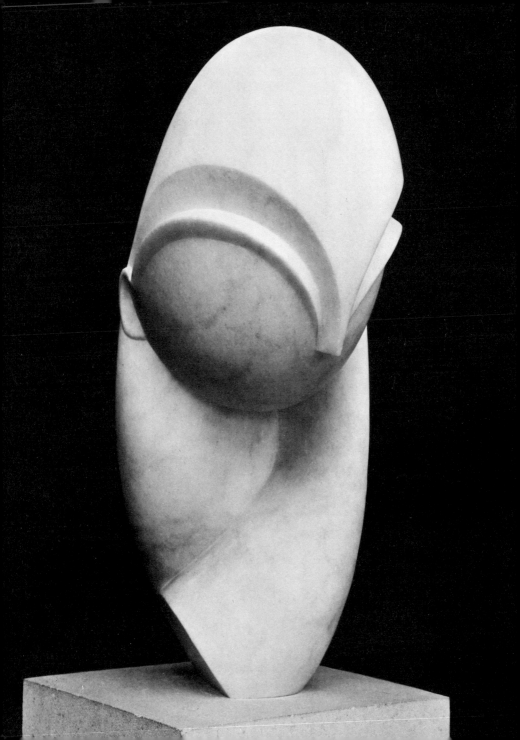

Gothic art is in general more naturalistic than Romanesque or Byzantine, or that certain African tribes produced more naturalistic wood-carvings than others. And there are various kinds of naturalism. Different artists and periods of art show interest in different aspects, features, and qualities of things and therefore represent them in different ways. The bronze heads from Ife, Epstein's portraits, the Renoir *Washerwoman*, the Bernini *Neptune*, the Parthenon *Dionysus*, Rodin's *Saint John*, and Michelangelo's Medici Chapel sculptures are all naturalistic works of art, yet how different they are in the aspects of nature which they portray and in the expressive qualities they possess!

3, 51 95 78

IDEALIZATION One of the most persistent tendencies in the sculpture of the world has been that towards idealization. Because the art of sculpture has the power to create images of its own which transcend reality, it has been called upon continually throughout most of its history to embody ideals of nobility, strength, desirability, physical beauty, kingship, and so on in a more perfect form than they are ever realized in actual life.

The stimulus for this idealization comes from many different directions: gods and goddesses imagined in the likeness of human beings may be required to have an abundance of the qualities that are most admired by the people who worship them; mythical heroes may be pictured as strong supermen, better proportioned, larger, and more handsome than real men; Indian apsarases must look as though they are capable of providing an eternity of sexual delight; Assyrian kings and Egyptian Pharaohs must embody the qualities of perfect rulers; and Stalin and other modern dictators must be made to project the benign paternalism of an idealized father-figure.

The most thoroughly idealized sculpture is that of classical Greece. We have already discussed the development of Greek sculpture towards a mastery of the structure and movement of the human body and the complex schemata in which this understanding was formulated. The Greek sculptors, however, aimed not merely to understand the human body but also to perfect it. They sought to achieve perfect balance, symmetry, and clarity, to make its shapes more regular and to perfect its proportions. They aimed at a complete harmony between its parts and a complete lucidity in its internal structure. Plato says in his *Timaeus*: 'He who takes for his model such forms as nature produces,

facing page
98 Detail of NEPTUNE AND A TRITON (*c.* 1620) by Giovanni Bernini. *Victoria and Albert Museum. Crown Copyright*

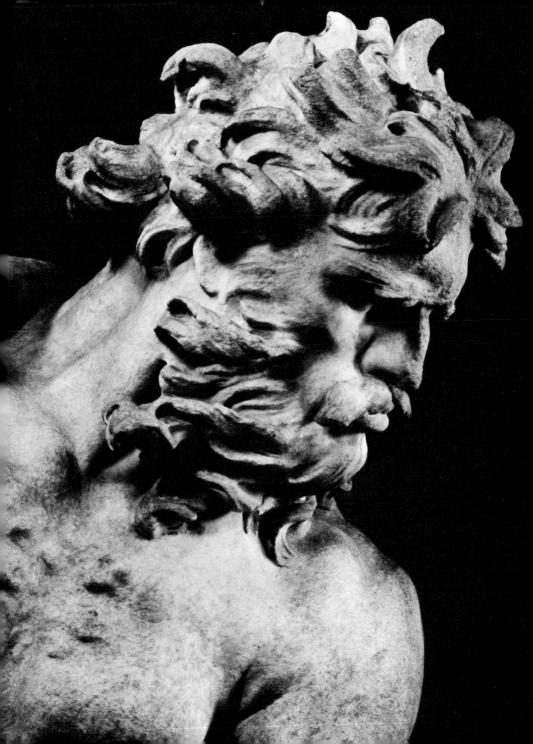

and confines himself to an exact imitation of them, will never attain to what is perfectly beautiful. For the works of nature are full of disproportion and fall very short of the true standard of beauty.' Individuality, which depends on irregularities and involves departures from the ideal standard, tends to be lacking in classical Greek sculpture. Its regular features and structure are those of perfect human types.

The power and influence of this idealized naturalism in the history of European art can hardly be over-estimated. In particular it became the standard of beauty for generations of sculptors and even influenced in a negative way the realism of Rodin. His intense study of the living human model was largely undertaken as a reaction against the perpetuation of the idealized classical Greek formulas in the academic sculpture of the nineteenth century. It would be difficult to find a greater contrast in spirit to the calm regularity of form and the idealized physical beauty of Phidean sculpture than the rugged in- 30, dividuality and expressive intensity of Rodin's *Saint John* or the pathetic physical decay of his *Old Courtesan*.

REPRESENTATION
WITHOUT IMITATION

The attitude of mind required for the careful observation and study of natural forms and for the attempt to imitate them accurately by constant comparison of the work with the model is a special kind of attitude which has been by no means universal among sculptors. Moreover, the kind of knowledge that Greek and Renaissance sculptors possessed of the structure of the nude figure, drapery, and animal shapes (especially the shapes of horses) was not achieved immediately, simply by a decision to imitate what was in front of their eyes. It was the result of prolonged and intensive study. After stating that it took 'almost two centuries of concentrated effort' for the Greeks to acquire 'an understanding of the structure of the human body', G. M. Richter says:

Their newly acquired knowledge was indeed an event in the history of art. We today take this knowledge for granted. It can be acquired in any art school and anatomy book. But never before 500 B.C. had a sculptor had this understanding. The Greeks by patient research had acquired it and, once in possession of it, they never returned to the conventions that they had inherited from Egypt and Mesopotamia and that had obtained for thousands of years. Henceforth Greek art was always naturalistic.[1]

[1] *Three Critical Periods in Greek Sculpture* (Oxford, 1951), p. 2.

There is another broad category of sculpture that is certainly representational but is not naturalistic. Among Indian, medieval, Egyptian, Mesopotamian, Oceanic, African, and Mexican sculpture there are some minor styles and individual pieces which tend more towards naturalism than others, but we would not describe the typical products of these styles as naturalistic. The human figures, animals, and other objects which are represented have undergone a degree of simplification or stylization that prevents them from being naturalistic to the same extent as classical Greek, Hellenistic, Roman, and Renaissance sculpture. The majority of twentieth-century sculptures of the human figure also come into this category.

Some of the transformations that objects undergo in ancient and primitive sculpture are obviously a result of the play of the artist's imagination with the forms of nature. But we must not assume that the sculptors of the past who did not produce naturalistic sculpture were consciously striving to produce work which was not 'true to nature'. Being as yet unaware of naturalism as a possible approach, they could not reject it as many sculptors did in the early part of the present century. The attitude of mind required for the careful, objective study of natural form is as foreign to ancient and primitive societies as the modern scientist's attitude towards nature. Stylization is not necessarily something that is deliberately imposed upon the objects of perceptual experience. Among ancient and primitive peoples it arose spontaneously out of the attempt to find a way of representing what they experienced in perception. But what they experienced was different from what we experience and their art is correspondingly different.

When looking at the sculpture of societies which are culturally remote from our own, especially primitive societies, we must bear in mind that we cannot take the point of view of the artists and see their work as their contemporaries saw it. Anthropology and history can help, of course, but we cannot know the background of this work as we can know the background of the work of our own contemporaries. We recognize now that the minds of children are in many ways a mystery which adults can only approach from the outside. The minds of primitive peoples are similarly inaccessible. Only by the greatest efforts of imagination can we even begin to grasp the state of mind of people who believe that a river is a god who needs to be humoured with sacrifices or who interview the

Fig. 81
Malanggan Carving, New
Ireland; painted wood, 26 in.

spirit that lives in a tree before they chop down the tree in order
to use it for carving. For most people living in our scientifically
educated society even the mental attitudes of our own Middle
Ages are unimaginable. So when looking at the art of other
societies we must beware of thinking that it arose out of modes
of consciousness similar to our own. With primitive art in par-
ticular it is probably best to take it as it stands and not to specu-
late too much about the attitude of mind which produced it or
what the artist's intentions were. Above all, when we observe
that a work is a simplification, stylization, or transformation of
the forms of nature the very last thing we should assume is that
the sculptor has first looked at nature 'realistically', seeing it
'as it is', and then altered what he has seen. This would be a
complete distortion of the facts. All we can say is that, from our
point of view as twentieth-century observers looking first at
his work and then at the kind of object it represents, the work
is a simplification, stylization, or transformation.

Most twentieth-century sculptors treat the forms of the
things they represent with considerable freedom but in their
case this is a result of a consciously held attitude. They have
lost their innocence and can only reach the primitive, as
R. R. Marett puts it, 'by way of repentance'.[1] It was, in fact,
only when European sculptors themselves began to feel free
from any obligation to imitate nature that they were able to
appreciate the sculpture of traditions other than their own. It is
the modern artist who has taught us to appreciate African,
Oceanic, Mexican, and Romanesque sculpture. 'Correctness'
of proportion and form is seldom demanded of artists today as
it has been for the last few centuries. There is still a small body
of opinion which holds that a horse or human figure in sculp-
ture should be anatomically correct, but such prejudices are
dying out and it seems no longer necessary to justify the fact
that sculptors depart from nature. Indeed what seems to need
justification and explanation at the moment is the fact that some
sculptors represent natural forms at all.

There is enormous diversity among the great sculptural
traditions. Their characteristic transformations and stylizations
of natural objects embody widely different outlooks on life
and often serve quite different functions. Similar divergences of
style are apparent among the work of modern sculptors. In
many African sculptures, in the Vézelay *Christ*, and in the 53

[1] In his foreword to Adam, *Primitive Art* (Harmondsworth, 1940).

Fig. 82
t-plaque, Luristan, *c.* 1000
c; bronze, 5⅛ in.

Fig. 83
Antelope, African (Bambara);
wood

emaciated figures of Giacometti the stylization is what we nowa-days call 'expressionistic', that is it heightens the emotional impact of the work. Other sculptures transform natural objects in order to fit them into a decorative scheme. They may, for example, be made to fit into a capital, a tympanum, or a door-way or to take on a character that fits in with the character of the building they decorate. This is most apparent in medieval 49 sculpture. Sometimes, as we have already remarked, stylization seems to spring from sheer imaginative play with the forms of nature. Consider, for example, the variations on the forms of animals and birds in Oceanic sculpture, or the fantastic animal 37, *Fig. 81* forms in the Luristan bronzes, or the complicated play upon 99, *Fig. 82* the forms of the antelope in Bambara carving. But perhaps the *Fig. 83* greatest stimulus to the transformation of figures and animals in sculpture has been the desire to represent beings from the realm of the supernatural. The spirits and gods that have been invented by men in all societies have frequently been imagined in semi-human or semi-animal form. This has provided an opportunity for the inventiveness of sculptors and other artists and has resulted in the creation of a whole world of beings who exist only in art. They range from the near-naturalistic Gothic angels to the near-abstract spirit beings of some African tribes.

We are here concerned with what Focillon has called the 'life of forms in the mind [which] propagates a prodigious animism that, taking natural objects as the point of departure, makes them matters of imagination and memory, of sensibility and intellect'.[1] One of the most interesting results of this 'life of forms in the mind' is the way in which sculptors have been able to combine in one image forms that are derived from different realms. Some simple and straightforward examples of this are Greek centaurs, the cat- and wolf-headed gods of Egyptian mythology, and the elephant-headed god, Ganesha, of India. 101 A more intimate fusion of animal and human attributes occurs in many primitive masks and figures. These are not just animal in one part and human in another but have forms which manage to suggest both human and animal attributes at the same time.

A number of modern sculptors have exploited the possibili-ties of this ambiguity of forms in extremely effective ways. Some of Paolozzi's earlier sculptures have the general form of a human figure but are composed of forms made out of the junk from industrial scrap-yards and electronic factories. The result

[1] *The Life of Forms in Art* (New Haven, Conn., and London, 1942), p. 47.

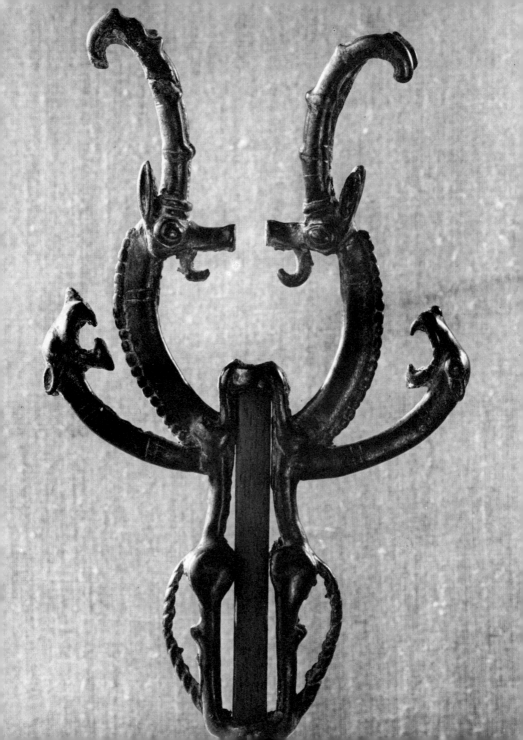

of this strange marriage is a breed of technological monsters, the kind of creatures that might stalk at night through the cellars of the glass palaces of modern industry. Germaine Richier has combined human and animal forms with the forms of insects, twigs, leaves, and bones to produce a desiccated, withered, nightmare world of semi-human, semi-animal, semi-vegetable creatures. Moore, too, has exploited this world of ambiguous forms. The general disposition of the forms of many of his 102, 28 sculptures suggests a human figure but the qualities of the components may call to mind the forms of mountains, caves, cliffs, rocks, bones, driftwood, leaves, and armour.

ABSTRACT SCULPTURE An important step is taken in the imaginative transformation of natural objects when the sculptor begins to introduce features into his work which are his own inventions rather than versions of what may be observed in the objects. In such sculptures as the Buli figure, the Chartres *Ancestors of Christ* and the Modigliani 23, 49 *Head* from the Tate Gallery the sculptors have elongated or 100 contracted, simplified or otherwise modified the forms of the human body; but none of the forms in the sculpture is a complete invention. In a great deal of twentieth-century sculpture, however, the forms of nature are merely used as a starting point for a process of radical transformation at the end of which the identity of the object may well be indiscernible. In *Figs. 9,* the Cubist-inspired sculptures of Lipchitz, Laurens, and Archi- 41, 84, 85 penko, for example, forms that are nothing like the forms of 34 the figure are introduced everywhere. There is usually some 41 suggestion of a figure in the over-all composition but its component forms are almost all complete inventions.

This process of transforming objects to the point of unrecognizability is not an entirely new twentieth-century development. In primitive sculpture the animals, birds, and figures which provide the starting point of the work are often submitted to an equally radical process of transformation. Nevertheless, in both Cubist and primitive sculpture some trace of the character of the object, some general suggestion of its particular expressive qualities and over-all shape, usually survives. Picasso himself has put clearly the position of the artist who transforms natural objects in this way: 'There is no abstract art. You must always start with something. There is no danger then anyway because the idea of the object will have left an indelible mark.'

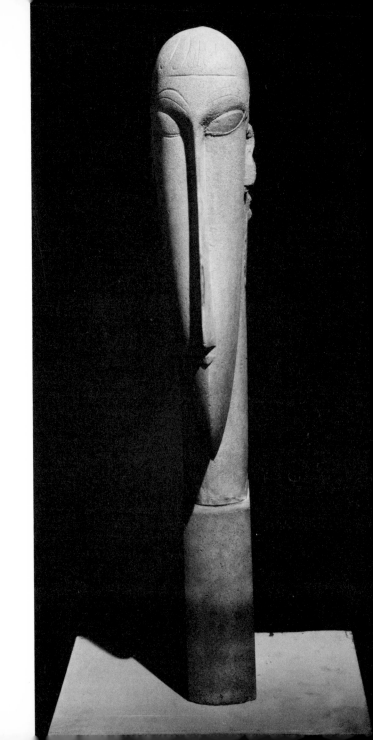

100 HEAD (1910–13) by Amedeo
Modigliani; enville stone,
62 cm. *Tate Gallery*

facing page
101 GANESHA, Indian, 16th
century; bronze, 66·5 cm.
Madras Presidency (photo:
Royal Academy)

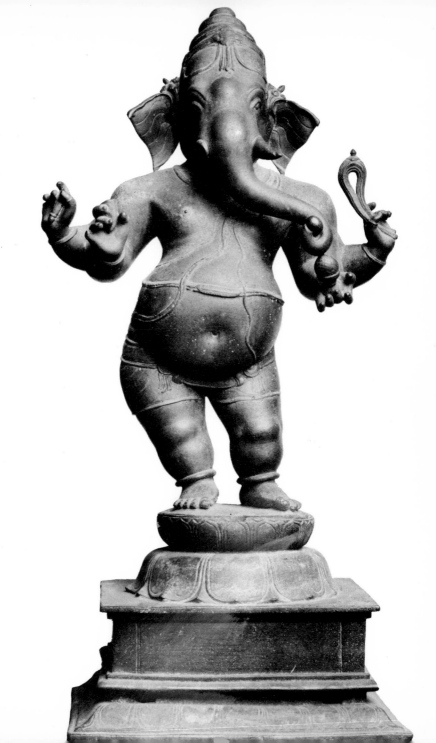

Fig. 84
THE BOXER (1920) by Henri
Laurens; stone

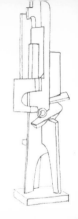

Fig. 85
MAN WITH GUITAR (1915) by
Jacques Lipchitz; stone, 96 cm.

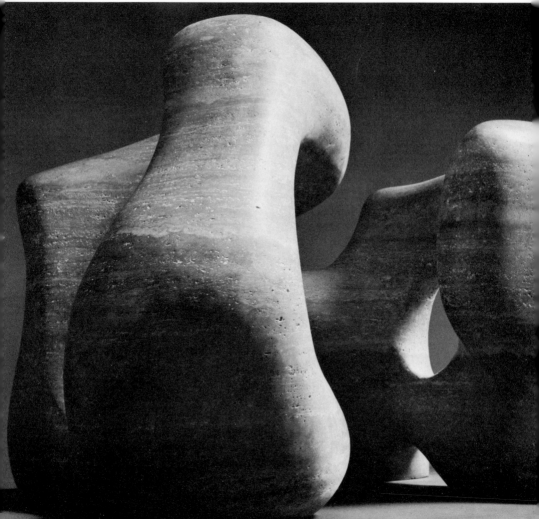

There are many twentieth-century artists who would not agree that 'you must always start with something'. They produce completely abstract, or non-figurative, sculpture which does not even have its starting point in anything that may be observed in the world of objects and they regard sculpture as a completely autonomous art of creating three-dimensional expressive form. There was a tendency in the early days of this non-figurative art to justify it with high-sounding theories deriving ultimately in some cases—Mondrian, for example—from Plato. Its forms were sometimes held to be 'purer' and of a higher ontological status than the forms of representational sculpture. Or it was sometimes claimed that by freeing itself from its ties with the realm of objects sculpture had at last achieved the 'condition of music'. Nowadays the approach of non-figurative sculptors to their work needs no such dubious theoretical justification. So much has been achieved in the mature work of such pioneers of abstract sculpture as Pevsner, Gabo, and Arp and by numerous younger sculptors in many parts of the world that the validity of this approach to the art of sculpture can no longer be doubted.

The attitude of the non-figurative sculptor certainly implies a new conception of the relations between sculpture and nature. In the past the invention of non-representational three-dimensional expressive forms was confined to the arts of pottery, architecture, metal-work, and other arts that have their roots in man's practical need for utensils, shelter, places of worship, tools, weapons, and so on. Sculpture was always figurative. But the reasons why an art of non-figurative sculpture is possible are fundamentally no different from the reasons why any other art of three-dimensional form is possible. We referred in the first chapter to the sculptor's highly developed awareness of the recurrent structural and expressive properties of three-dimensional form. He sees the world, so to speak, under the aspect of three-dimensional expressive form and acquires an extensive form vocabulary.

The language of sculpture, as of all the three-dimensional arts, is this language of expressive form. Potters, architects, and figurative and non-figurative sculptors all use the elements of this language to create structurally and expressively coherent configurations. In the case of figurative sculpture these configurations are derived from natural objects and resemble them in such a way that they can function as representations of them.

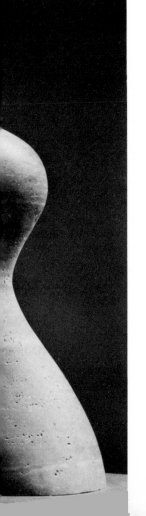

102 TWO FORMS (1966) by Henry Moore; red Soraya marble, L. 60 in. Photo: *Marlborough Fine Art*

In non-figurative sculpture the link between art and nature exists only on the more general levels at which forms in both realms may be seen to possess similar expressive characters or to embody similar structural principles.

Moore's abstract sculpture reveals a profound knowledge of 102 the expressive and structural properties of a wide range of natural forms. He has said this of the importance of the study of natural objects:

The observation of nature is part of an artist's life, it enlarges his form-knowledge, keeps him fresh and from working only by formula, and feeds inspiration.

The human figure is what interests me most deeply, but I have found principles of form and rhythm from the study of natural objects such as pebbles, rocks, bones, trees, plants, etc.

Pebbles and rocks show nature's way of working stone. Smooth, sea-worn pebbles show the wearing away, rubbed treatment of stone and principles of asymmetry.

Rocks show the hacked, hewn treatment of stone, and have a jagged nervous block rhythm.

Bones have marvellous structural strength and hard tenseness of form, subtle transition of one shape into the next and great variety in section.

Trees (tree trunks) show principles of growth and strength of joints, with easy passing of one section into the next. They give the ideal for wood sculpture, upward twisting movement.

Shells show nature's hard but hollow form (metal sculpture) and have a wonderful completeness of single shape.

There is in nature a limitless variety of shapes and rhythms (and the telescope and microscope have enlarged the field) from which the sculptor can enlarge his form-knowledge experience.[1]

Other abstract sculptors are not as deeply interested in natural objects as Moore and turn for their inspiration to the realm of man-made things, such as machines and other engineering products and all the things that make up our urban, commercial, industrial, and domestic environments. Paolozzi uses such sources of form in many of his latest works. In *The City of the Circle and the Square*, for example, his forms are intentionally 103 evocative of a great many different kinds of object in our urban and commercial world although they do not directly represent any particular one of them.

[1] Henry Moore, 'The Sculptor's Aims' from *Unit One* (London, 1934), ed. Read.

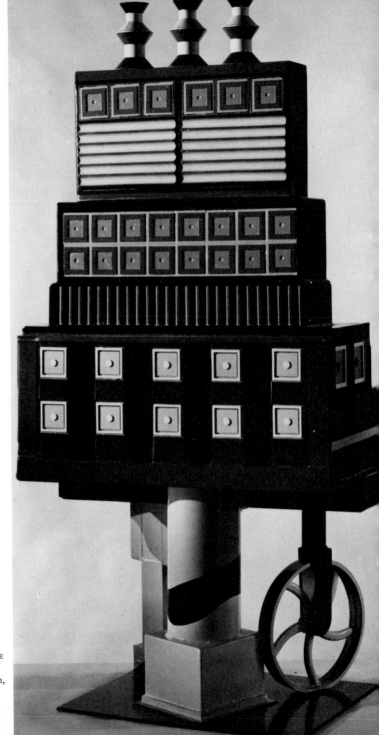

103 THE CITY OF THE CIRCLE
AND THE SQUARE (1963) by
Eduardo Paolozzi; aluminium,
84 in. *Tate Gallery*

But whatever the source of its forms, whether they are derived from the human figure or from other natural objects, or have their origin in the shapes of man-made things, or are wholly invented, sculpture always speaks the language of three-dimensional expressive form. Until we begin to make this language our own we cannot begin to appreciate the art of sculpture on any but the most obvious and superficial levels. It is, of course, a language only in a metaphorical sense. Whereas the words and sentences of a true language always signify something other than themselves and are used as signs to communicate a meaning, the forms of sculpture are to be apprehended primarily for what they are in themselves. This is as true of representational sculpture as of abstract. Even when a piece of sculpture is an image of some object or event in the real world, it is to be apprehended in appreciation primarily as a structure of expressive forms, never simply for what it represents. The most realistic replica of the most beautiful natural object is artistically worthless unless it offers to contemplation an intelligible structure of expressive forms. This is why waxworks have no value as sculpture even though they are models of beautiful human figures. On the other hand most of the finest sculptures are far from being exact replicas of what they represent.

The ability to perceive expressive sculptural form, which in most people is poorly developed, must be cultivated and refined. We must not allow ourselves to become so concerned with what a piece of sculpture represents and with its immediately appealing expressive qualities that we cannot see beyond them. In order to develop our sensibility to deeper levels of form and expression we must learn what to look for, on what to direct our attention. It has been the aim of this book to offer guidance in this, to give some idea of the kinds of expressive sculptural form there are, and to show how they are combined and to what uses they are put. This is not a thing which can be learned theoretically and stored away as a piece of intellectual furniture like textbook information. It can only be mastered practically in the way of a skill that is acquired, in this case a perceptual skill. The purpose of the book will be frustrated and whatever potential usefulness it has will be destroyed unless everything that is said is tested continually and repeatedly at first hand by contact with actual works of sculpture (not illustrations) and unless the book is treated more or less as a

series of suggestions for the training of perception in the particular field to which it relates. It is a practical guide rather than an elementary textbook.

One further point in conclusion. If nothing else, this book should at least give an indication of the immense variety of the material which the sculpture of the world offers for perception. The most dangerous of all mistakes is to approach any piece of sculpture with preconceived ideas and either to reject it because we cannot see in it what is not there to be seen or—perhaps even more unfortunate—to persuade ourselves that we do see what is not there. This is a mistake which may be made just as readily by those who pride themselves on being forward-looking and up-to-date as by traditionalists. The observer must approach each work of art with an open mind, without preconceptions, prejudices, or restrictive theories. His sole aim is to perceive what is there, to perceive it fully and comprehensively. This is the final aim and the object of cultivating the sense of form.

Index